IMAGES
of America

BETTENDORF
IOWA'S EXCITING CITY

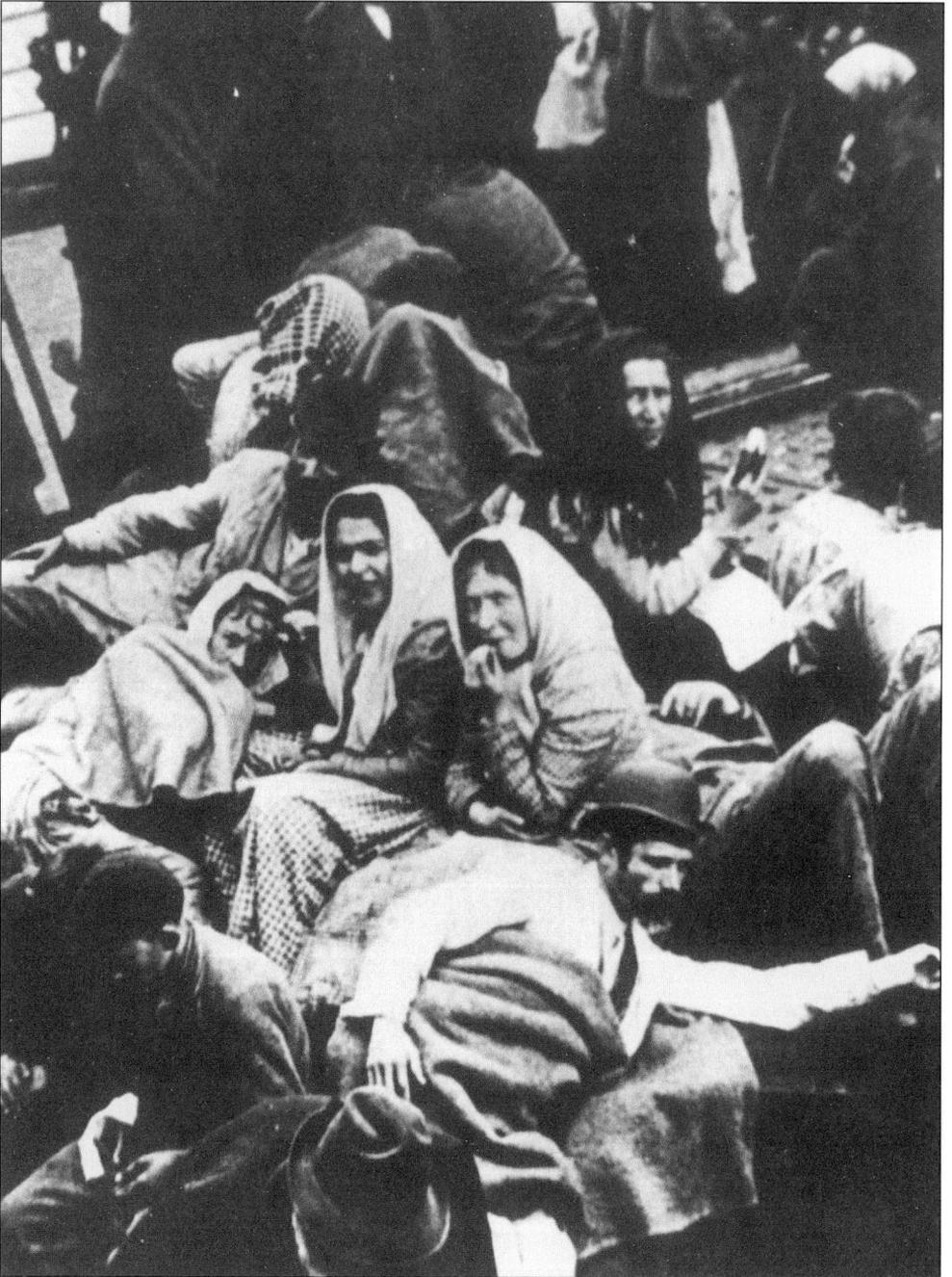

What brought so many immigrants to Bettendorf in the late 19th and early 20th centuries? Opportunity to work in the rich soil of the Mississippi Valley, planting and harvesting crops? Or perhaps it was a chance to become a skilled laborer in area factories, learning through observation and experience. Indeed both agriculture and industry beckoned Germans, Irish, Greeks, Mexicans, and many other nationalities. Here, an Armenian family shares meager accommodations aboard a trans-Atlantic ship that would land them in America and eventually lead them here to Iowa.

2

IMAGES
of America

BETTENDORF
IOWA'S EXCITING CITY

David R. Collins, Bj Elsner,
Rich J. Johnson, and Mary Louise Speer

ARCADIA

Copyright © 2000 by David R. Collins, Bj Elsner, Rich J. Johnson, and Mary Louise Speer.
ISBN 0-7385-0703-2

Published by Arcadia Publishing,
an imprint of Tempus Publishing, Inc.
2 Cumberland Street
Charleston, SC 29401

Printed in Great Britain.

Library of Congress Catalog Card Number: 00-100064

For all general information contact Arcadia Publishing at:
Telephone 843-853-2070
Fax 843-853-0044
E-Mail sales@arcadiapublishing.com

For customer service and orders:
Toll-Free 1-888-313-2665

Visit us on the internet at http://www.arcadiaimages.com

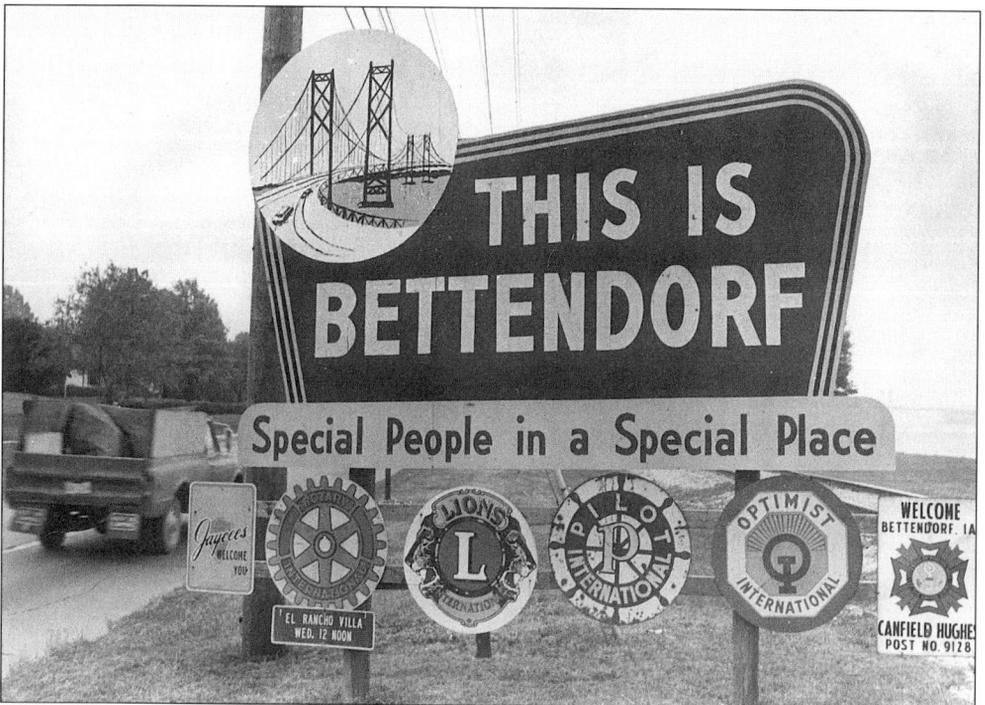

It was an editor of the *Bettendorf News* who first proclaimed Bettendorf, "Iowa's Most Exciting City," and the community took it as a challenge to be that, and more. This welcome sign proclaims the numerous civic organizations at the core of "Special People in a Special Place." Whether it's the Jaycees, Rotary, Lions, Pilot Club, Optimists, or the American Legion, opportunities abound for getting involved in Bettendorf through community service. Not only do clubs provide fellowship for their members, the members get behind a variety of special events and show their civic pride by volunteering their talents and their time.

CONTENTS

ACKNOWLEDGMENTS

By any standards, Bettendorf is a *new* city, having seemingly sprung up in the blink of an eye, from fertile prairie to 20th-century urban landscape. In fact, its historic roots are as deep as the American psyche; the quintessential Iowa town: a place where fortunes have been made and lost and spirits reclaimed have marked its seasons of growth. The land first opened to homesteaders in 1833, and its original name, Lillienthal, was in honor of the first land purchase by a family who ran a tavern and dance hall. Elias Gilbert, a gentleman farmer from New York, platted the first town, which took his name in 1858. It remained unincorporated until 1903, when the city of Bettendorf was established by entrepreneurs William and Joseph Bettendorf, the iron wagon magnates who relocated their factory from Davenport.

Within the pages that follow, many of the people and places, the events and times of "Iowa's Most Exciting City" have been captured in photographs and text. Only an overview is possible in 128 pages, but it will hopefully be a pleasurable experience to share a few glimpses of Bettendorf's past and present.

In appreciation for their contributions to this volume, the compilers wish to acknowledge: Debra Barnhart, McCarthy-Bush Corporation; Vern Berry; Mark Brooks, Bettendorf High School; Faye Clow, Bettendorf Public Library; Scharlott Blevins; The Delbert Blunk Collection; Lorna Dawson; Amy Groskopf, Mary Ann Moore, and Pat Richardson, Davenport Public Library Special Collections; Lettie Ernst; Carolyn Anderson and Tom Stranger, Family Museum; Connie and John Heckert; Ruth Hendricks; Mayor Ann Hutchinson, City of Bettendorf; Walter Jindresek; Lady Luck Casino & Hotel; Julie McDonald; Morris "Gene" Nelson; Mark Peterson; Arlene Vogel Phillips; Roy Booker, *Quad City Times*; Ross' Restaurant; St. Katharine's/St. Mark's; Juanita and Richard Schillig; Lenny Stone, Scott Community College; Al Steinbrecher; Lennie E. Stone; George Thuenen Jr.; The Voelliger Family Collection; John and Virginia Voss; Henry Weber; B.J. and Kathy Weigle; Ruth Etta Wallace Wilson; Paul Wymore; and Betty Yegge.

INTRODUCTION

What draws people to a particular place? Dreams for one. Dreams of a better life, an opportunity to establish homes, to set up businesses, to connect with family and friends. A dreamer's journey leads to places where anything is possible.

Bettendorf, Iowa, is such a place. Bettendorf first opened to homesteaders in the 1830s after the Black Hawk Purchase. Unlike other river towns, such as LeClaire and Dubuque, Bettendorf's identity formed in its rich, rolling prairies.

German immigrants flocked to the area, attracted to its fertile land and ideal growing conditions. The Irish came, too. Farmers guided wooden plows through the rich loam; John Deere's steel plow eased their labor.

Pleasant Valley would especially become famous for the large yellow onions grown there by Isaac Hawley, his sons George and Daniel, and the Henry Schutter family.

In 1834, an army surgeon, Dr. John Emerson, purchased 340 acres of land and built a cabin, where his servant Dred Scott resided to stake Emerson's claim. Later, Scott would claim his residency in what was then the Wisconsin territory, which entitled him to freedom. The U.S. Supreme Court ruled against Scott in 1857. In an April 17, 1857, newspaper interview, Scott was quoted as saying he was not discouraged by the ruling. But he died the next year, five years before President Abraham Lincoln's Emancipation Proclamation.

Another early settler, Lyman Smith, traveled from the east by boat to Chicago, wanting to join his family in Pleasant Valley. Unable to afford the "comfort" of a horse, the intrepid young man trudged the 170-plus miles on foot. Records do not tell if Smith arrived with holes in his shoes, or how many blisters chafed his feet. Nearly 15 years after Smith's long walk, a New Yorker named Elias Gilbert traveled with his family to the quiet hamlet of Lillienthal. He built what was then the finest house in Scott County.

Gilbert's keen mind winnowed out plans for developing Lillienthal's natural resources. He opened a starch factory and attempted to grow tobacco along the riverfront. Both enterprises failed. He moved on west, but his legacy endured in the rumors of his efforts on behalf of the Underground Railroad. Gilbert's spacious barn and home had a hidden tunnel, providing temporary refuge for those attempting to flee slavery in the South.

Lillienthal became unofficially known as Gilbertown, a rural community where people kept pigs and chickens in their yards, and socialized at Borneman's Tavern and Dance Hall. A tyrannical headmaster taught German to all students who attended Gilbert School, regardless of their nationality.

Laid-back, rural life was just fine for most folks. But those living along State Street thought there must be something more that their town could become. After a fire destroyed a Davenport wagon-making business, the owners—brothers Joseph and William Bettendorf—agreed to rebuild their factory on the former Gilbert farm, if the residents would help them purchase the land. Townsfolk agreed. Fund-raising efforts were spearheaded by a young man named Clarence

Brown. Riding in his horse and buggy for the better part of three weeks, Brown canvassed households and knocked on the doors of local businessmen to raise the $15,000 needed.

Brown's efforts paid off. In 1903, the doors opened at the new riverfront facilities of the Bettendorf Axle Company. Later that year the name Gilbertown was replaced with Bettendorf, and the city was officially incorporated.

The decades that followed turned a quiet rural community into a model of 20th-century life. A city hall was constructed in 1907. Residents organized an all-volunteer fire department. Electric lights went up, and the landscape changed once more.

The luxurious Meteor automobile, built by the Bettendorf Company, became a must-have for those with enough money to own one. The demand for factory workers brought new immigrants from Armenia, Greece, and Mexico. And so the city grew.

A visionary young Bettendorf Co. employee named Frank Wallace made it possible for local aviation enthusiasts to take to the air. Wallace Airfield, Iowa's first airport, opened in 1919. Wallace and partner Don Luscombe led efforts to create the Monocoupe—the first small, enclosed-cabin aeroplane.

Bettendorf was a company town. Even the recreational interests of the residents were supported by company-sponsored bowling, golf, and baseball teams. Joseph Bettendorf foresaw the need to create a city park and purchased 300 acres on Devil's Glen Road.

Because so much of its prosperity depended on its manufacturing industry, Bettendorf was devastated by the Great Depression, probably more than other neighboring cities. Bettendorf Company's production idled to almost nothing. Families returned to field work, earning pennies a day topping onions.

By 1936, Bettendorf eased back toward prosperity. The factory reopened its doors. But Frank Wallace was told he had to close his airport because town leaders wanted Standard Oil to locate on the property. Davenport's Cram Field and the Moline airport provided enough airport service, they reasoned.

After World War II, the Bettendorf Company was sold to J.I. Case. On the riverfront farther east, in an unincorporated area between Bettendorf and Pleasant Valley, a huge factory was built by Alcoa. To the north, Bettendorf battled Davenport for land. Mayor Arnold Kakert (1954–62) successfully sued for the tract that would eventually be the site of Duck Creek Mall and several new housing developments.

Today, Bettendorf is a community of more than 30,000. Few farms remain, and those that do are quickly giving way to upscale housing developments and commercial retail centers. According to current Mayor Ann Hutchinson, the city is 70 percent residential. After the recession of the 1980s, J.I. Case closed shop and the city leaders have since focused on attracting new industries to Bettendorf.

During the 1980 recession, J.I. Case folded and the vacant riverfront made folks take a second look at how the river could better serve the community. Bike paths and picnic areas have been developed along the shore. Bettendorf became the first city in the nation to offer casino boat gambling. The former Case property is now home to the Lady Luck Casino and Hotel.

What does the future hold for Bettendorf? Plans are in the works to rejuvenate the State Street corridor, new housing developments are popping up everywhere, and much-needed building renovations are underway thanks to the taxpayers' support of a school bond referendum.

Bettendorf is an exciting city to live in and be a part of. Dreams, and those who dare to dream them, make anything possible.

One
WHAT'S IN A NAME?

So asked the bard of Stratford on Avon and even as he pondered it,
a Spanish explorer by the name of DeSoto, having discovered
the mouth of a great river, could not in one lifetime imagine how far
that mighty waterway had flowed from a trickling stream at its source
to a half-mile-wide channel of limestone and loess, turning gently west
and there, where the sun rises on the water's surface, turning it to gold,
there is where three centuries passed till river, prairie, and people came together as one.

The year was 1835. Andrew Jackson was in the White House, while here on the western prairie, partners Davis and Haskell operated a grist mill at Crow Creek. "An awful thing it was," complained one customer. The primitive mill was nothing more than two ragged boulders. "I got seven bushels of corn ground in one night and staid all night with a hoop-pole digging meal out of it."

William "Buffalo Bill" Cody spent his childhood upstream from Bettendorf in LeClaire, Iowa. The famed Wild West showman passed through town frequently, when it was called Lillienthal. Back then, the only place to get a hot meal and a shot of whiskey was at the Borneman homestead, located at what is now Seventeenth and State Streets. The Bornemans were Austrian aristocrats and their residence, built in 1852, served as a tavern, post office, meeting place, and dance hall.

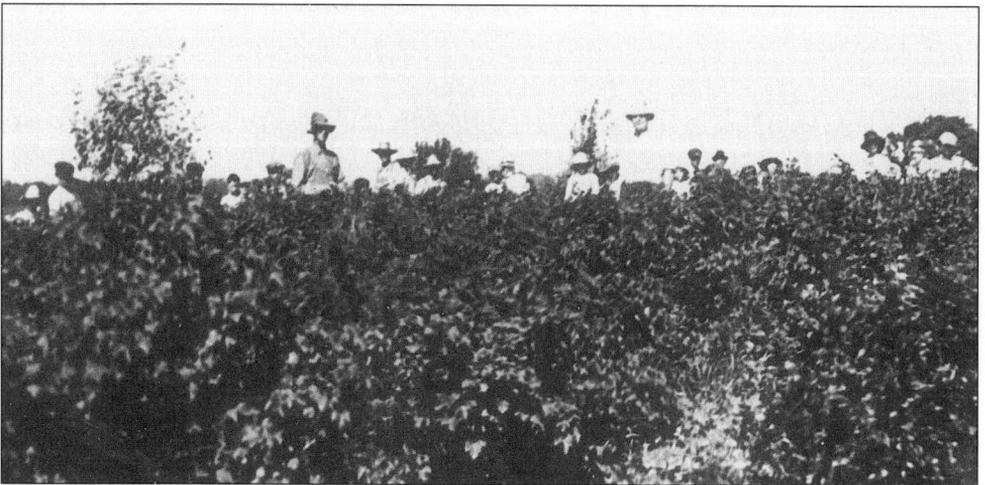

Onions weren't the only crops to thrive in the rich soil of the Mississippi Valley. Berry patches such as this were thick and numerous as well. William Holmes, brother-in-law of Elias Gilbert, had a 17-acre fruit and vegetable farm where he employed many poor German families, including women and children. About the only other opportunity for employment was in the stone quarry, which paid 50¢ a day. Holmes had season after season of bountiful harvests and converted his first house into a wine cellar. As for Elias Gilbert, the area proved inhospitable to his tobacco growing and starch factory enterprises.

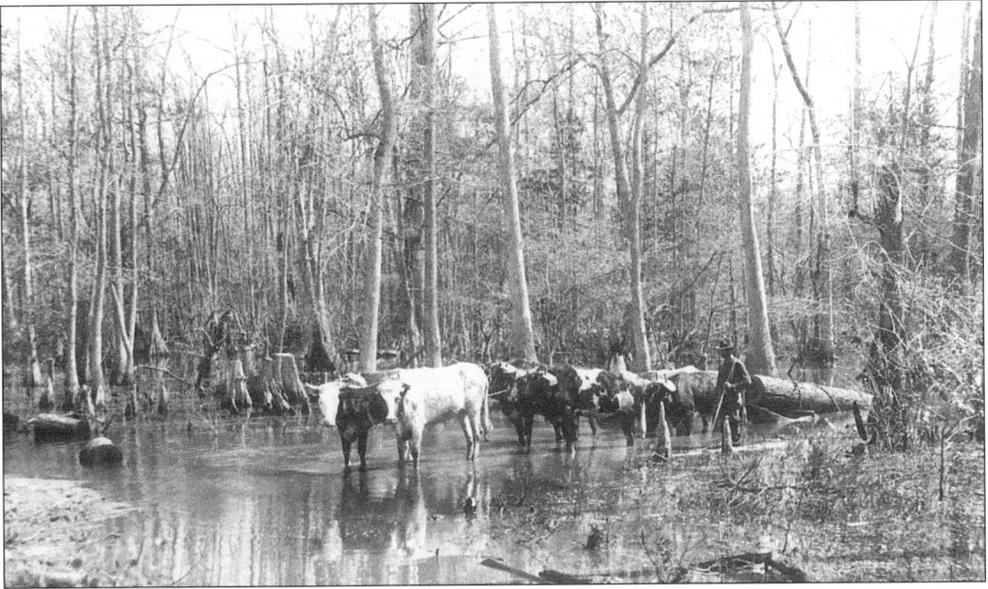

This spot along Duck Creek, just north of present-day Route 67, was the site of a sawmill operated by Captain Benjamin Clark in 1835, fifteen years before Elias Gilbert platted the origins of Bettendorf. Clark's nearest competitor was Pleasant Valley resident Samuel Hedges, who owned a sawmill on Crow Creek. Later evidence of a race track among the trees where this team of oxen are dragging logs, and historical references to a tavern and proposed town hall are all that remain of what might have been—Iowa's first incorporated city. But Captain Clark was only interested in getting the lumber downstream to where he was building the town of Buffalo.

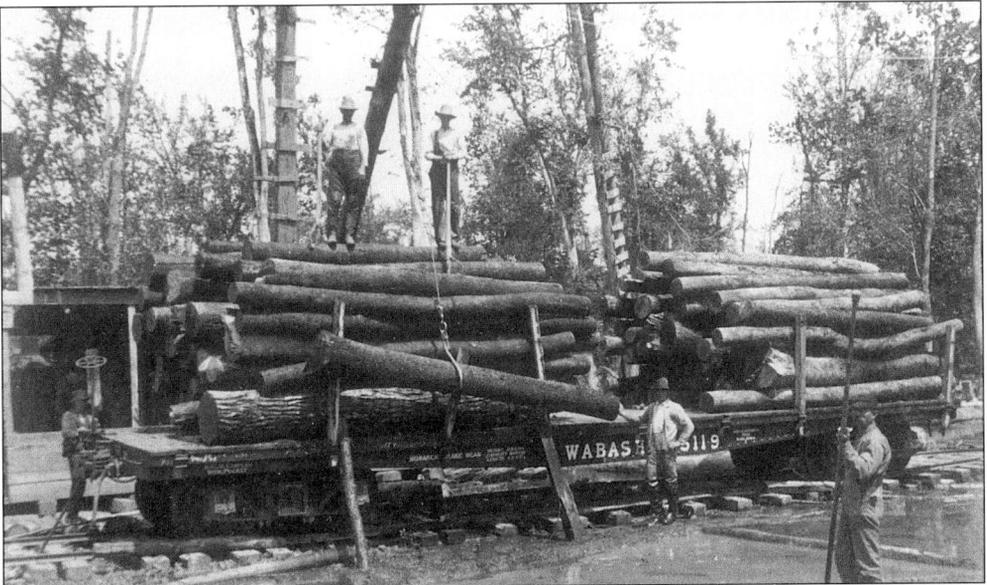

So many houses were being built in the 1800s that the demand for lumber pretty much wiped out the forests in the upper Mississippi Valley. Timber was planed into boards at sawmills located on Spencer's and Crow Creeks. In this photograph, the giant logs are fished from the waters and stacked onto flatbeds to be transported by railroad to sawmills. The lumber would go on to towns both east and west of the Mississippi.

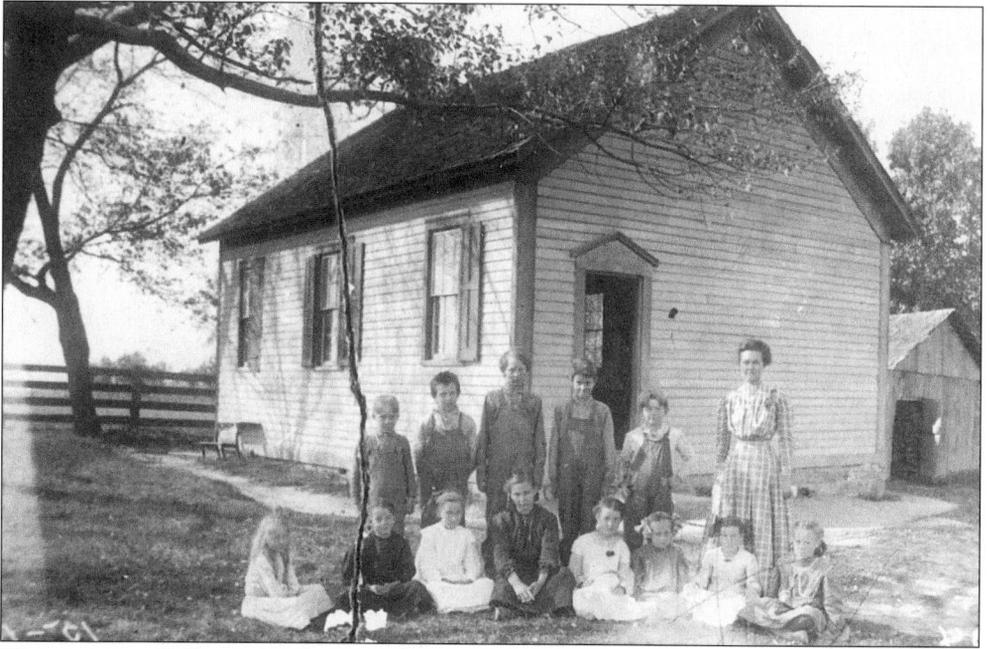

The two-room Gilbert schoolhouse served youngsters living in town. Country kids like Mabel Spencer attended the one-room Stokes School, located near Twenty-third and Central Streets on a parcel of land owned by Young Stokes. The rural school closed in March 1907. On the last day, students presented teacher Flora Seeman with this beautiful picture as a memento of their time together.

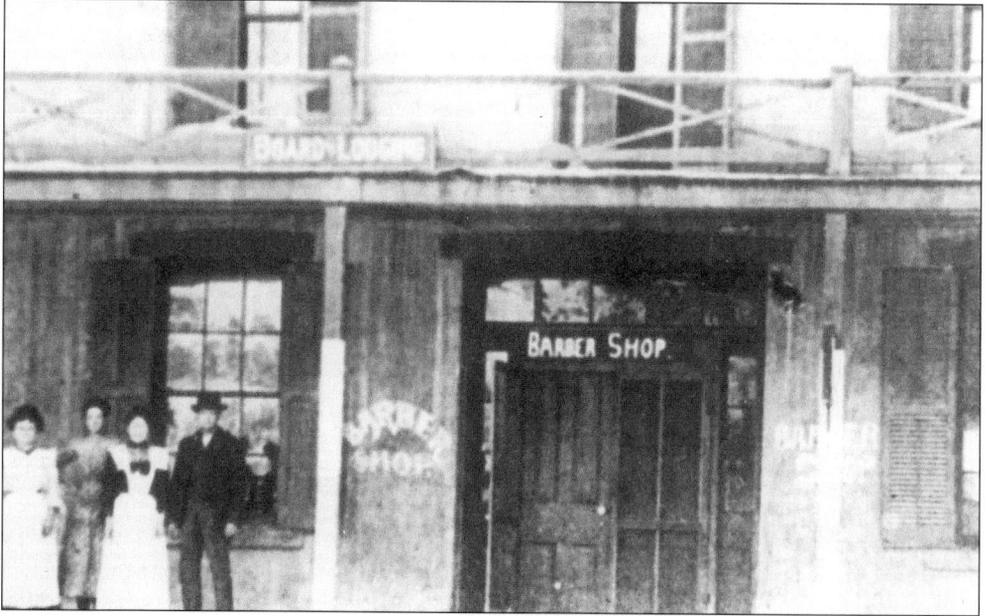

Shave and a haircut, two bits. Actually, it only cost a dime for the barber, but maybe for a little extra, the ladies would sing "Sweet Adeline" in three-part harmony—four-part if the gentleman could sing bass. This old barbershop operated out of the old Borneman place at Seventeenth and State Streets. It was owned by the Druehl family.

12

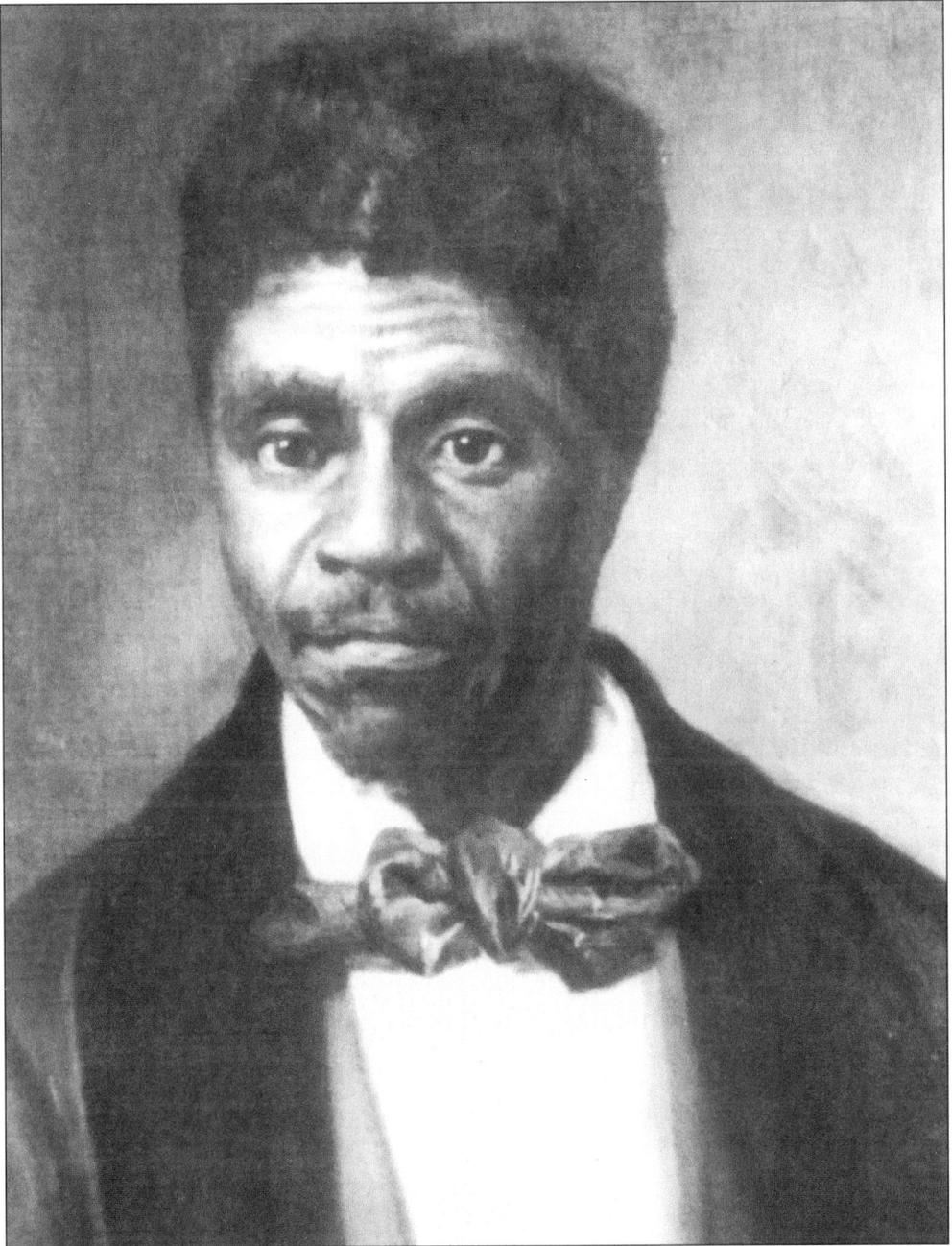

When the land where Bettendorf now stands was first opened to homesteaders, Dr. John Emerson, an Army surgeon at Fort Armstrong, staked his claim from the Mississippi River to present-day Mississippi Boulevard, between Fourteenth and Eighth Streets. He had a cabin built and occupied by his slave, Dred Scott. Later, Scott would claim himself a free man for having resided in Wisconsin Territory, where slavery was illegal. Scott's case was argued before the U.S. Supreme Court in 1857, six years before Lincoln's Emancipation Proclamation. Scott died in 1858, knowing only that he had lost his legal claim to freedom and little realizing the historical significance of his life.

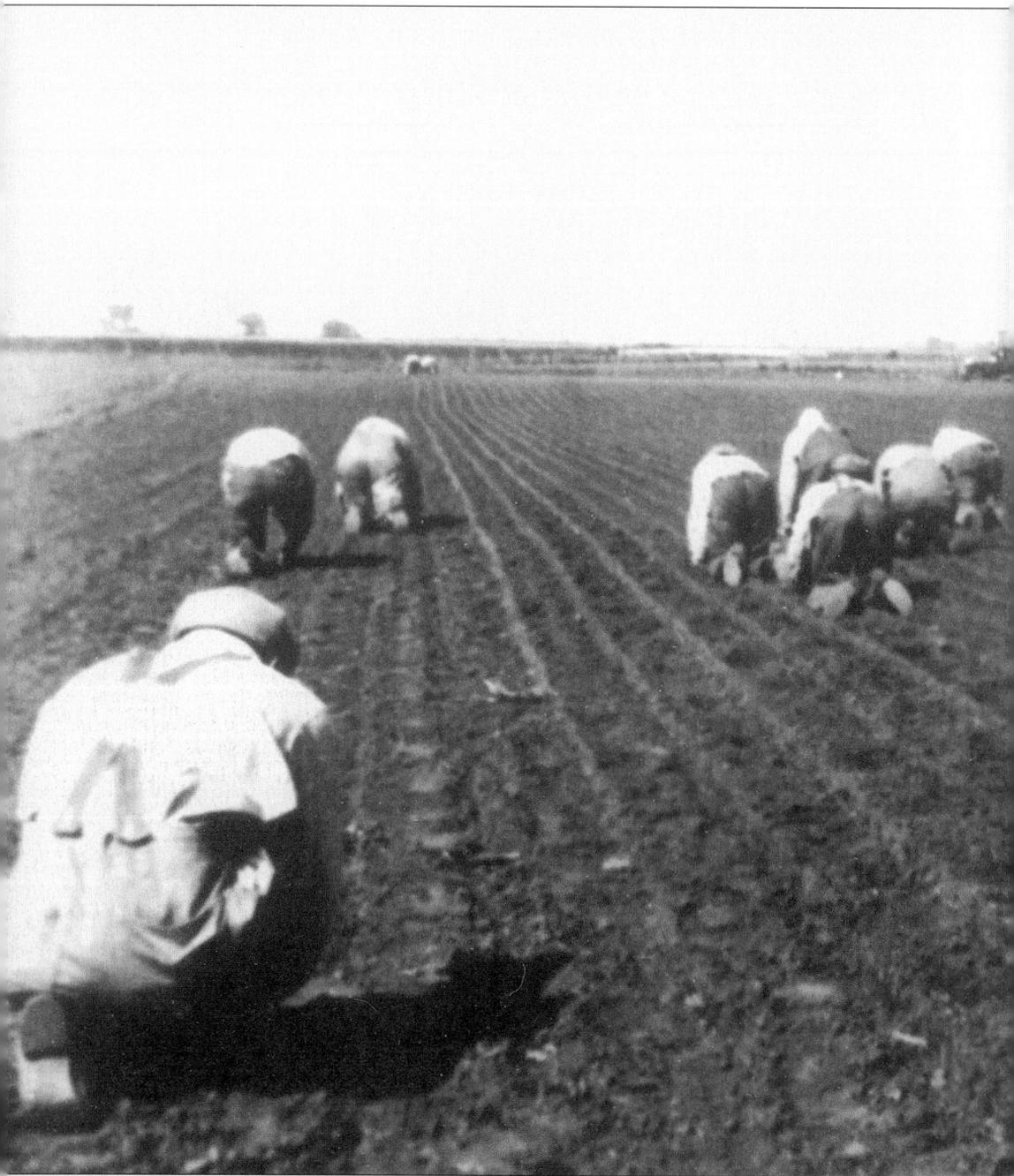

Operating under nature's invincible clock, planters slowly and carefully slip the onion bulbs into the ground. The onion field workers were mostly of German descent. Bettendorf's onion fields covered hundreds of acres and produced from 500 to 600 bushels per acre. Workers came

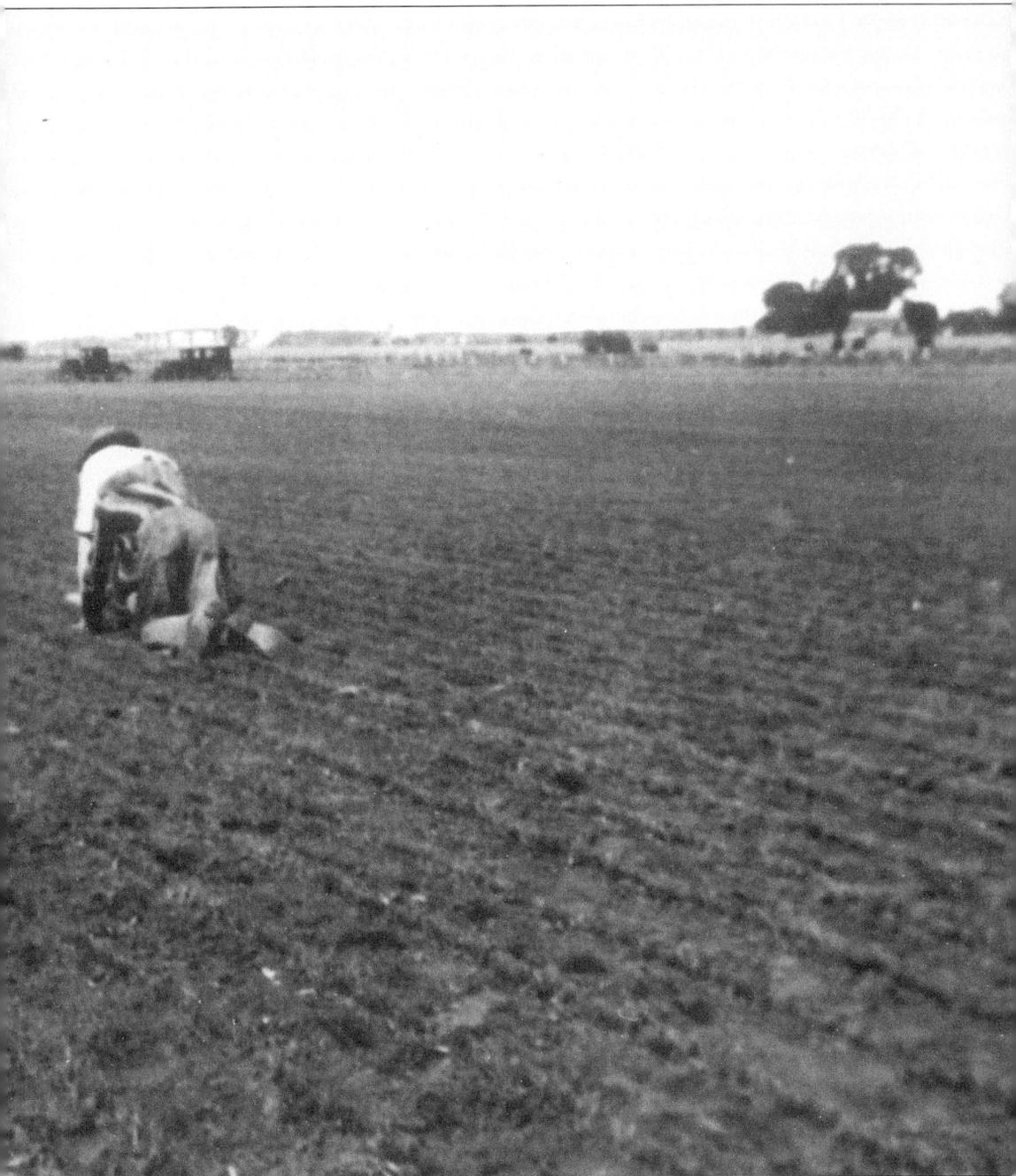

from nearby and surrounding areas to labor in the fields from planting to harvest. "It was hard work," observed one onion field worker, "but it was good, honest work, too."

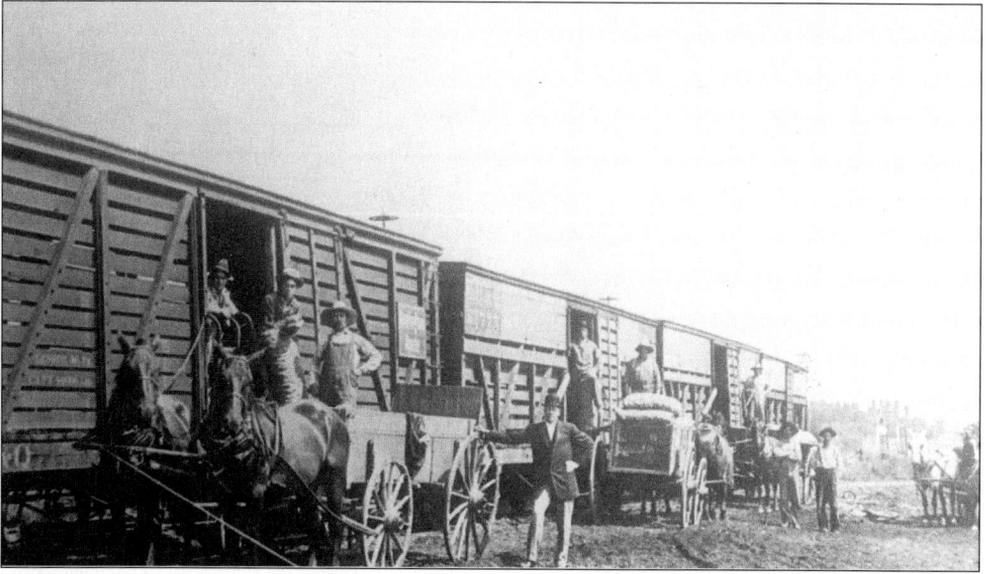

"To market, to market . . ." railroad cars filled with another season's harvest. The record for Bettendorf's onion fields came in 1912 when 950 bushels per acre were harvested; a culmination of many hours and many hands working together to plant, prune, pick, and pack. A way of life passed mostly into history after "Yellow Dwarf" fungus infested the fields in the 1920s. Only a few acres of onion farms remain, losing ground to urban growth and the changing Bettendorf landscape.

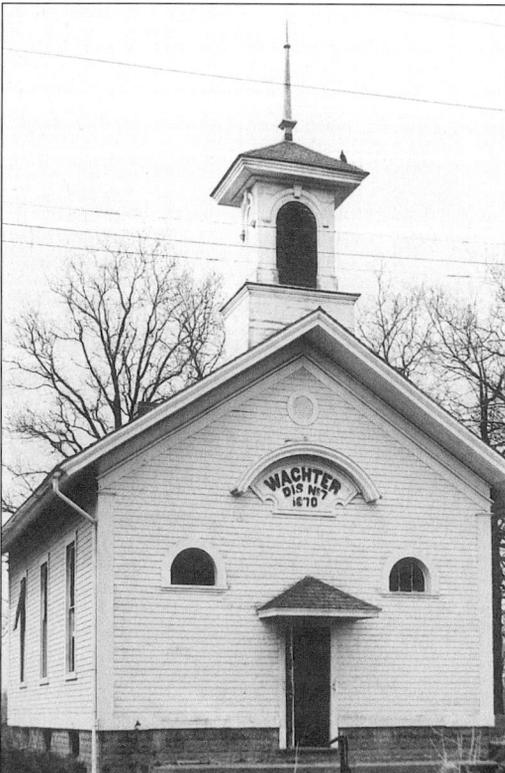

The Wachter School was built in 1870 on property owned by two local farmers. Ulysses S. Grant was president, and the first vacuum cleaner was patented, and that same year the Cincinnati Red Stockings became the first professional baseball team franchise. Parents of the children at Wachter School kept the building cleaned and repaired, painting walls, fixing the roof, and keeping the furnace in working order.

"And do you, Nels Nelson, take this woman, Florence Linstrand, to be your lawfully wedded wife, to love and to cherish, for richer or poorer, in sickness and in health. . . ." And with their wedding vows still echoing in their heads and hearts, the bride and groom posed for their wedding photograph. This early pioneer couple raised a family and, "till death did they part," made their home in Bettendorf, the city they loved.

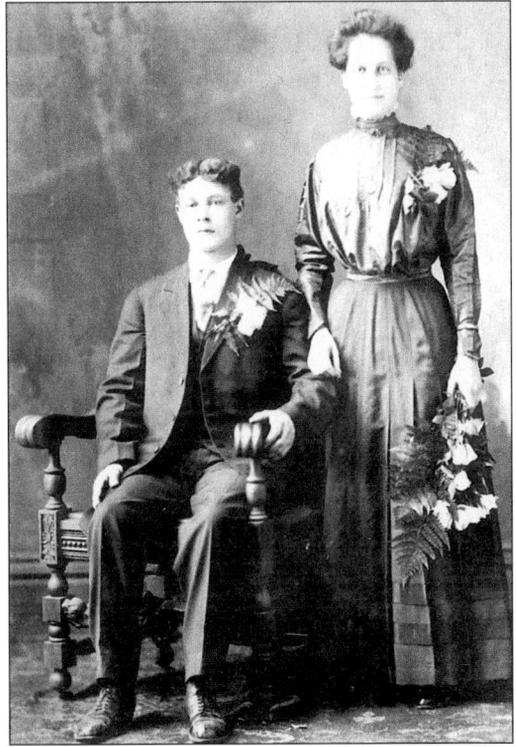

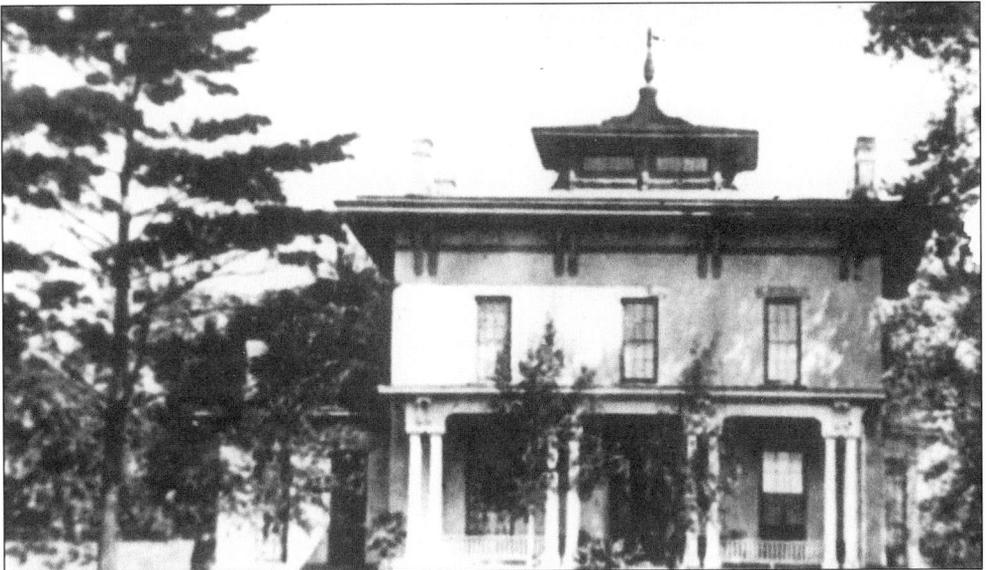

Long before St. Francis Monastery and Joseph Bettendorf's mansion crowned Bettendorf's hillside, an easterner named Elias Gilbert came to the town of Lillienthal in the early 1850s and built what was then the finest house in Scott County. It cost $12,000 and featured two-foot-thick limestone walls and a cupola from which, as legend tells, Gilbert used to watch out for rafts on the Mississippi, carrying runaway slaves. His home was rumored to have been a stop on the Underground Railroad. Two other families would call the Gilbert mansion home before it was sold to the fledgling Our Lady of Lourdes Catholic Church and converted to a school.

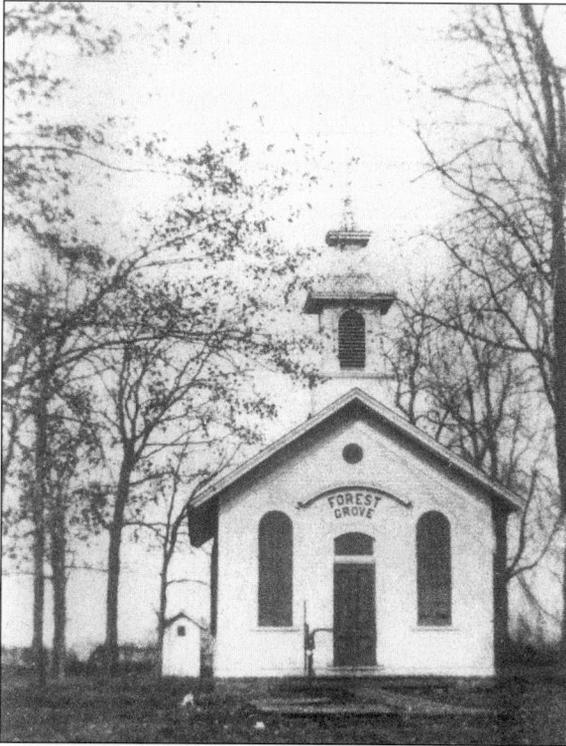

Imagine, if you will, the teacher at Forest Grove School, which opened in 1888, tolling the bell to summon children to their seats. When this photo was taken in 1930, the recitation of the day may have been Lincoln's Gettysburg Address or multiplication tables. Maybe the boys and girls were competing in a spelling bee, or perhaps all was quiet as they practiced writing in Palmer script. But when the teacher dismissed them at the end of the school day, there was sure to be excitement in their voices as they headed out the door. Forest Grove School closed in 1956.

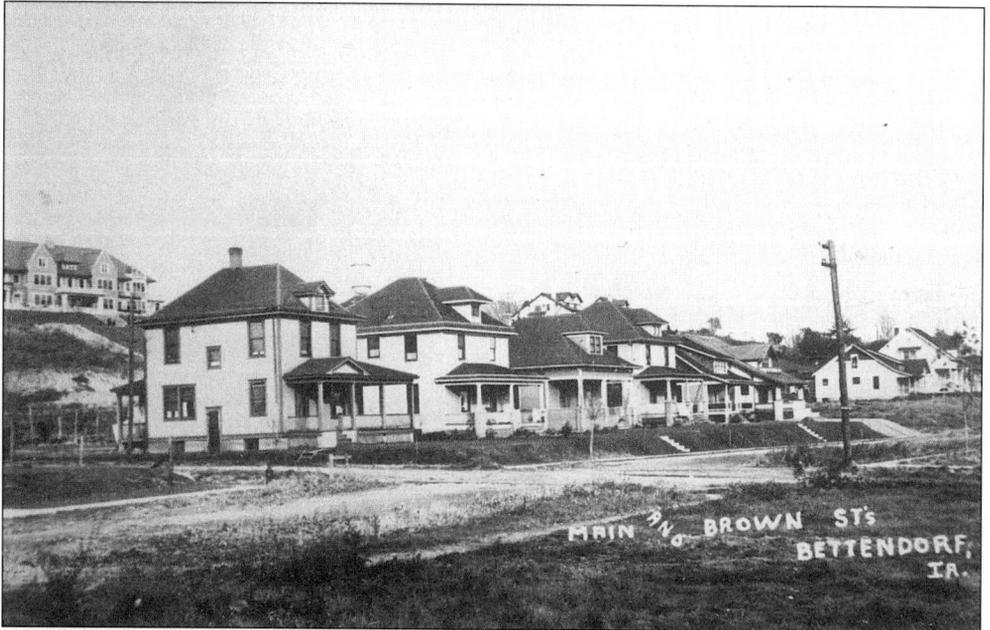

The homes along Main and Brown were similar in architectural style, as can be viewed in this 1910 photo. They were built strong and sturdy, each containing tall ceilings and wooden stairwells. Large porches were featured on the front of the houses, while smaller ones were attached to the back. Short terraces and manicured lawns lined the streets. In 1911, the entire appearance of the block changed when the road was paved.

Two
CHANGES

Now others indeed had come here first and named a name for every creek
and glen and trail of the mighty buffalo, the deer, the multitudes of flocking birds.
But names like Si-ka-ma-que Sepo are lost on the winds of change
and those who followed brought names of their own,
claims of their own and dreams of their own to tame the untamed river,
the wilderness, the western plain and so the name of man everywhere on the land:
Lillienthal, Spencer Creek, Gilbertown, Grant Street, Holmes Street,
Brown Street—Bettendorf.

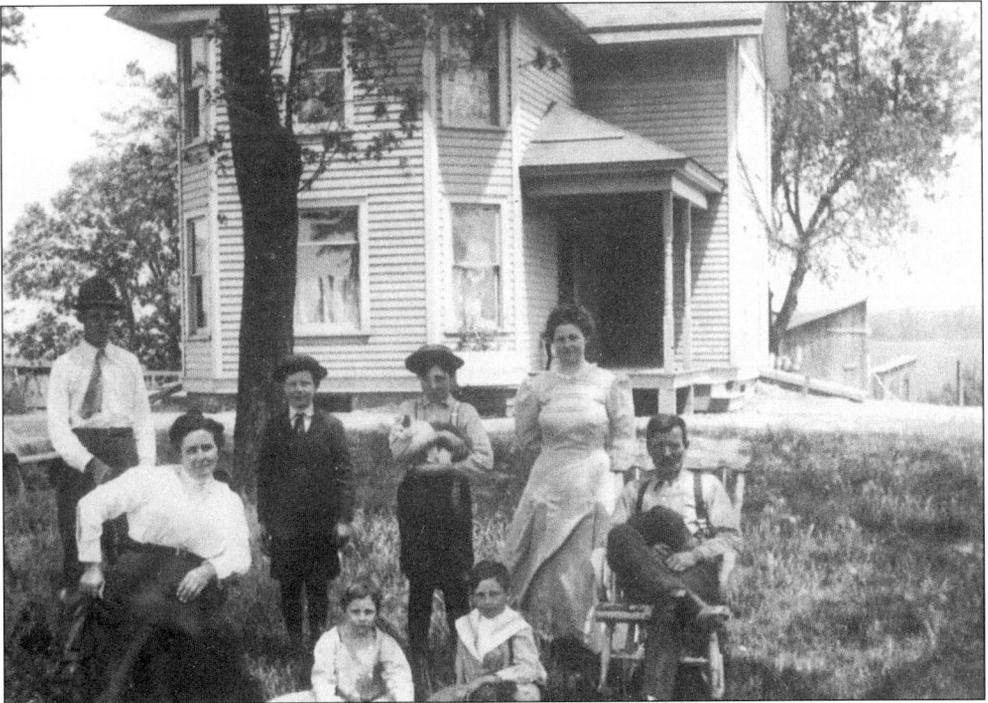

Summertime long ago in Bettendorf called for dressing up and visiting with family and friends. The Rice family, shown here, gathered outside their home in their Sunday best, selecting a shady spot in the yard to pose for a traveling photographer. The family feline must have decided a profile view was "purrferred."

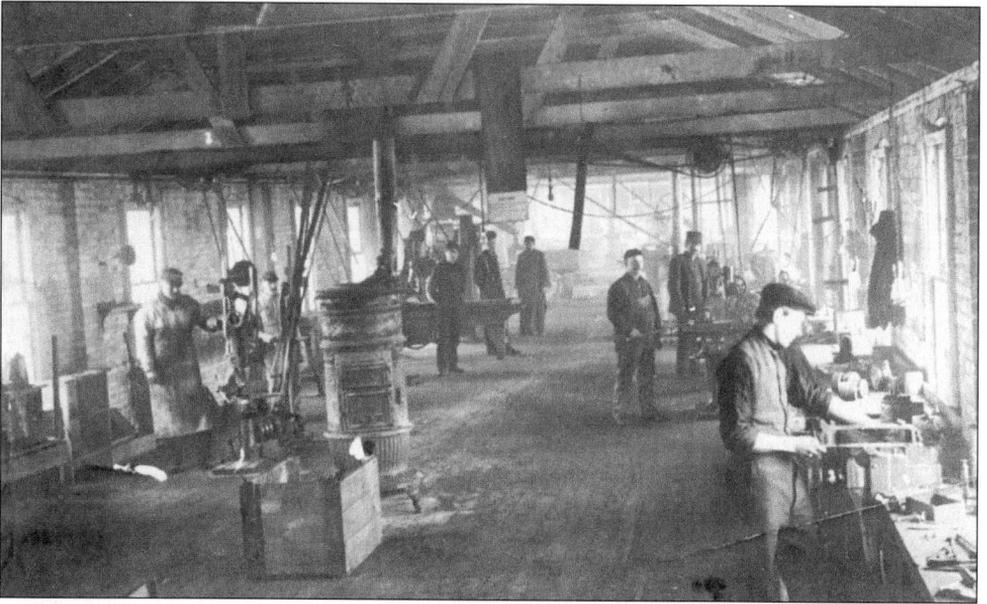

Nothing glamorous about the workplace in the early 1900s. The focus was on the job of producing Meteor automobiles in this area of the Bettendorf Company (present site of the Twin Bridges Motel). The seven-passenger Meteor retailed for $3,000, more money than any of these workers could imagine saving in their lifetime.

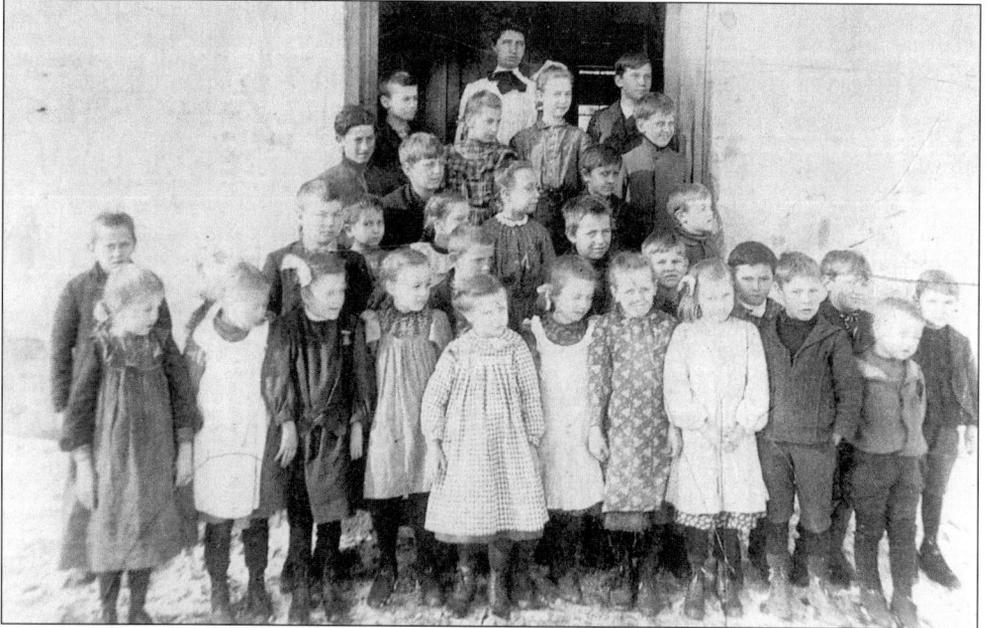

Long-time teacher Florence Carroll said of her 48 years teaching Bettendorf children: "I don't think I could ever teach anyplace where I could find finer people and more wonderful children." The first public school was opened in 1908, and this class from that time period is gathered on the steps of what later became Washington School. Miss Carroll recalled that during the Depression, when there was no money to pay the teachers, a group, including Arthur Voelliger, traveled to Des Moines to get the money.

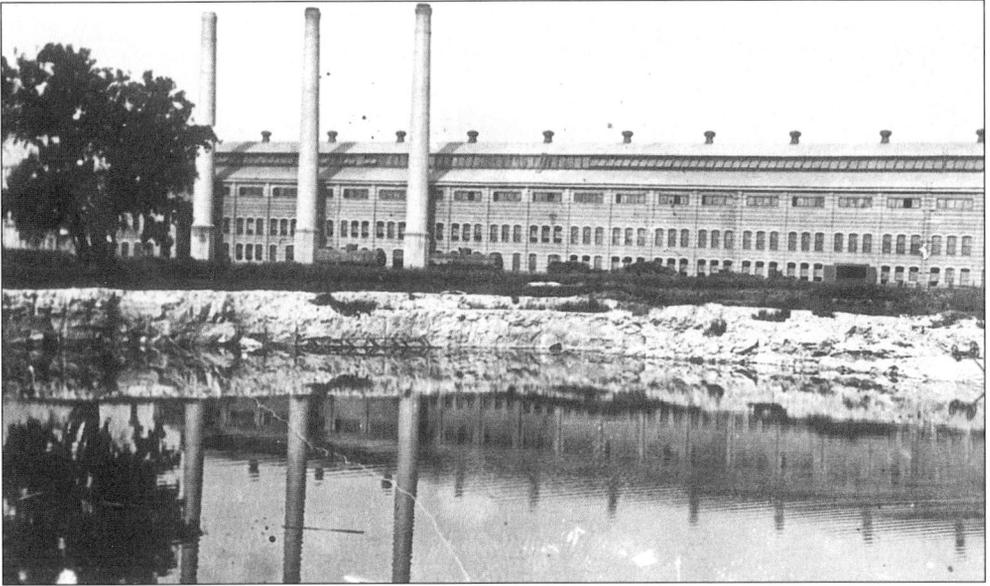

It was October 1912, and former President Theodore Roosevelt had dodged an assassin's bullet that lodged inside the bulky manuscript he was carrying in his vest. The papers contained his speech, which he was about to deliver to an audience in Milwaukee. All that national turmoil, while here at the Bettendorf foundry and quarry a still pond reflects so clear an image that it is hard to know which is up and which is down in this photograph. In later years, the smoke stacks served as landmarks for pilots coming in and out of Wallace Airfield.

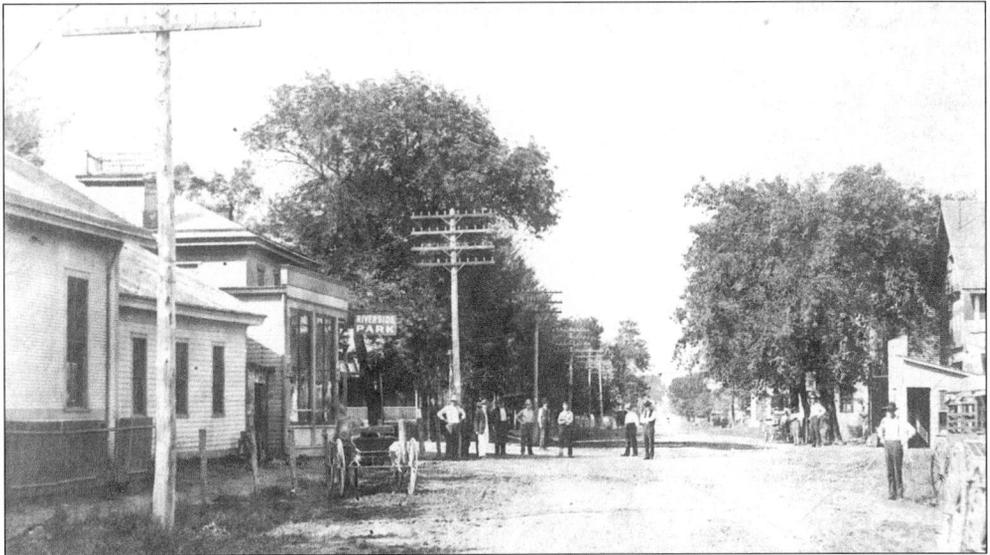

This 1907 postcard shows a gathering crowd outside Riverside Park, which later became the site of the old K & K Hardware Store. When State Street was later paved with concrete, it became known as Washboard Avenue because of the dips in the road about every 50 feet, caused by changing weather conditions that made the concrete expand and contract. The street was paved with brick in 1930 and later black-topped, making for a smooth ride on a long, straight road that proved attractive to heavy-footed drivers. Bettendorf's constables loved to hand out speeding tickets.

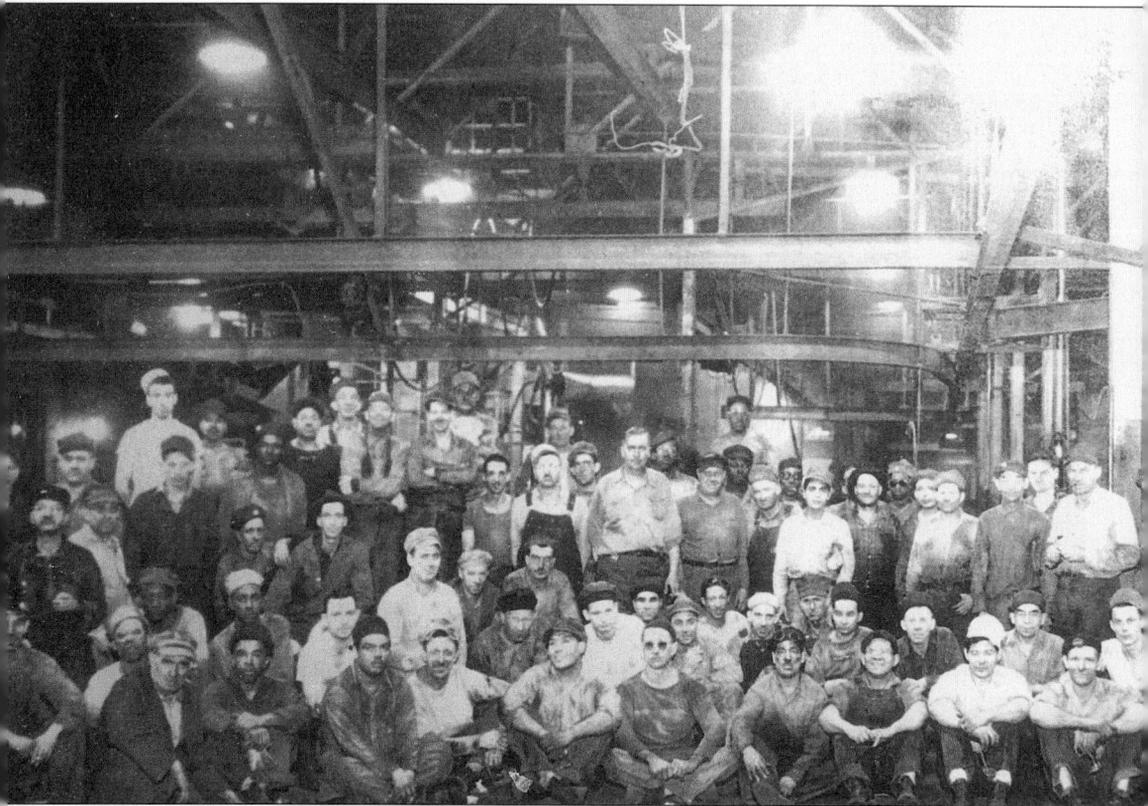

Employees of the Bettendorf Company had more than a working relationship with their co-workers and supervisors. "We were more like a family," observed Henry Thompson. Picnics and parties were held regularly, as well as athletic competitions. The *Car Journal*, a monthly magazine for the workers and their families, was published by the company, and employees with ten years of service and more were made members of the Loyalty Club. Bettendorf was a company town with many of the city's officials also employed at the factory. The Bettendorf Company's facilities stretched 1.25 miles, with 24 acres under one roof. In 1920, the plant was the largest railroad car manufacturer west of the Mississippi River, employing more than 3,000 workers. During the war years, 100 percent of the company's production was for the U.S. Navy. The company supplied ship protective devices, mine sweepers, and paravanes (torpedo-shaped protective devices suspended below a ship's hull). The truck plant was purchased by the U.S. government in 1942 for the production of tanks. In 1946 it was sold to J.I. Case.

By today's standards, the machinery and equipment inside the Bettendorf Company might appear tired and antiquated, but in the earlier part of the 20th century this factory was state-of-the-art, and the workers were well-trained under the leadership and inventiveness of William Bettendorf and the enterprising know-how of his brother Joseph, who operated their railroad car manufacturing plant on the banks of the Mississippi. They moved their factory to the former Elias Gilbert farm after their Davenport plant burned down, with the help of C.A. Ficke and other financiers who raised the $15,000 to buy the land.

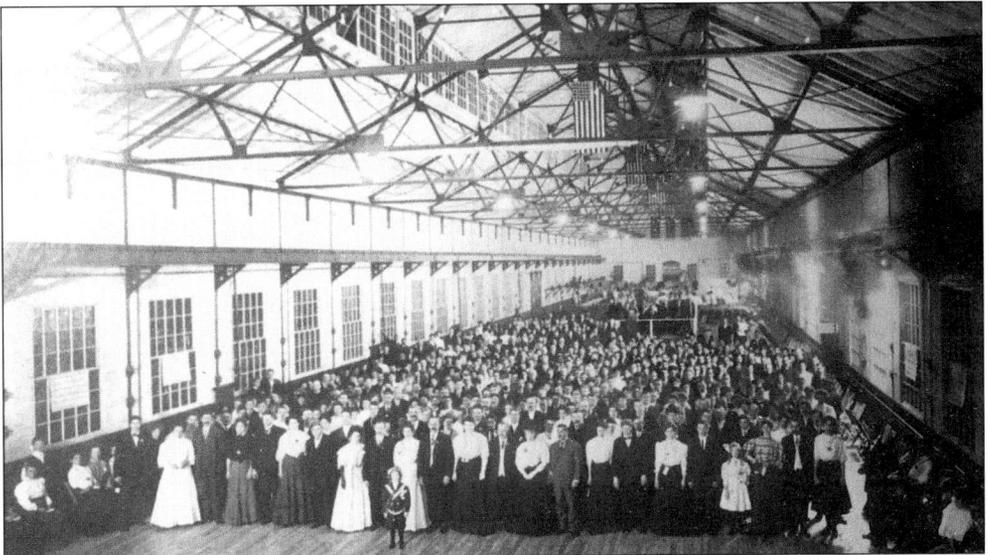

Dwarfed by the massive girders and beams of the Bettendorf Company, factory workers and their families were always happy to gussy up for a party. In this case the year was 1910, and the grand unveiling of the expanded plant was reason enough to celebrate. The climax of the celebration came with the entire assemblage singing the most popular song of the year, "A Perfect Day," composed and written by Mrs. Carrie Jacobs Bond, a boardinghouse owner who became rich from her one and only published tune.

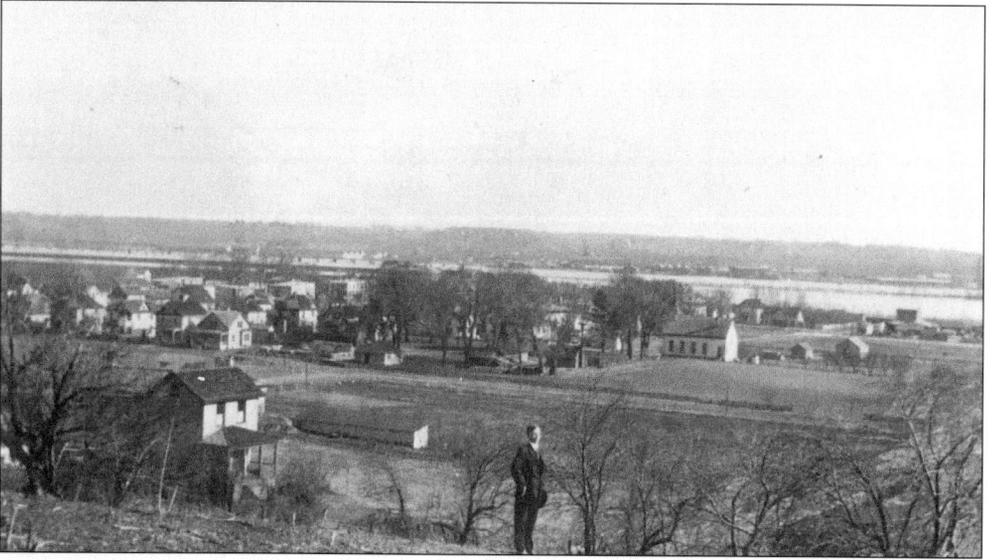

On a clear day, you can see forever. . . . Well, at least as far as Moline, across the Mississippi from this vantage point on the Bettendorf hillside in 1908. Already residential neighborhoods climbed above the river plain, spreading through the countryside. "Who knows—Bettendorf might be bigger than Davenport some day," resident Robert Stevens speculated. Not yet true. Nonetheless, what was once a bedroom suburb of Davenport (Austrian-German pioneers will tell you that indeed Bettendorf means "village of beds") has come into its own, continuing to prosper and grow.

Clear the streets, and please don't block the cameraman's shot of the volunteer firemen answering the call to duty in a converted Meteor, the city's first fire truck purchased in 1912 for $75. As with most vehicles of its day, it had to be cranked to start, and half the time they couldn't get it running. There were 25 active firemen when the crew was first organized April 1, 1908. The city's original pumping engine remained for several years in the Bettendorf Co. yard. Eventually it was sold and hauled away, discovered again in a barn in West Liberty and re-purchased by the Bettendorf Fire Department.

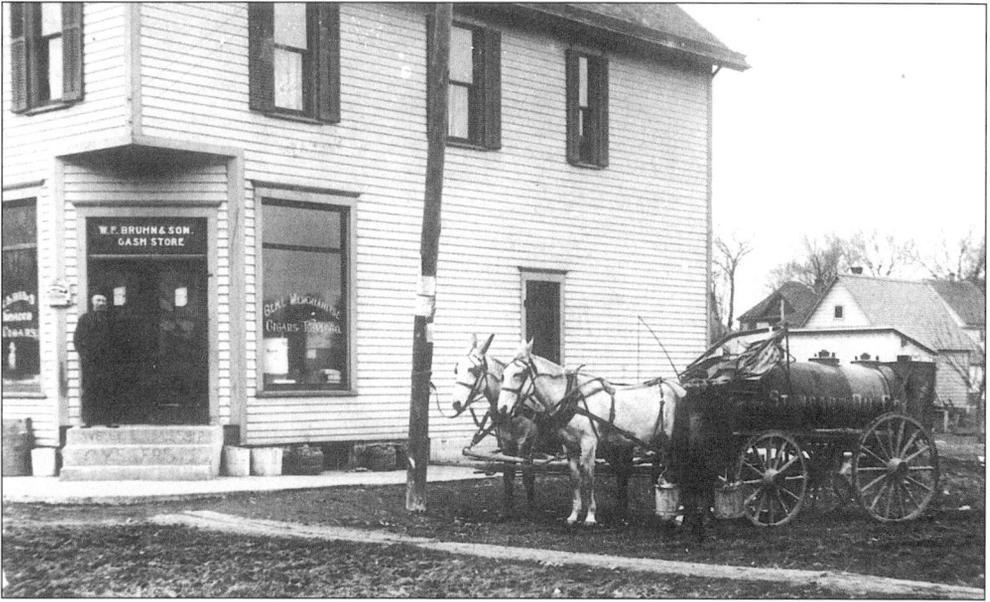

On the front of the store, the lettering reads: "W.F. Bruhn & Son. Cash Store." It was located at the corner of Sixteenth and State Streets. Word has it that the merchandise was of good quality and the service quite excellent, but the parking left something to be desired (we got that from the horses' mouths, the ones there tied to the pole). The Bruhns resided on the second level of the building, as was the custom in the early days of family-owned retail businesses.

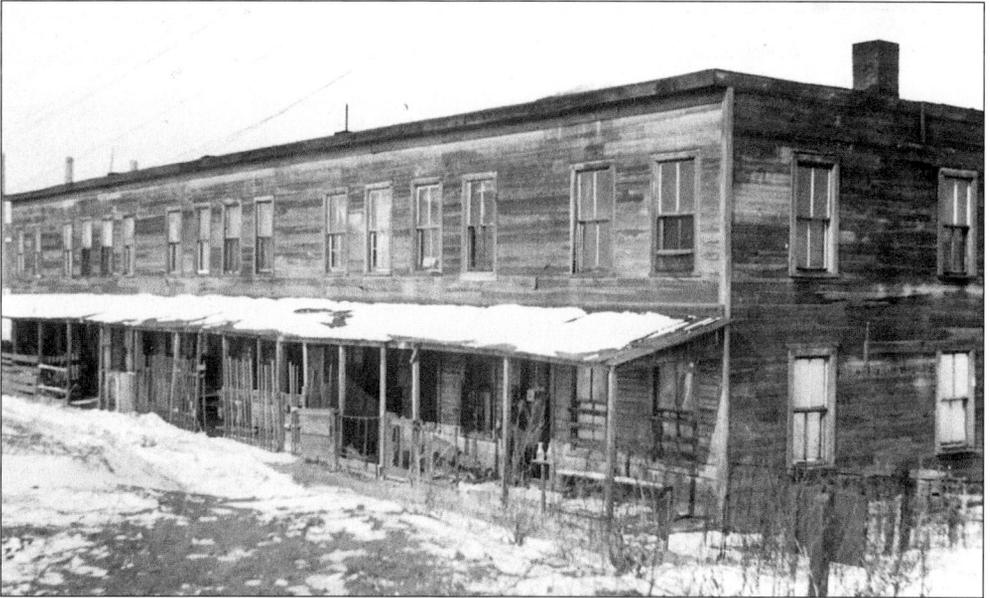

They were known as the Riverside Flats, an extended row of living quarters near the Mississippi shoreline. Nothing fancy, just enough space for a bed, a modest pantry, and an indoor bathroom. Renters were usually Bettendorf Co. workers, staying only long enough to find more permanent living arrangements—maybe something with enough room for a family. Flood waters posed annual problems, and fires were a constant threat to the structure, which was built entirely of wood.

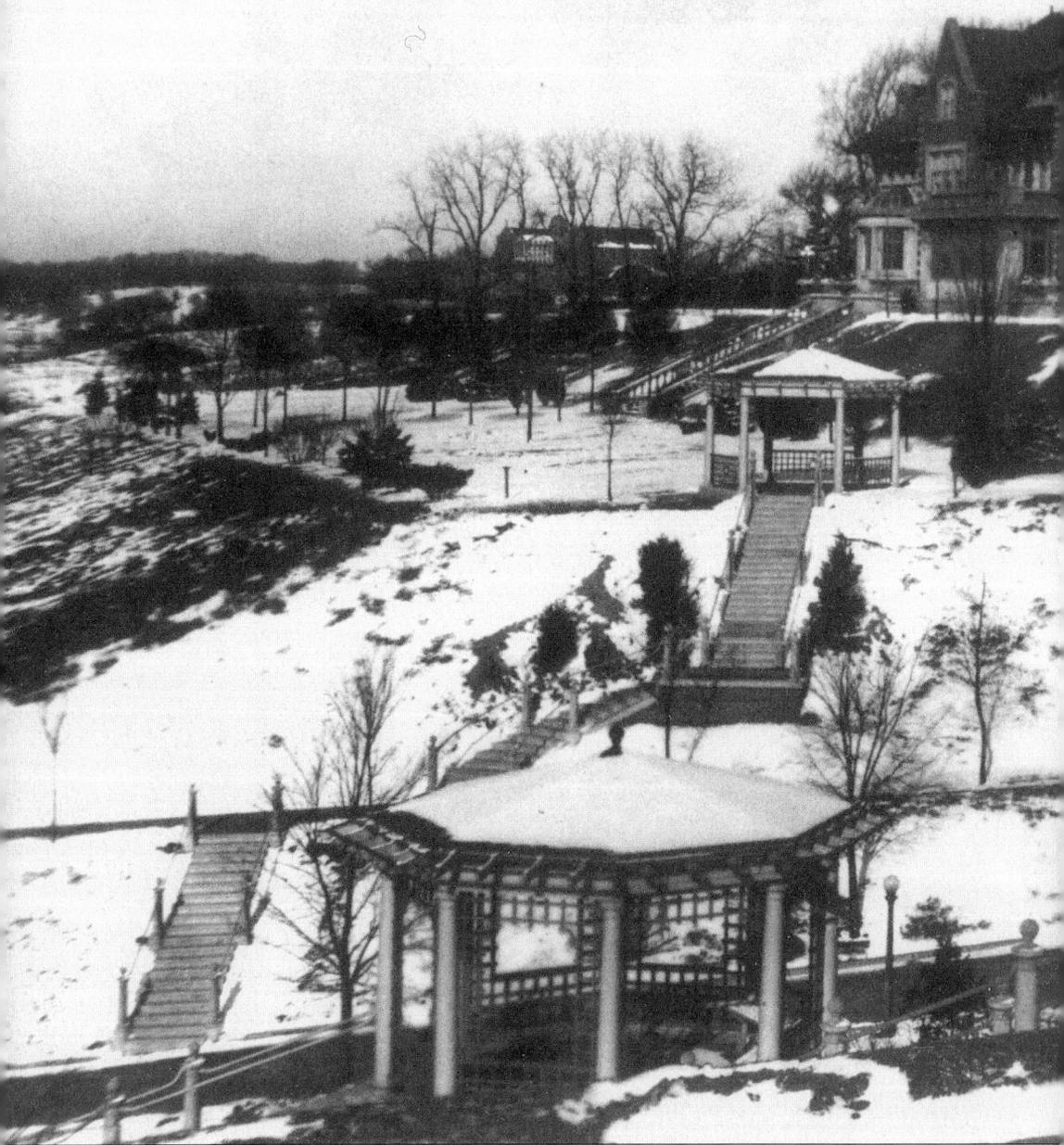

Like a jewel on the hillside it sits. The home of Joseph Bettendorf is definitely an eye-catching view. There was no skimping on quality in this 28-room mansion built in 1914–15. Only the very best craftsmanship went into the joining of stone and mortar, of wood and cement. Gazebos dotted the landscape, with tree branches like elegant fingers reaching skyward. Inside were all of life's little amenities—a swimming pool, bowling alley, third-floor ballroom. The

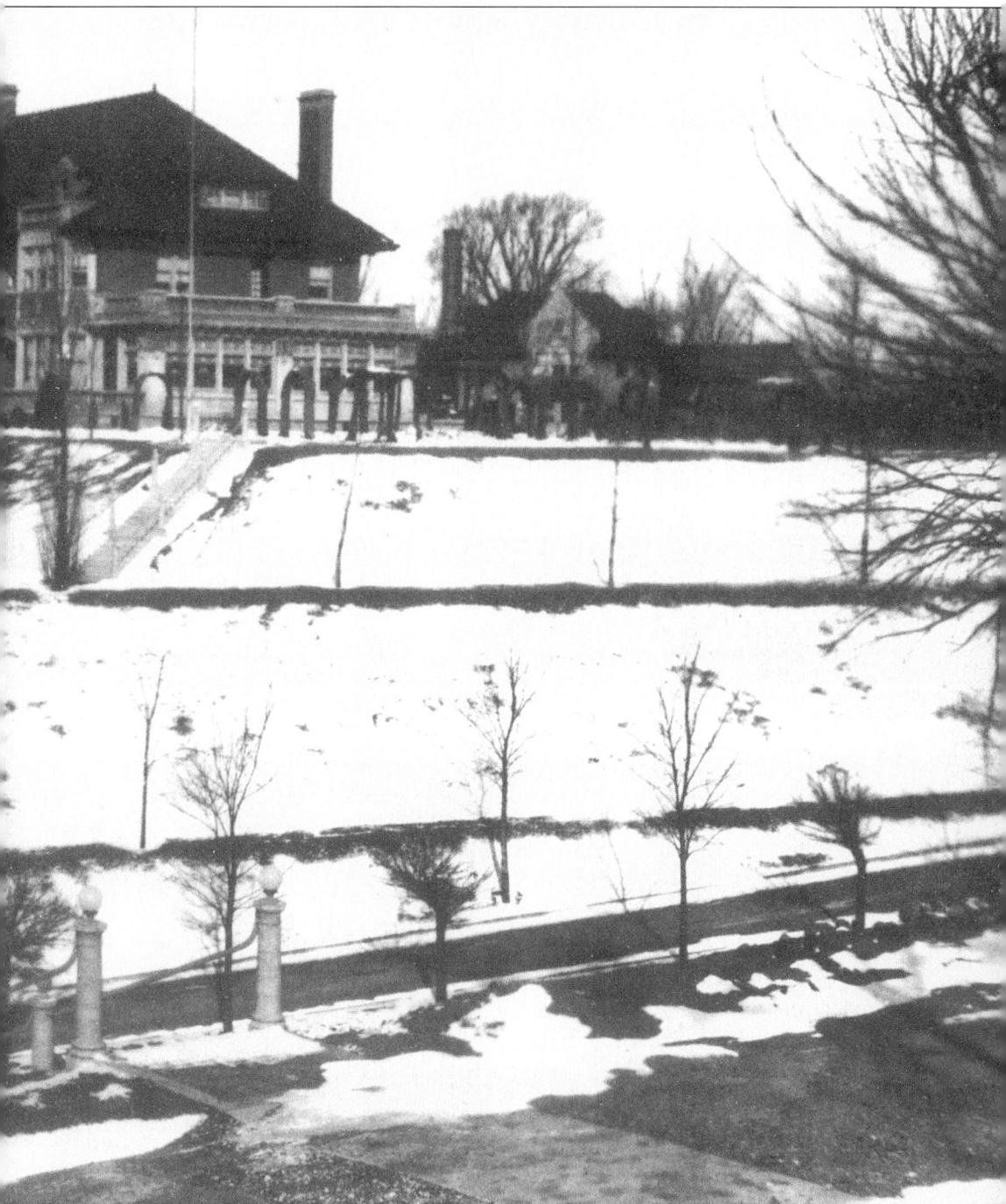

greenhouse included many exotic plants. A staff of 15 serviced the needs of Joseph, his wife, and their two sons, Edwin and William. The home was sold to the Marist monks in 1959 and served as a seminary until it was sold in 1973 to St. Katharine's/St. Mark's, a non-sectarian college preparatory school.

As a young man, William P. Bettendorf was an apprentice machinist in Illinois, inventing the first power-lift sulky plow (or horse lift plow) and a metal wheel used on agricultural equipment. He held more than 94 patents by age 53. But in his personal life, William knew much tragedy, losing his first wife and two children and, just as his own business ventures were coming to fruition, he suddenly took sick and died in 1910.

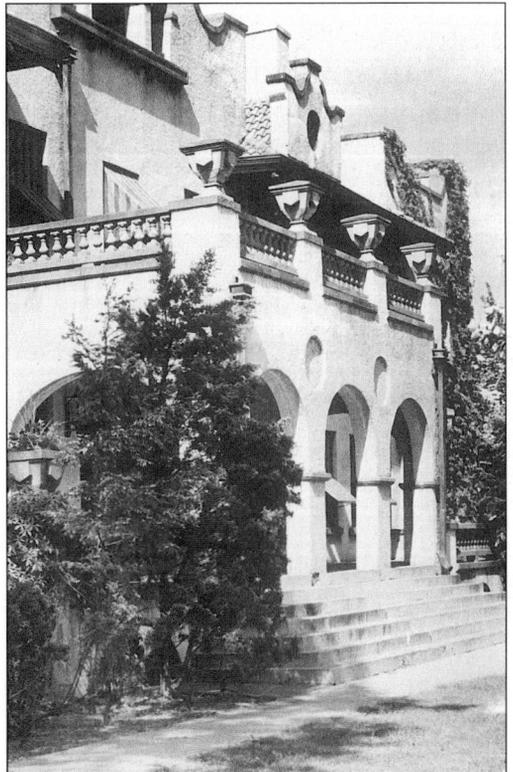

Cuanto hay de aqui Plaza de Toros las Ventas? What do you mean there's no bullfighting ring around here. Isn't this Madrid? A sun-drenched entryway to the William Bettendorf mansion makes it almost seem like you're in Spain. At a cost of $125,000 in 1910, the mansion was constructed by European craftsmen, transported here to work on the site. Entire trees were brought in and sawed into panels; one room in the house is paneled entirely with wood from a single tree. Sadly, William did not see the finished home. A week before he was to have moved in, he underwent emergency surgery and died soon after.

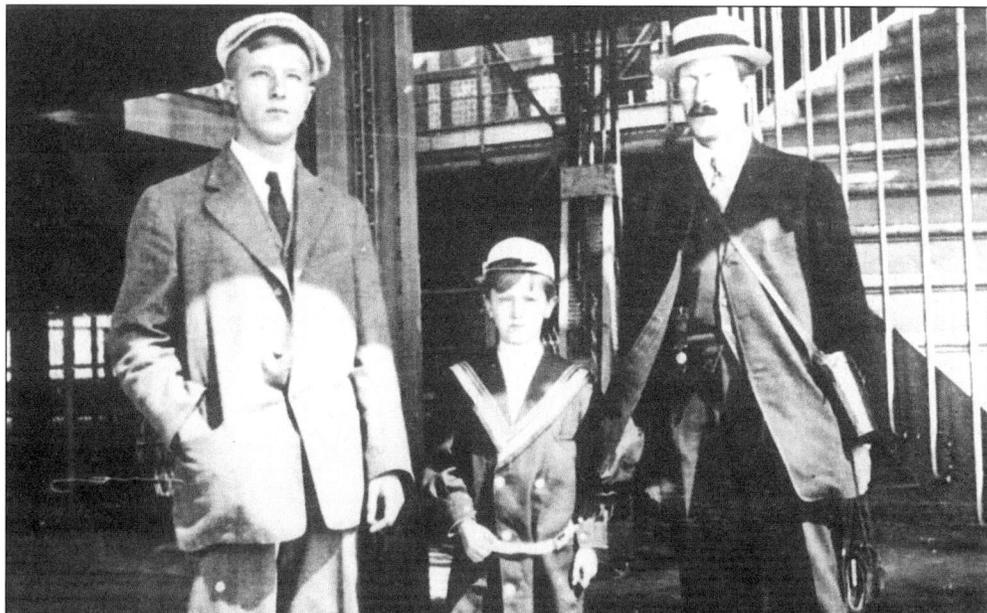

Not everyone had the means to travel the world as did Joseph Bettendorf and his family. This photo, snapped aboard a trans-Atlantic ship, captured the father and his two sons, Edwin and William Jr., looking rather dapper in their 1920s traveling attire. So, who was looking after the 28-room mansion while the family was overseas? A staff of 15 kept the homestead neat and tidy, awaiting their employer's return.

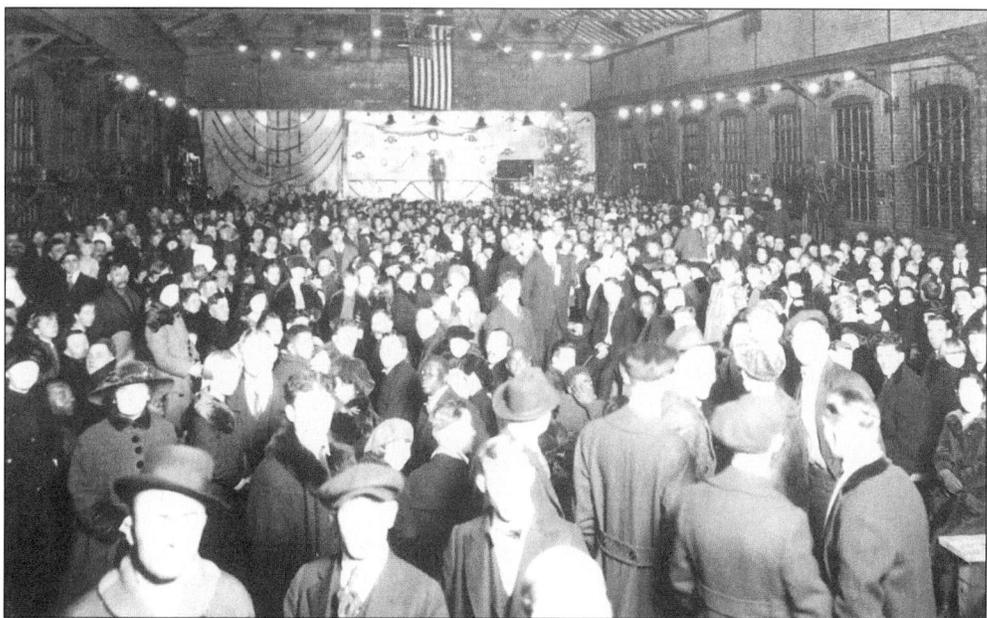

Most of the time the factory floor of the Bettendorf Company was a scene of hard work, but every now and then a massive shipping area would be transformed into a majestic ballroom. Such was the case in this 1914 photo of workers and their families at a pre-Christmas celebration. "Deck the halls . . .," or make that "walls," and join in the holiday mood with food, frolic, and the fellowship of friends.

Forget that one-horse open sleigh. This carriage is on its way to becoming a Meteor, and not the kind you'd expect to come burning out of the sky. The Meteor automobile, built from 1907 to 1912, had a 50-horsepower engine, with four forward speeds and two reverse. All but the tires and electrical system were manufactured under the supervision of Arnold Peterson at the Bettendorf Company's Meteor plant, at a site now occupied by the city's Volunteer Park.

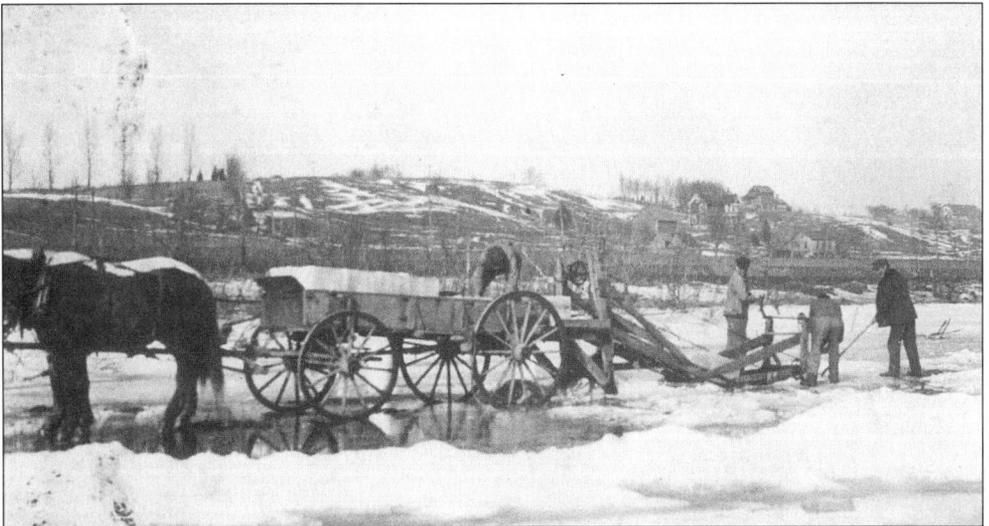

The Schutter family was renowned for their onions. But their lives held other challenges, such as cutting ice on the stretch of Mississippi River between Pleasant Valley and the family-owned Spencer Island. Come wintertime, Henry Schutter and his workers donned heavy clothes, loaded up their long ice saws and tongs, and carved out chunks of ice from the river. The ice was stored in sawdust and, when summer came, it provided for a season of yummy ice cream and chilled lemonade.

30

Children, creeks, and caves. . . . Young Ruby Schutter remains forever framed by innocence in this turn-of-the-century photograph. As they do for boys and girls nowadays, Spencer and Duck Creeks offered one big playground. No matter if pants and dresses got wet or shoes got muddy. There is adventure hiding in those limestone bluffs, and youngsters are determined to find it.

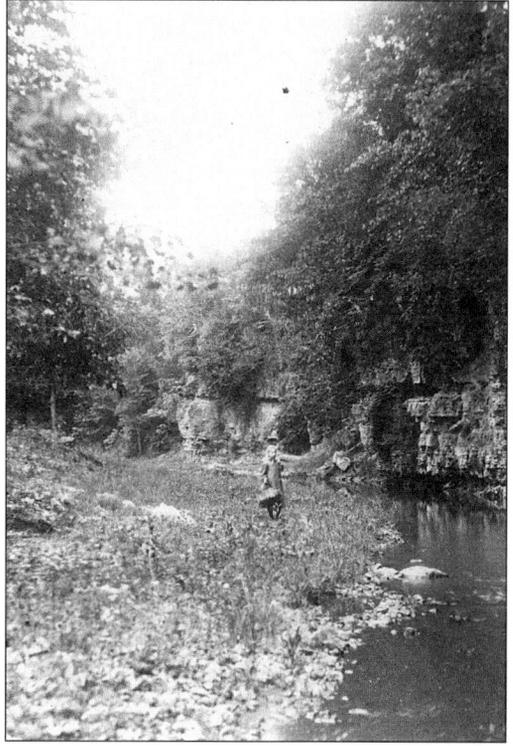

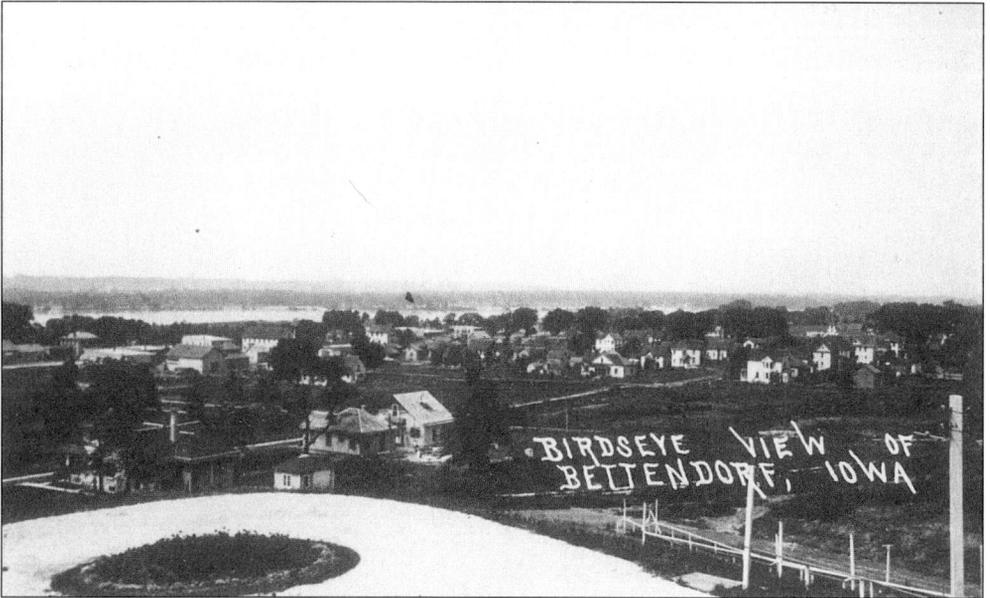

This early 1900 photograph shows how Bettendorf looked when Arthur Voelliger and his brother Paul were growing up in Bettendorf. "There were always things that puzzled me," Art recalled, "What happened here and what happened there." He began collecting photographs and anecdotal reminiscences from locals such as Edgar Ade, grandson of one of the earliest settlers, Henry Kuehl. Mr. Ade described it as a typical little German town: "Everybody had a picket fence and a garden, and chickens and a cow and a few pigs."

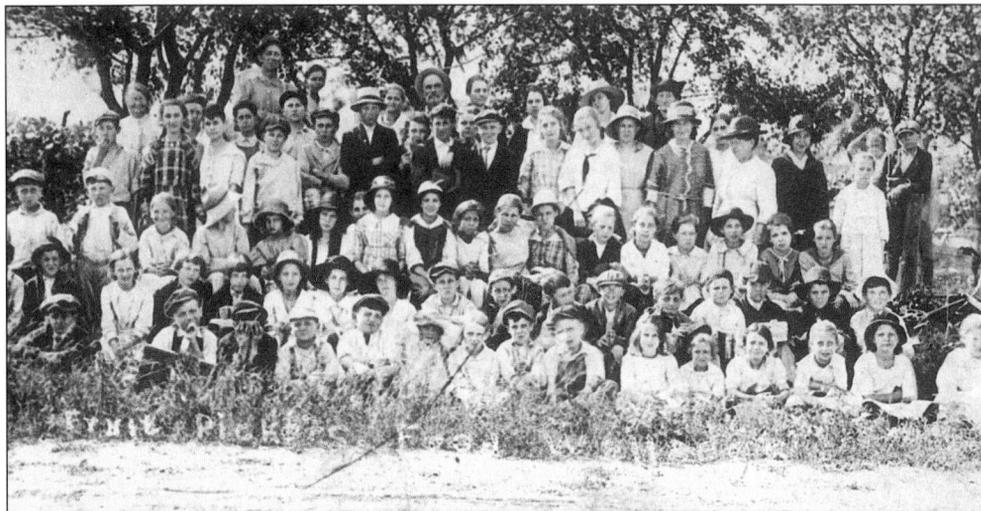

These pickers enjoyed having the pick of the crop at the Fred Wallace farm in rural Bettendorf. Onion fields and berry patches covered many acres, and the crop yields were rich and plentiful. Hardly a child growing up in early Gilbert had not done his/her share of crop harvesting. This is a group of berry pickers, and from the looks of their hands and faces, they appear to have had time to scrub up a bit before posing for the photographer.

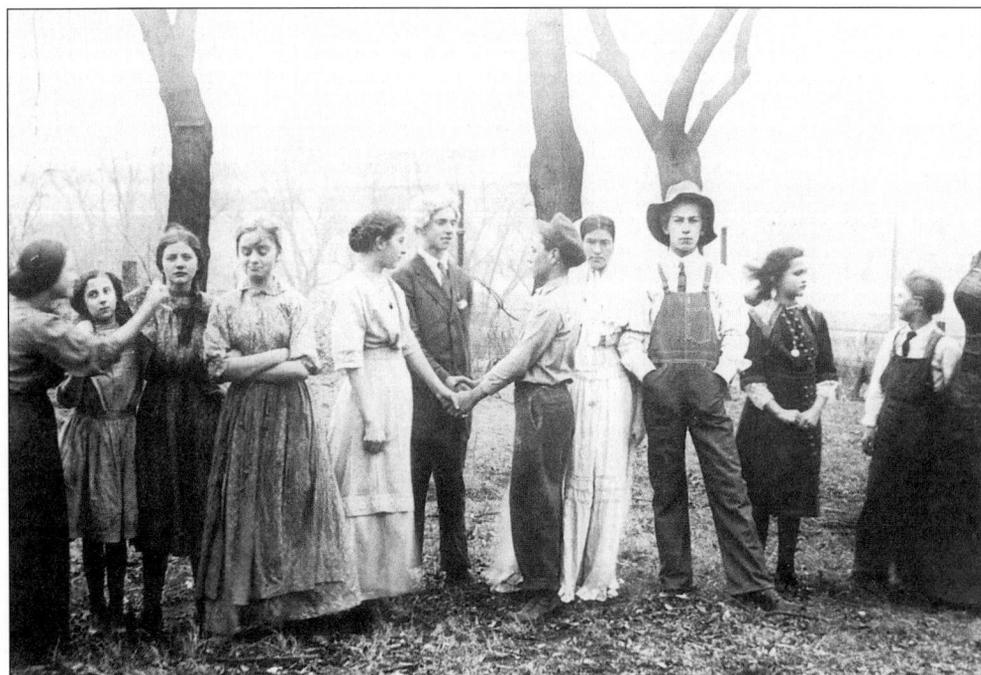

Broadway bound? Not quite there yet. This 1910 production was staged by the Bettendorf High School students. The play was entitled "Mrs. Wiggs and the Cabbage Patch" (and with that title, it must have been a comedy, right?). Emphasis on the arts and plenty of extracurricular opportunities have long established Bettendorf School District's excellence, and the tradition continues to this day.

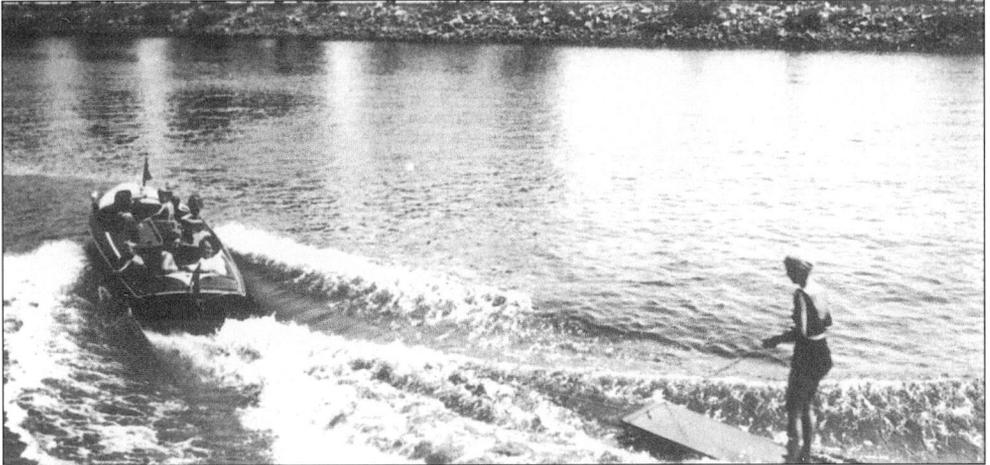

Think surfboarding is a recent phenomenon? In the late 1920s, spunky young Virginia Schutter enjoyed surfing the Mississippi River with the help of a tow line and motor boat. Her cousins impatiently await their turn to escape the muggy summer heat. According to dictates of the time (and their mothers), the young ladies dressed in modest, one-piece, black bathing suits.

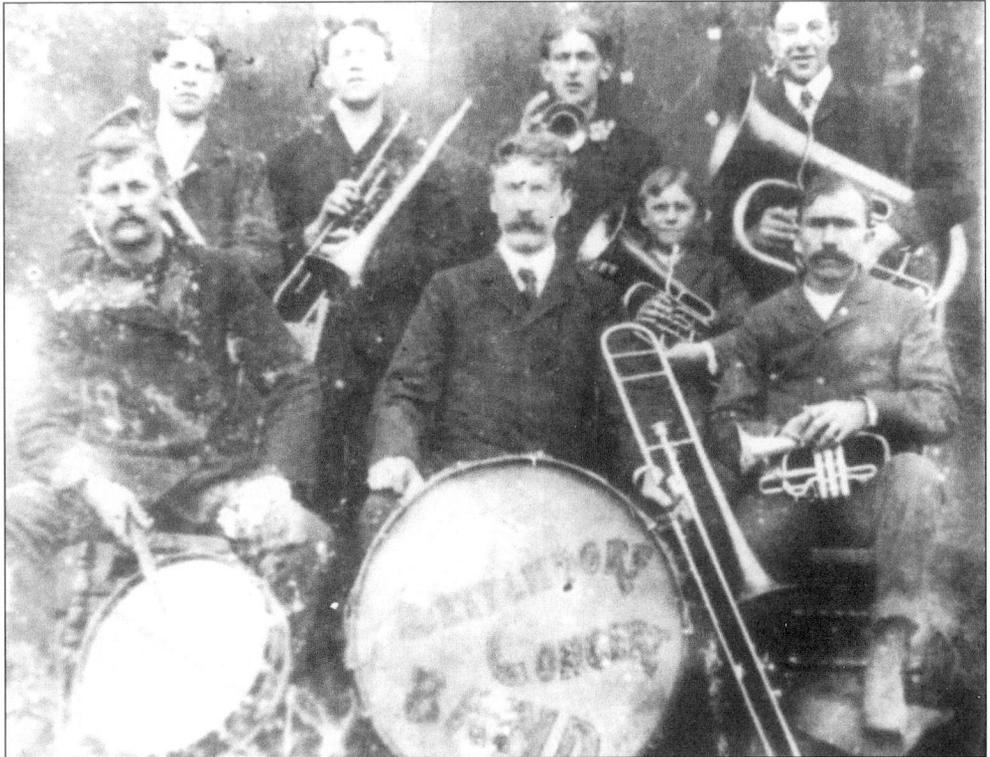

No need to send out a call to Professor Harold Hill. Bettendorf had far less than 76 trombones, but still plenty of musical instruments to keep the youngsters out of trouble right here in this river city. Concert bands such as this performed at weddings and community dances, playing everything from polkas to waltzes. Grover Cleveland was in the White House when this stout-hearted assembly of musicians performed for the townsfolk. "You never had to ask them to play louder," observed one city resident in a newspaper column.

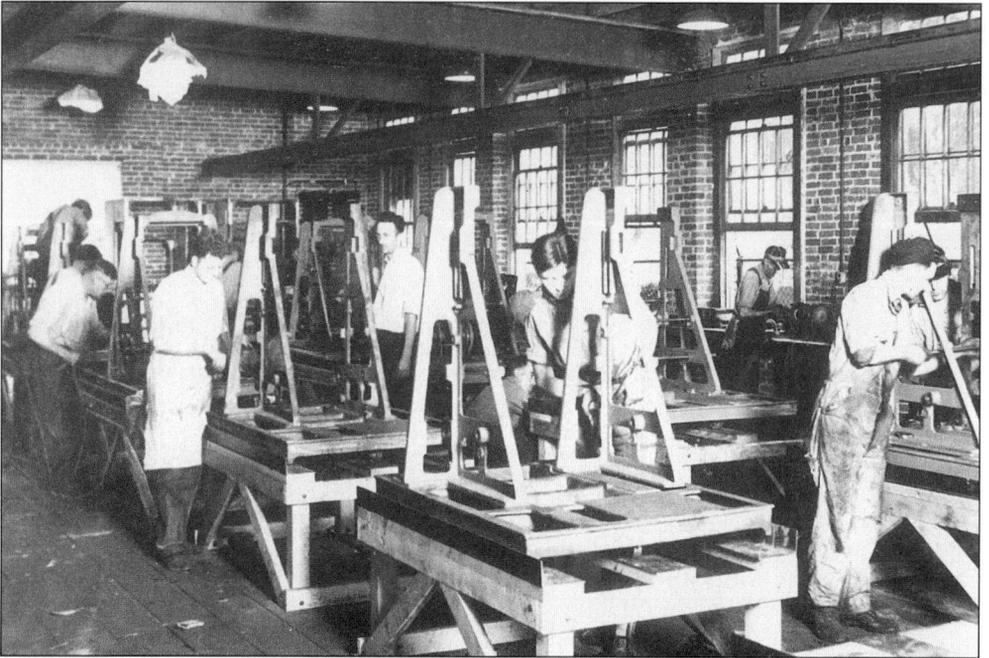

Many claims have been made as to who originated the idea of a machine that slices bread, but Bettendorf is the undisputed birthplace of commercial bread slicing machines. Here workers at the Micro Company (a division of the Bettendorf Co.) are assembling the machines. The original design may not have looked particularly fancy or even streamlined, but it proved dependable and guaranteed an even slice every time.

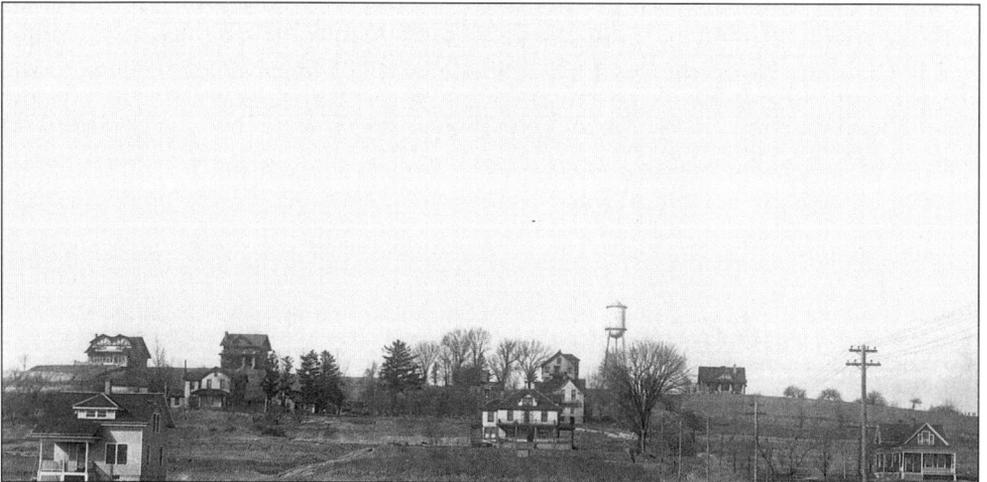

"Oh give me land, lots of land, and a starry . . . wait a minute, make that sunny sky above! . . . don't fence me in." Bettendorf was the answer to that request, as can be seen in this 1912 photograph looking north from the city. There was plenty of privacy back in those days, less than a decade after the city had been officially incorporated. But plans were already in the works for residential and commercial development.

34

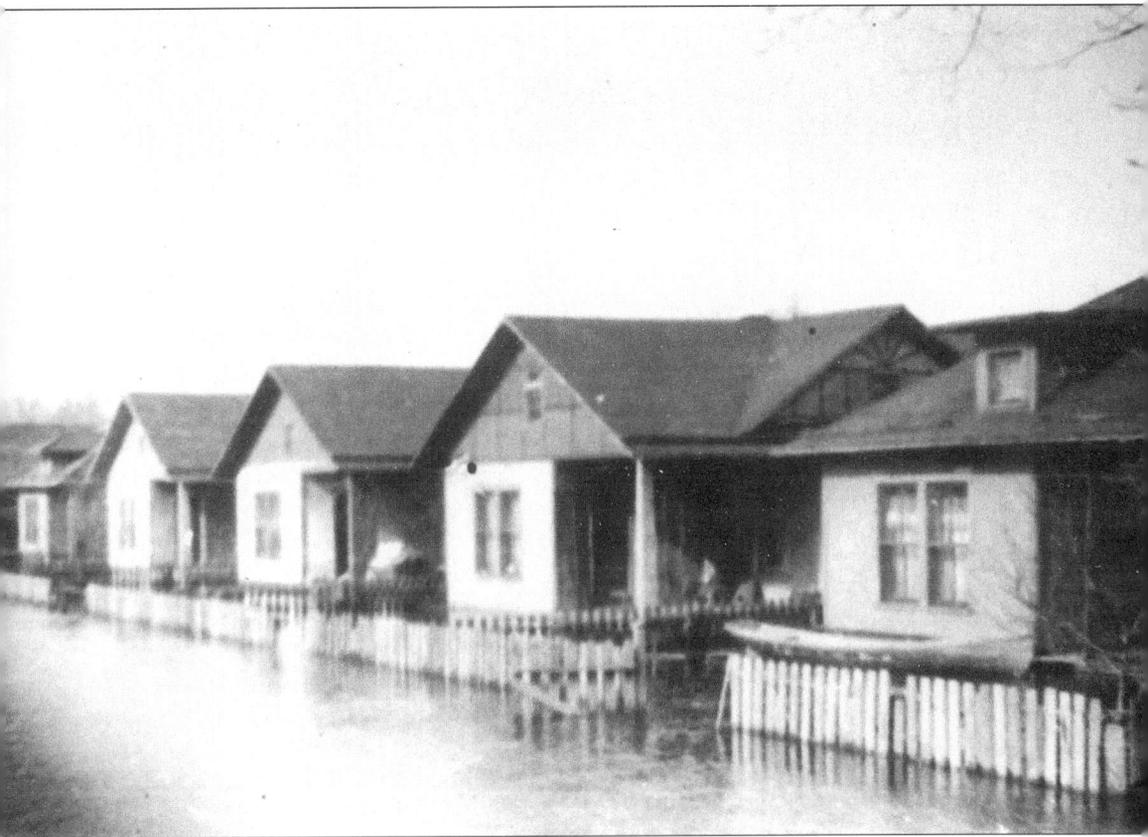

It was known as Holy City because, as legend tells, so many of the residents living there were named "Jesus." They came by train from Mexico, hired for the Bettendorf Company by its representative David Macias, who returned to his hometown of Juarez to find the needed workers to sustain production demands shortly before World War I. Company-built cottages were in such short supply that many had to live in box cars until new homes were finished. The Flood of 1916 forced residents to move to higher ground, but they reclaimed the area soon after and remained until the 1930s, when the cottages were torn down and Wallace Field closed to make way for Standard Oil Company.

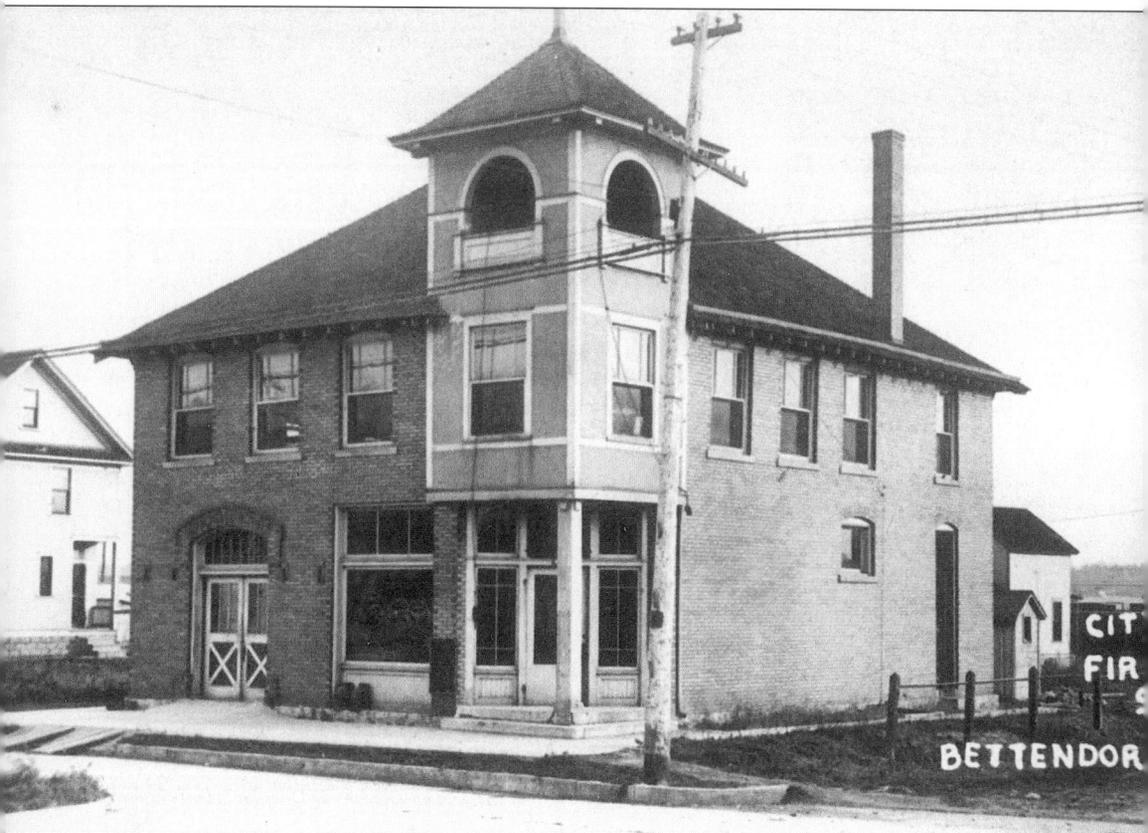

If you aren't happy with the situation, take your complaint to city hall. Unfortunately, the complaint *was* city hall and the $12,000 it cost to build it in 1907–08. Still, residents agreed it was quite a showplace, with council chambers on the ground floor, as well as a storage garage for the fire equipment. The top floor was used for meetings and as a dance hall, while in the tower a bell tolled whenever the volunteers were needed at the scene of a fire. The structure was moved to accommodate the first span of the Iowa-Illinois Memorial Bridge, and later torn down when the second span was built.

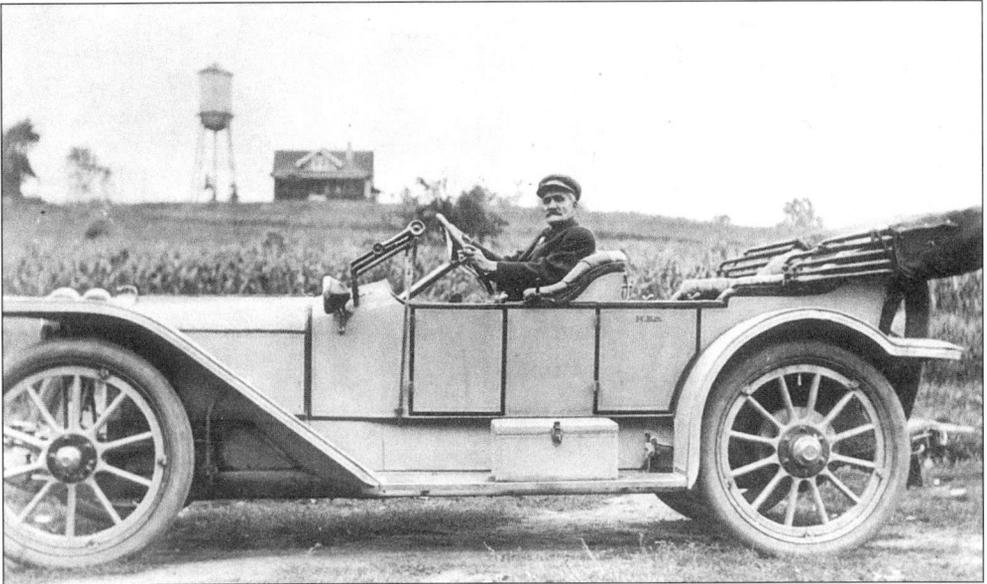

They called the car an "underslung," and its distinctive big wheels and large body made owners like Mr. Burgess here feel safe and secure on the highway or just toolin' around town. People who owned Meteors and Model-Ts scoffed at the huge automobiles, and the low demand made for a very small number of these automobiles to be built in America. In the background is the old Seaman home, which burned in 1967.

The world of commercial advertising has been around for a long time, as this 1910 postcard testifies. The Bettendorf Savings Bank makes an engaging plea to potential customers that "the only way to be successful is to be systematic not only in your business but in your saving." Handing out the penny postcards instead of mailing them supports that old adage, "a penny saved is a penny earned."

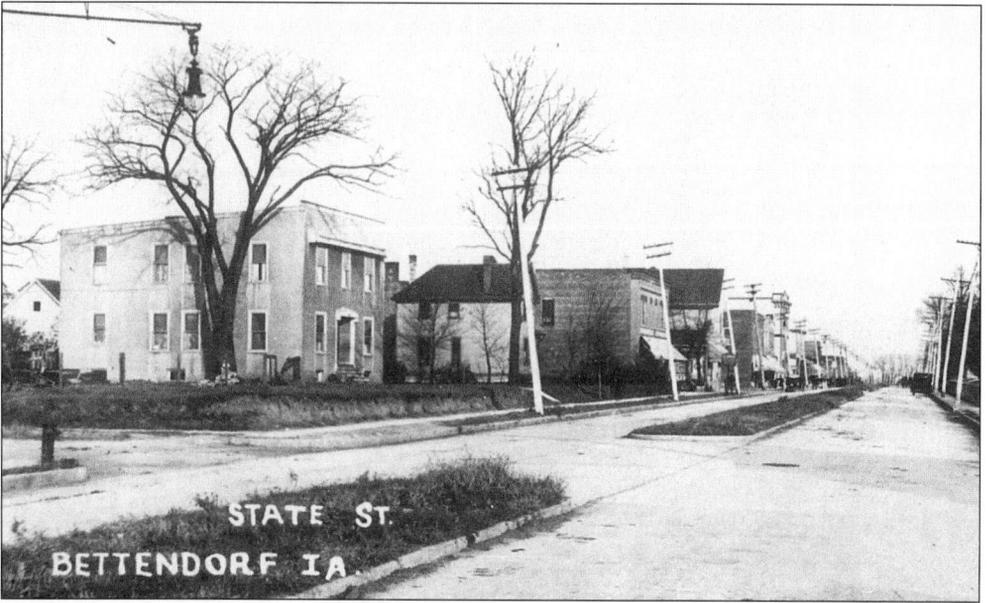

This is what the 1700 block of State Street looked like in the days when traffic was a little less congested. "There used to be a lot of pedestrians in this town," a columnist in Bettendorf County's *Car Journal* magazine commented. "But there ain't any left. We just got broad jumpers and sprinters and there are just two kinds of them, the quick and the dead."

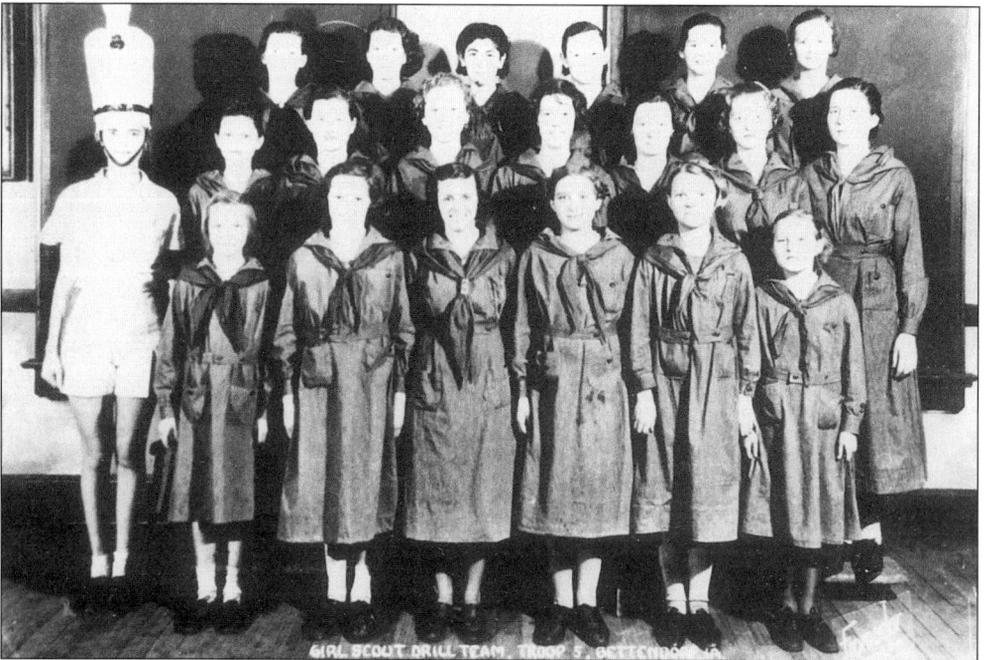

In 1912, Juliette Lowe founded the Girl Guides in Atlanta, Georgia, changing the name the following year to the Girl Scouts of America. Troupes were organized across the country, including this Bettendorf troupe. Not only did Girl Scouts promote character and loyalty, but the scouts were also inspired to be self-disciplined and march to the commands of a drillmaster, who is rather easily spotted in this photo.

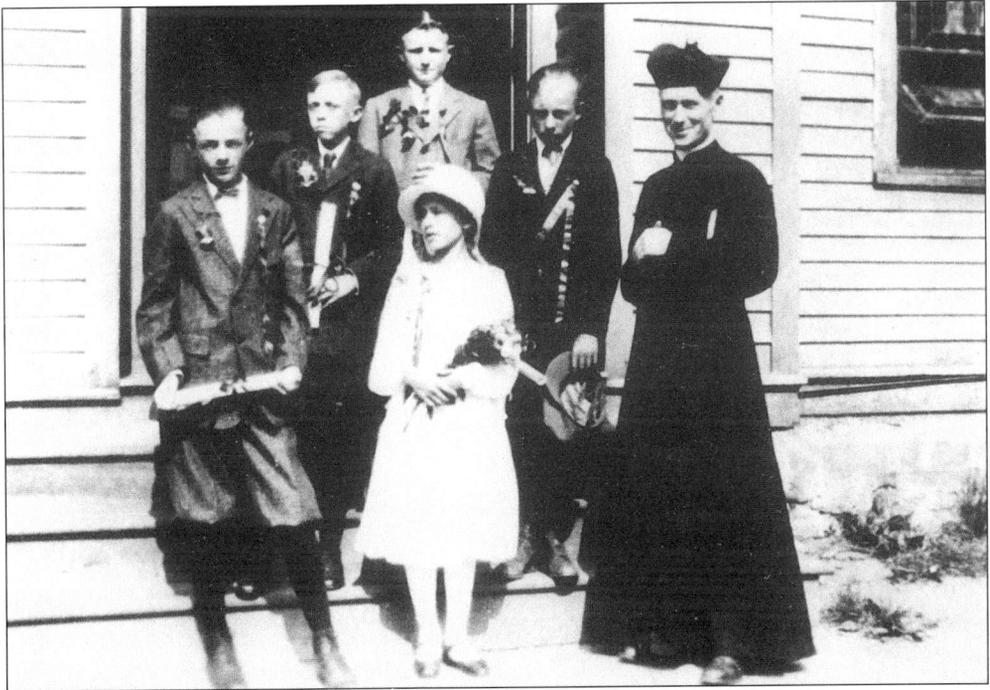

Graduation Day at Our Lady of Lourdes. No, that's not Barry Fitzgerald in the priest's cassock. It's Father Stephen C. Davis, who called the roll for the Class of 1925: "O'Neill, Wheeler, Lepetit, Retzl, and Michl." Lourdes was founded in 1904, after Catholic families asked the Davenport diocese for permission to hold mass in Bettendorf. The former Elias Gilbert home was purchased and converted to a school, with the church built across the street.

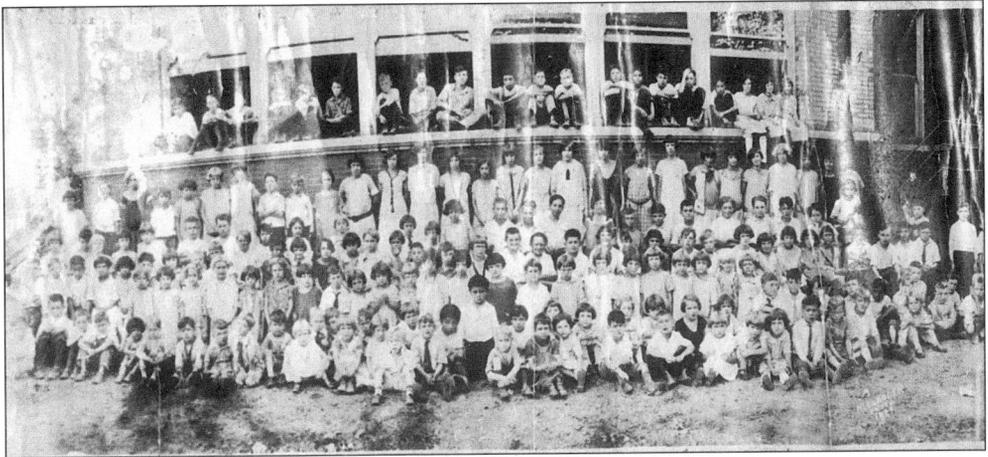

Hey, where's Waldo? There has to be someone named Waldo among these elementary schoolchildren, photographed in 1925. It looks to be a fine, well-behaved group of youngsters— and in among them is someone's grandmother and grandfather, maybe even a few great-grandparents as well. All that reading, 'riting, and 'rithmetic has not gone to waste. Just look around the city of Bettendorf today and behold the legacy of these young and nimble minds, melding to become the solid foundation of a community that, 75 years after this photograph was taken, is about to leap into the next millennium.

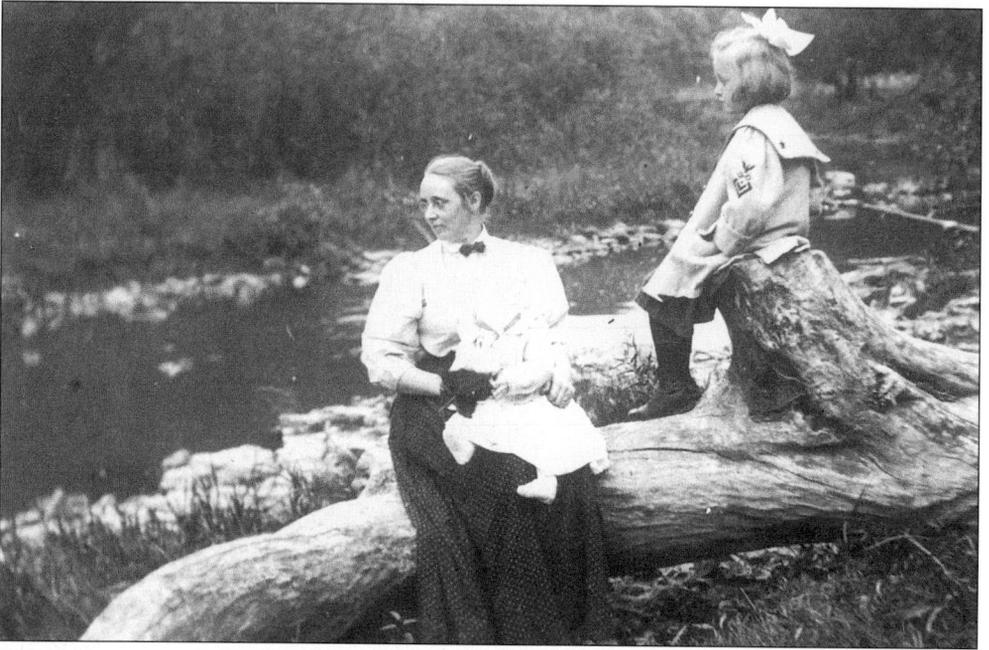

Few spots capture the beauty and romance of nature like this spot along Duck Creek, where a mother and her two daughters found a moment of peace and solace to pose for this photograph, taken September 6, 1909. Why this lovely place along the peaceful waterway would come to be known as Devil's Glen is not clear, but there is a tale, which has been handed down through the generations, of a Native American Indian who supposedly lived by himself in a cave deep within the glen.

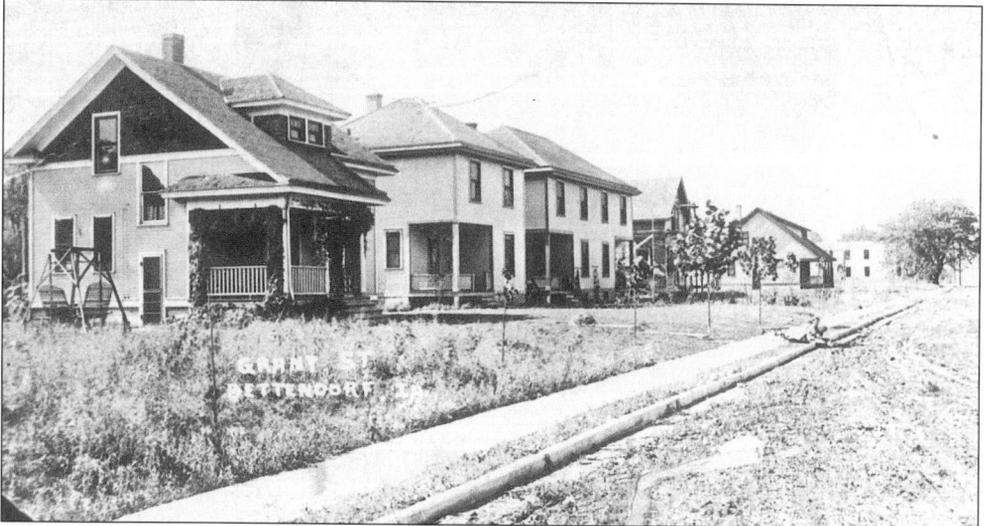

Remember the days when houses had porches and front yards where children played? Now and then you might see a young couple courting on that glider in the moonlight and, down the block, an old married couple might be rocking in their chairs, watching the goings-on in the neighborhood. That's Hans and Herb Goettch's place there on the left, and this is the 1800 block of Grant Street, named for Scotsman Alexander Grant, a sailor and Presbyterian minister who settled here in 1851.

Alvie teDuit enjoyed a reputation for setting a fine table back in 1923. Not only that, but his boarding house was said to be both clean and comfortable. You could get a room for the night and a full meal for four bits (that's 50¢). By the looks of the plants in the front window, Alvie must have had a green thumb too. Some people have all the talent!

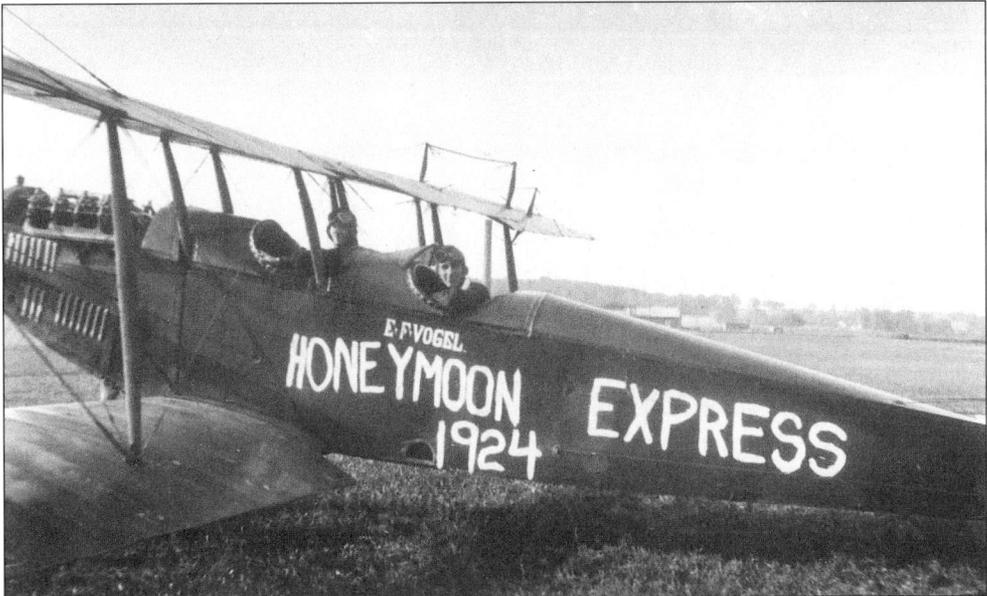

Three years before Charles Lindbergh flew solo across the Atlantic Ocean, two young Bettendorfers were secretly making plans for a more romantic adventure in the skies. Wallace Field mechanic Ernie Vogel and his fiancée Hertha eloped in 1924 aboard their love machine, affectionately named the "Honeymoon Express." Needless to say, the parents of Ernie and Hertha weren't pleased. But hey, think of all the money the kids saved back in the days before frequent flyer miles.

41

MY PROPOSITION

$1.00 DOWN
$1.00 PER WEEK

interest from start to finish.
taxes for the first two years.
interest in my contract is the big point.

"REMEMBER," Interest works while you sleep.

In case of death of husband, deed given to widow without further payment on her part.

In case of sickness, payments suspended for 10 weeks.

Deed and Abstract given without extra cost to lot buyer.

Discount all through the contract when you pay $25.00 or more at any one time.

The above means a contract where you "CAN'T LOSE."

PUT AWAY A $1.00 A WEEK -- IT IS NOT ONLY A GOOD INVEST-MENT -- BUT A GOOD SAVING.

Office Hours:

Do not put this matter off; buy a lot or two here at once. Any ambitious man or woman can own one of these lots. Good fortune starts with good sense. Good judgment and a little money means success.

Frontage of all lots 50 feet more.

All lots 125 feet to 175 feet depth.

My References

We, the undersigned, officers of the Iowa National Bank and Scott County Savings Bank of Davenport, Iowa, take pleasure in recommending H. B. Jones a reliable citizen of Davenport who will carry out any contract he may make.

IOWA NATIONAL BANK.
Chas. Shuler, Pres.
F. B. Yetter, Cashier

SCOTT COUNTY SAV. B.
J. H. Haas, Pres.
Gus Stueben, Cashier

THERE IS NO CHANCE TO "LOSE" WHEN YOU BUY REAL ESTATE IT IS THE REAL THING

If you wish to select a lot in Riverview, "DO NOT DELAY," but come to the office at once

H. B. JONES

Office: 304 Putnam
DAVENPORT,
PHONES:

Imagine owning your own piece of land with only a dollar down and payments of a dollar a week! That was the deal in the early days of Bettendorf, when city leaders were eager to recruit new homebuilders. No interest and no taxes, either. If the husband died, a widow's debts were erased. "It is not only a good investment," stated the advertisement, "but a good savings."

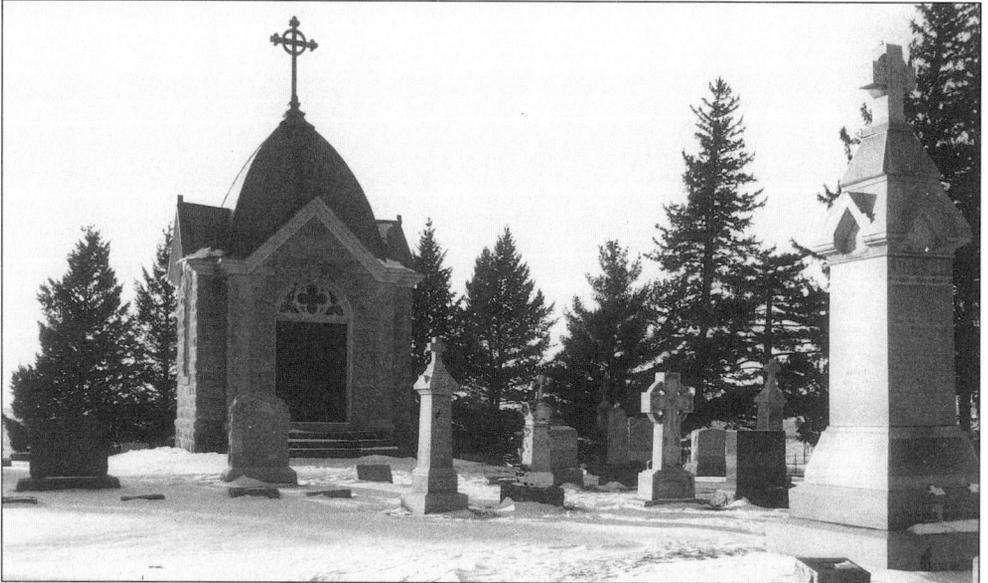

". . . May those brought here for their final earthly resting place enjoy peace and solitude." Such was the wish of one of the dignitaries who blessed the cemetery grounds outside the former St. Francis Monastery when it initially opened. No new burials are held here—the former monastery is now The Abbey Hotel. Indeed, there are no public cemeteries in Bettendorf. No hospitals, either. Guess that's why folks say you can't be born or die in this city.

42

Remember the days of the neighborhood butcher shop? Back in the 1920s, Helble's Meat Market was the best place to go, and Elmer Hildebrand was the man to see for whatever special of the week it might be— a plump rump roast or fresh frying chickens. He was always ready with a welcome smile and a sharp blade to slice meat just the way you asked, weighing your purchase and never once pressing his thumbs on the scale. Honesty and quality service, that's what kept the customers coming back.

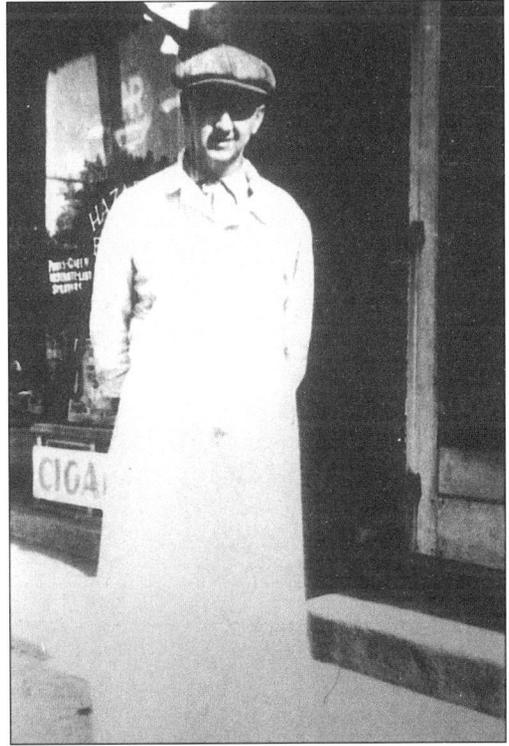

Those early movies in black and white were accompanied by a piano player, choosing just the right tune and tempo to capture the action taking place on the screen. Bettendorf's Moving Picture Theatre, located at the corner of Nineteenth and State Streets, was owned for many years by a Mr. Papst. Films shown on his screen starred silent film stars Charlie Chaplin, Buster Keaton, Mary Pickford, and Douglas Fairbanks. Bring your handkerchiefs. Lillian Gish appears in next week's feature.

43

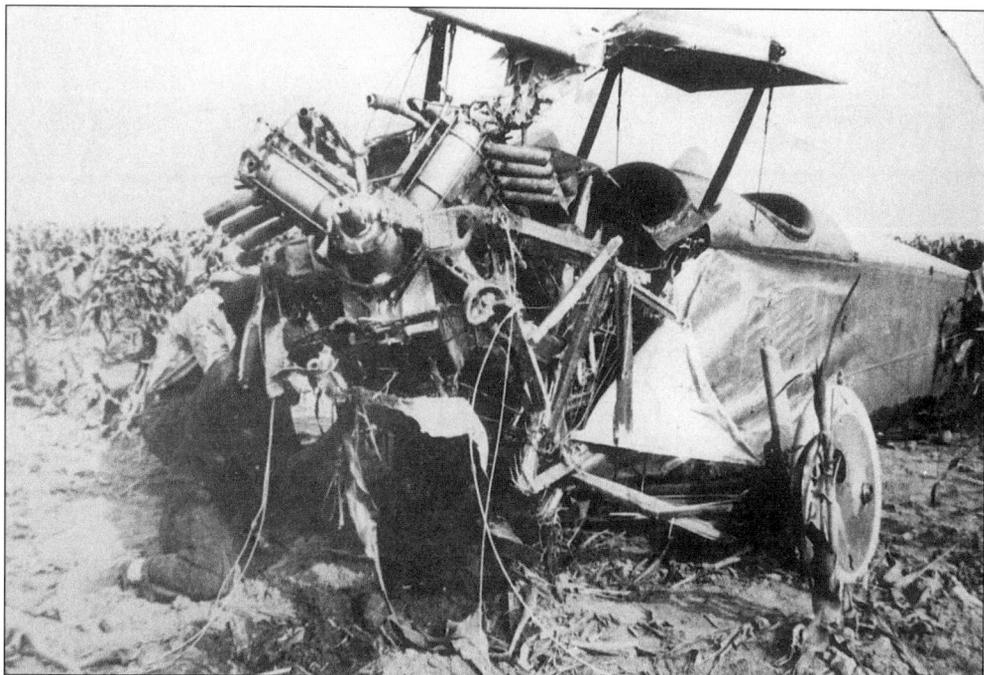

Bettendorf's Wallace Field boasted a fine safety record for its fliers. But every now and then a steel bird came hurtling to the earth. One might not think a pilot could survive a crash that left this airplane little more than a mangled, tangled mass of steel. But he did. Despite doctors' predictions that he was at death's door, Frank Wallace lived to fly again—with grace and a bit more caution. Frank's co-pilot, Edwin Bettendorf, walked away with a broken nose and some lacerations.

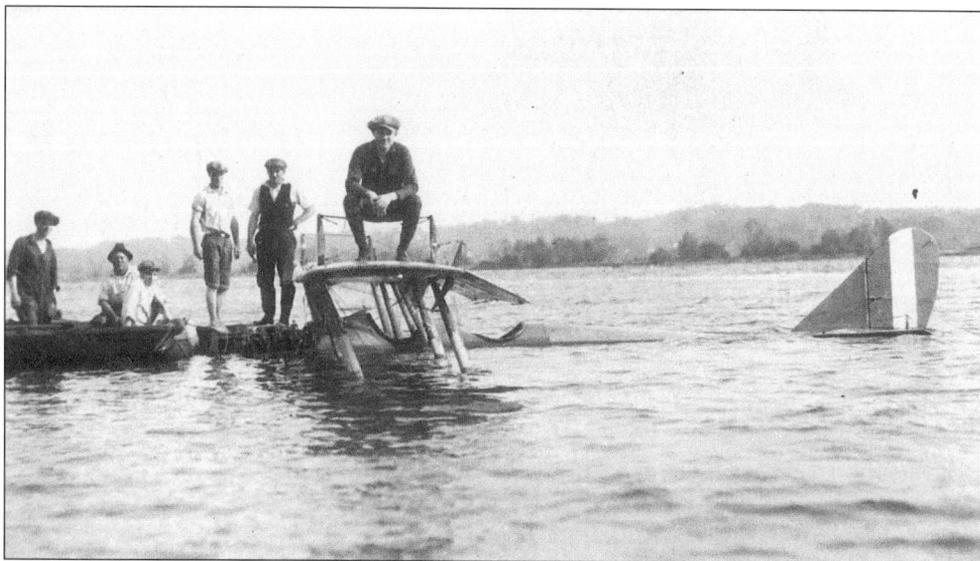

It was a glum Don Luscombe who sat aboard his downed Jenny on this day in 1925. No, he wasn't using the river to clean his aircraft. His friend and co-owner of the Jenny came out of the clouds, heading right into the Mississippi. Thankfully, there were no major injuries suffered in the mishap, unless you count one embarrassed pilot and a disheartened airplane owner.

Three
DIVERSITY

In the language of the German immigrant, it is a village of beds;
a slower, quieter pace in a place on the outskirts of
that Schleswig-Holstein stronghold downstream, that metropolis
where turnhalles and bierdergartens abound.
But here it is Traeger's and the barrio; on the landscape
and in the worship houses, the songs on tongues of Greek
and Gaelic, Armenian and Español . . .
Our Lady of Lourdes.
Bettendorf is a family legacy, a city's promise.
It is not one man's claim. It never was.

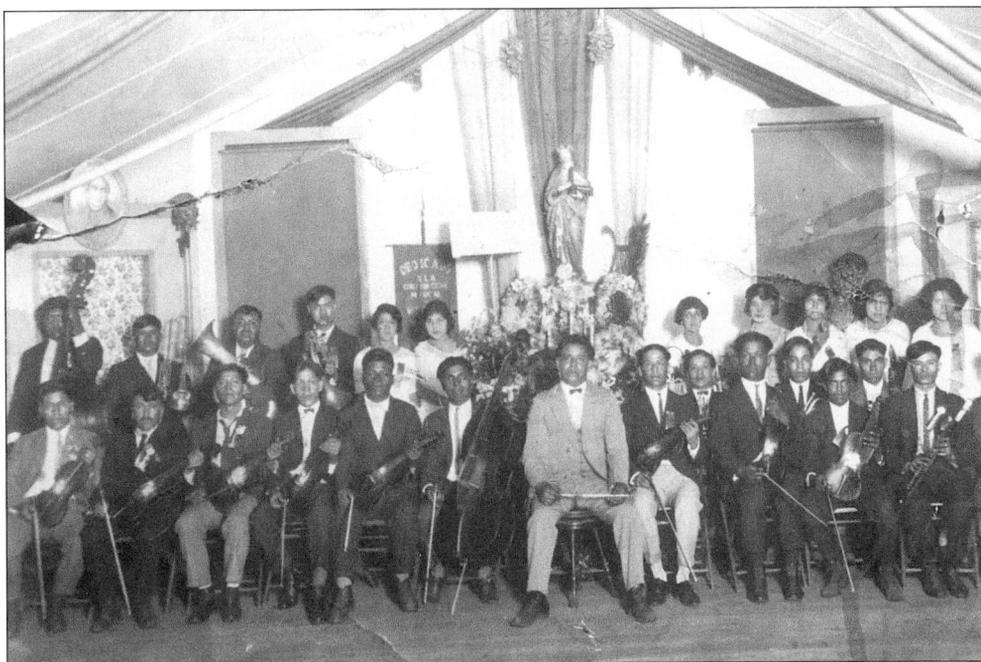

Mexico was a country caught between revolutionaries led by Pancho Villa and the federalist armies. As a result, workers traveled by train, coming by the hundreds and then by the thousands to Bettendorf to find jobs in local factories and fields. And along with their excellent work ethic, they brought their music and their art. Often practicing in church halls, bands like the one pictured here were popular sources of entertainment during city festivals and holiday concerts.

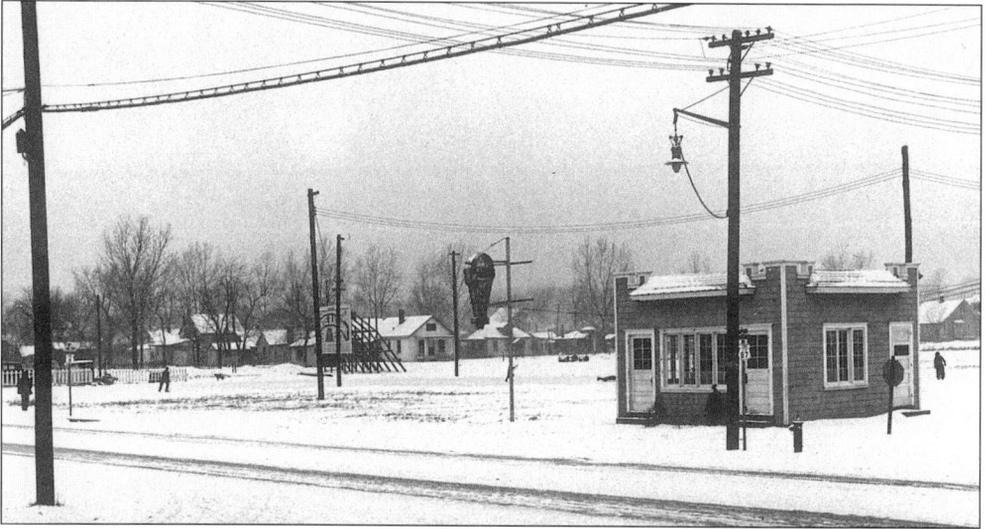

Long before Whitey's and Dairy Queen hit the Quad-Cities, Bettendorf boasted this ice cream parlor. The choice of flavors was limited to vanilla, chocolate, and strawberry, but you could get a five-decker cone for a dime! Business seems a bit slow on this chilly afternoon. Yet, if you look closely, you can spot some potential customers heading in the direction of the ice cream store.

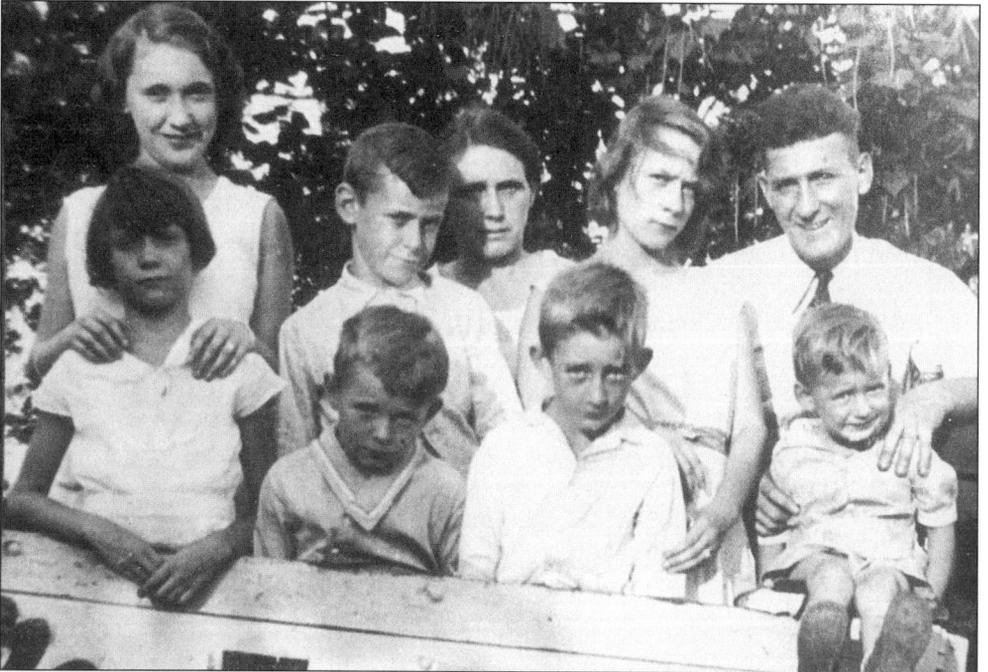

The 1930s brought economic depression across the nation, and the people of Bettendorf suffered their share of hardship. Yet the closeness and love of families like the Glynns of Bettendorf helped brighten the days and lift the spirits of neighbors and friends. William Glynn probably never imagined in the bleak years of the Great Depression that he would grow up to be his city's mayor, heading up the local celebration during the Bicentennial Year of 1976, America's 200th birthday. "I've always loved this place," Mayor Glynn declared, "and I feel blessed that this was my home."

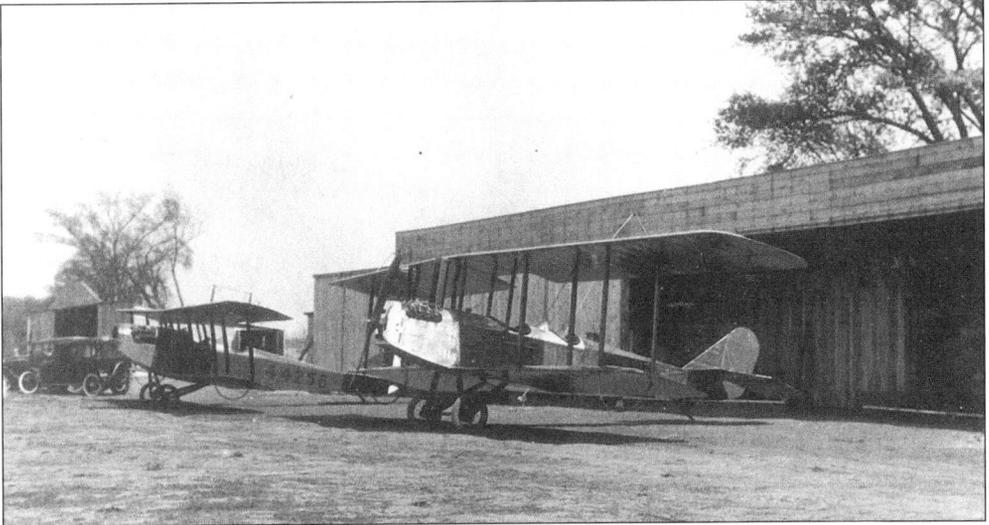

From 1919 until 1936, Wallace Field was home to many aircraft, both recreational and commercial. Air shows were popular in the 1920s, and pilots in need of repairs on their aircraft kept the Wallace mechanics busy. After the field closed, these hangars were converted to storage facilities for boats, until the 1950s, when a windstorm literally blew them away. Frank Wallace, still living on the field at the time, commented wryly, "There goes a lot of history."

A "high flier," dusting the clouds in the skies above what was then known as the Tri-Cities, Frank Wallace was one of those who put Bettendorf on the map and helped it to eventually achieve equal status with its neighboring communities of Davenport, Iowa, and the Illinois cities of Moline and Rock Island. As Bettendorf continued to grow, the airfield that Wallace built gave way to progress and the coming of a new industrial use for the space. With Standard Oil Company's arrival, Frank and his flying machines passed into history.

47

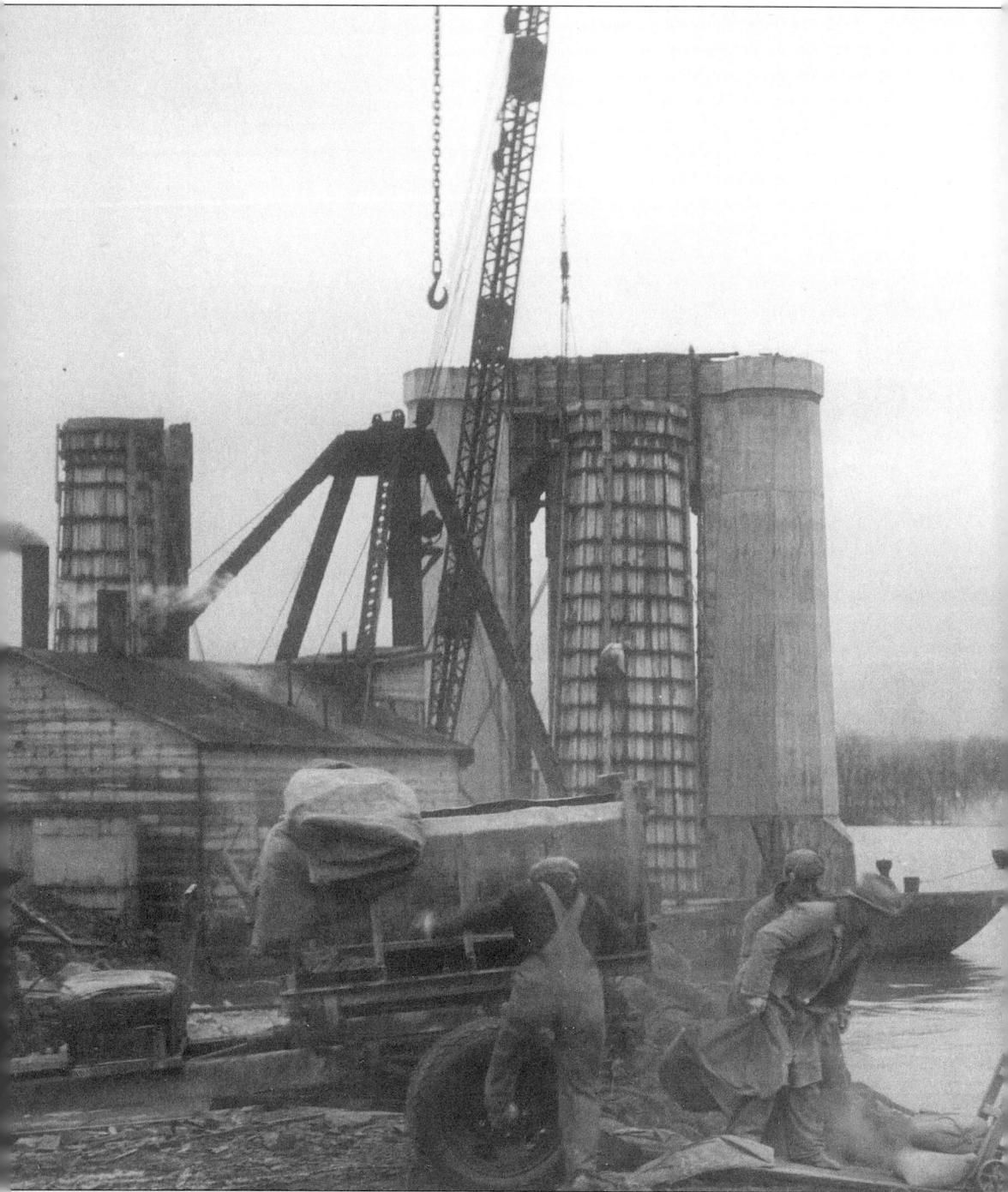

History—and a bridge—was in the making, as construction got underway in 1934 for the Iowa-Illinois Memorial Bridge. The traffic flow across the Mississippi had been steadily increasing with the advent of automobiles, and with federal backing through President Franklin D. Roosevelt's Works Projects Act, the first span was built at a total cost of $1.5 million and dedicated in grand style with a horse show and fair on November 18, 1935. The event brought

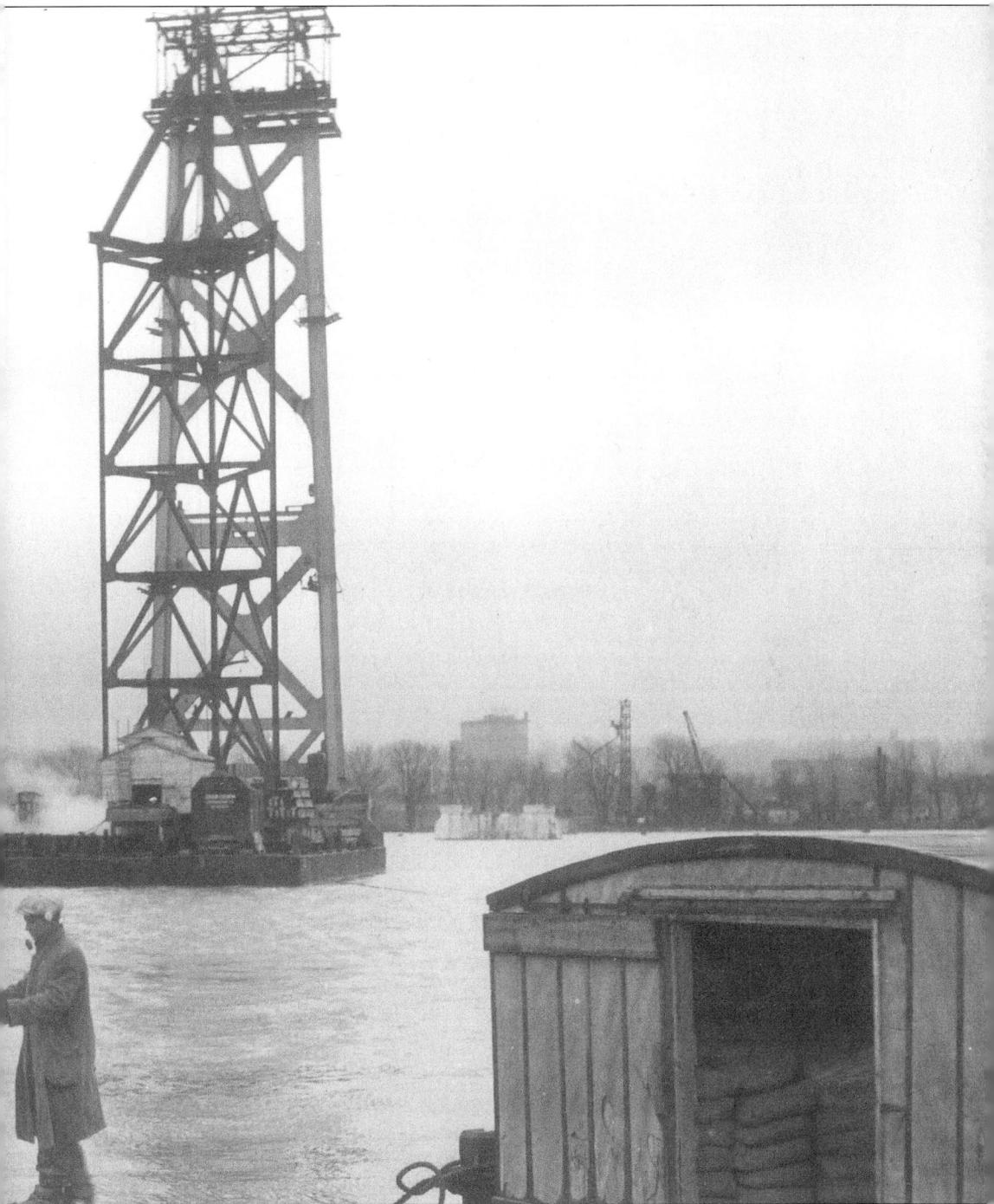

governors and dignitaries from both Iowa and Illinois. Youngsters from Lincoln School were herded on foot down the hill and paraded through town and across the bridge to Moline and back. Afterward, their ruddy, wind-chapped faces were still all smiles as they were treated to ice cream cones at the Iowana Farms.

Edwin Bettendorf (shown here) and his brother William faced a crisis after the death of their father Joseph in 1933. The Bettendorf Company had been devastated by the Crash of '29, and declining sales caused the company to go bankrupt in three years, in debt for back taxes. But the brothers benefited from the loyalty and support of their father's employees, and with assistance from the factory workers the company managed to repay the taxes and reopen the shops.

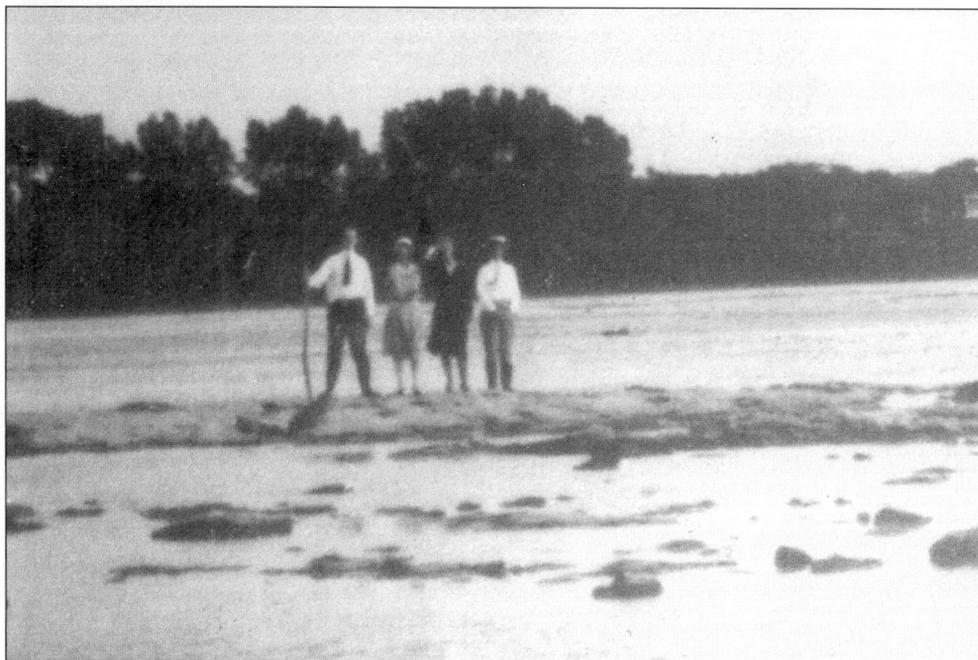

Are they marooned? Well, this picture was snapped long before the days of "Gilligan's Island." Work was underway for a system of locks and dams that would change the landscape—make that riverscape—when it was finished. This group shot, taken August 15, 1933, is of the McGinnis clan, including Finley, Preston H., Lottie, and Mark.

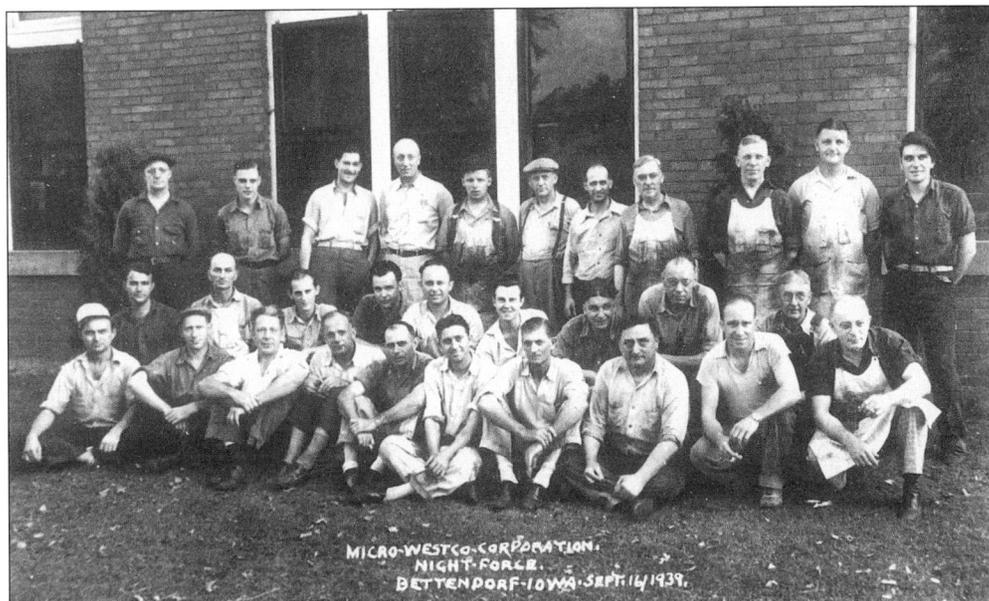

It wasn't easy getting these nightshift workers of Micro-Westco Corporation all together for this 1939 photo. No matter how you slice it, when men come to do a job they don't have their minds on smiling for the camera. Bettendorf's Micro-Westco was the first manufacturer of the commercial bread slicer. Orders came from all over the world for the quick and safe way to deliver pre-sliced loaves of bread to consumers. Hey guys, anyone got a bologna sandwich to trade for liverwurst?

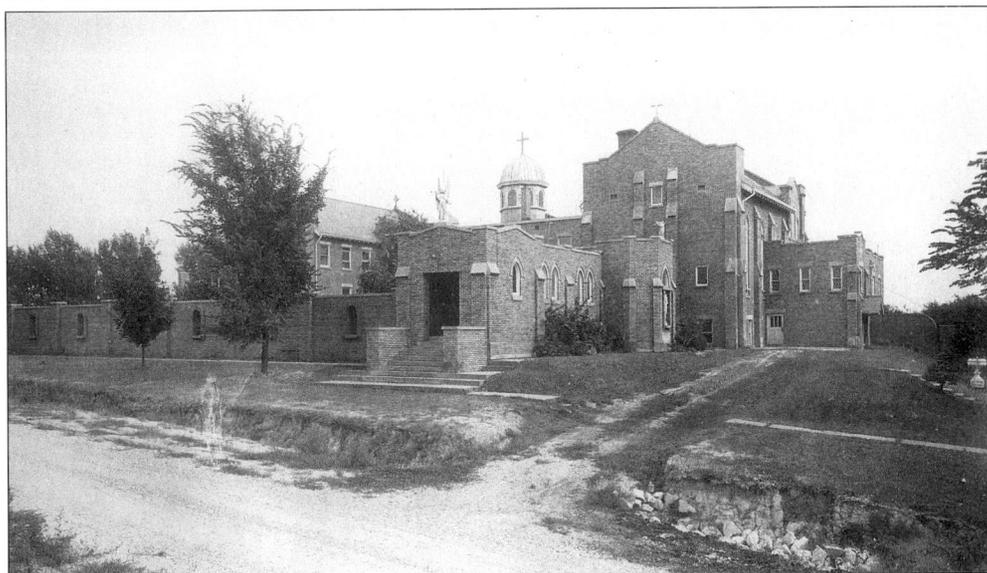

In the 1930s, Bettendorf struggled within the clutches of a national depression. As in cities across the country, local banks closed, factories shut down, and workers lost their jobs. Amid the chaos and clamor, the Carmelite Monastery, once named "The Queen of Heaven Monastery," at the top of Fourteenth Street, provided a safe and secure world for the nuns living there. They moved, in 1975, to a farmhouse near Mount Joy, and the property was taken over by the Unity Church.

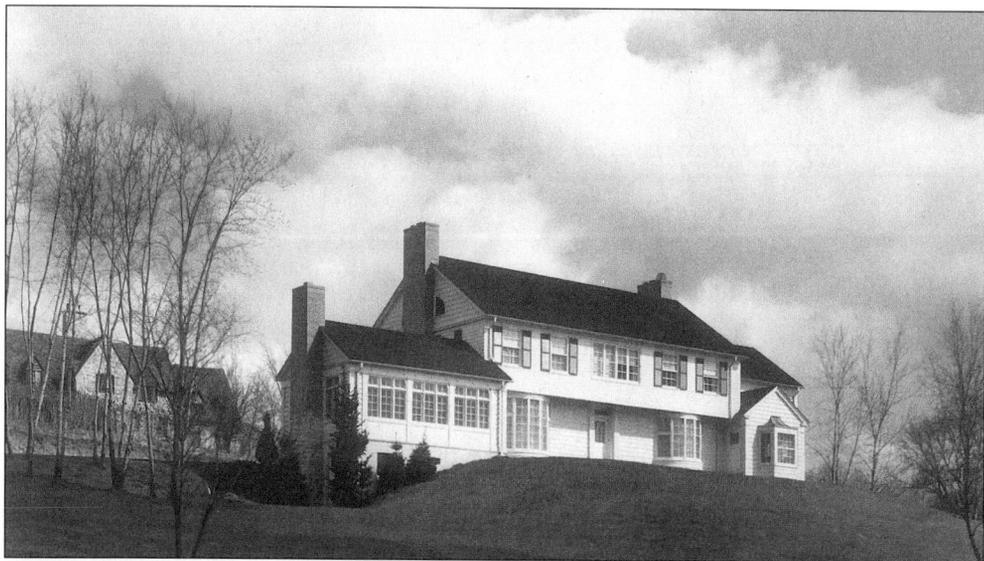

Bettendorf has long been a showplace of beautiful residential neighborhoods. Former Moline resident Jason Moskowitz, now living in Chicago, recalled countless family outings to Moline's sister city across the Mississippi. "Our family liked to take drives across the river just to admire the beautiful houses there," he said, no doubt including this fine jewel glimmering in the afternoon sunlight—the Henry C. Wurzer home at 505 Riverview Terrace, photographed in 1937.

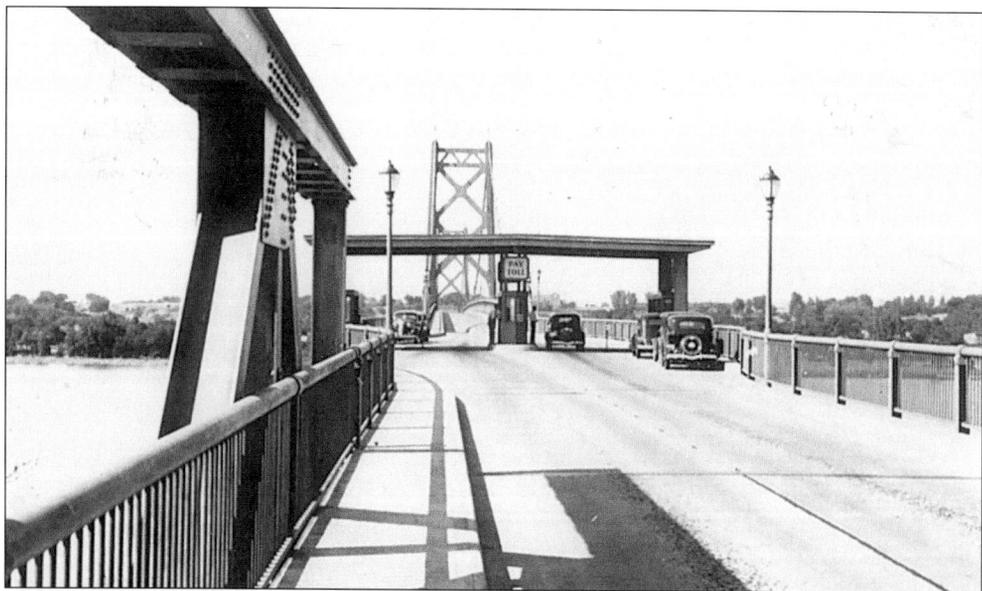

Before a second span was added in 1960, the Iowa-Illinois Memorial Bridge was maintained through tolls collected as vehicles crossed over from either side of the Mississippi River. Note the lamp poles in this photograph, which captures a moment in time when cars were not lined up during peak rush hours. After three decades the decision was made to add a second span and, when the work was finished, the bridge became part of the federal highway system, designated Interstate 74.

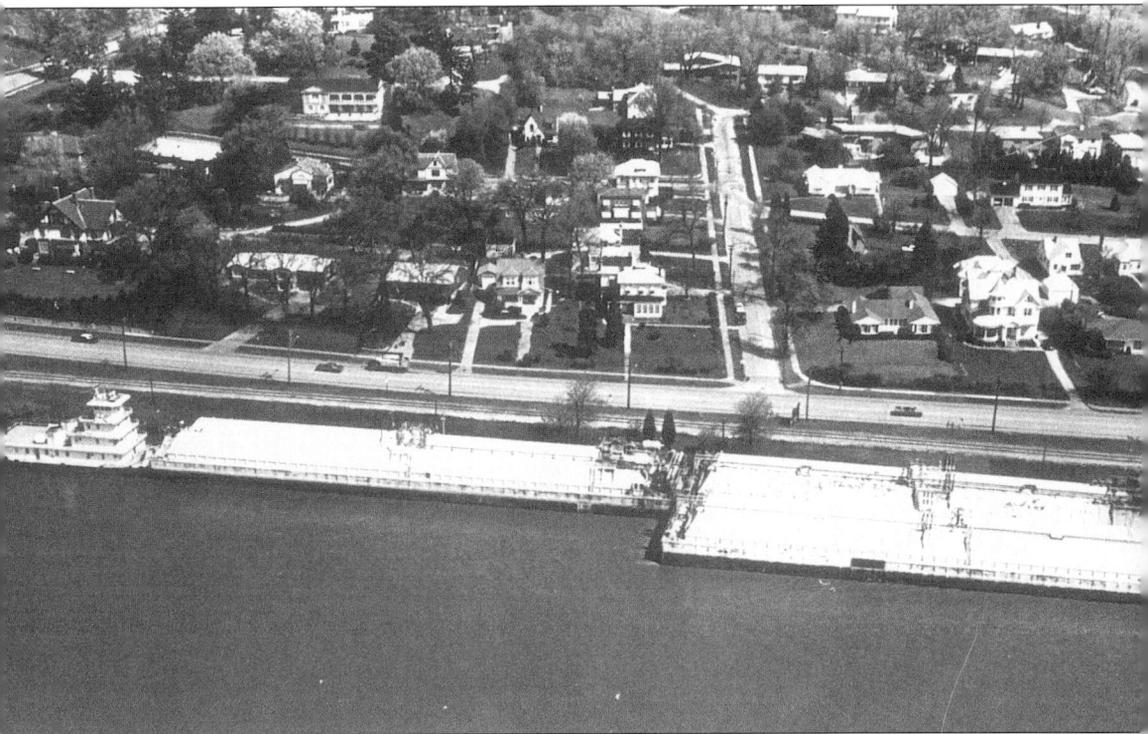

"Go down by the levee, I said, by the levee . . ." and there in the 1930s, riverboat barges docked along the shore where houses and businesses were few and far between. Times change. Today's view along Bettendorf's shore reflects a busy commercial center, and it continues to change as "Iowa's Most Exciting City" bets its future on tourism and a reclamation of its scenic riverfront.

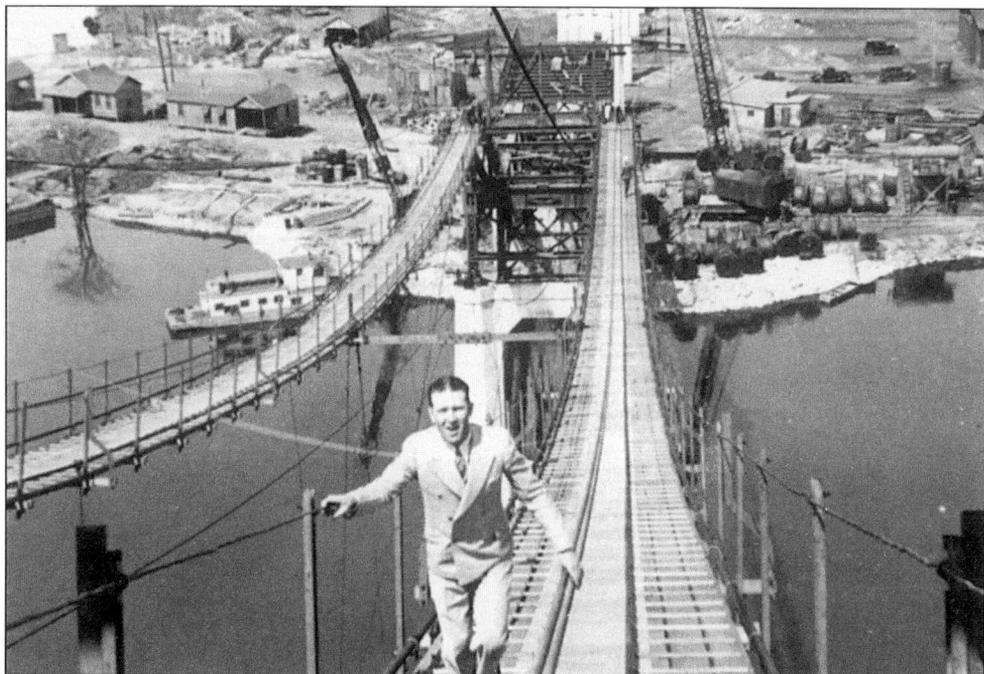

Young man! You, with your hair smartly parted in the middle and that daredevil smile, climbing the skeletal beginnings of the Iowa-Illinois Memorial Bridge. Does your mother know where you are at this very moment? What would she say if she saw you there, high above the rushing waters of the Mighty Mississippi? A construction worker, you claim. What, the safety and security of a factory job wasn't challenge enough?

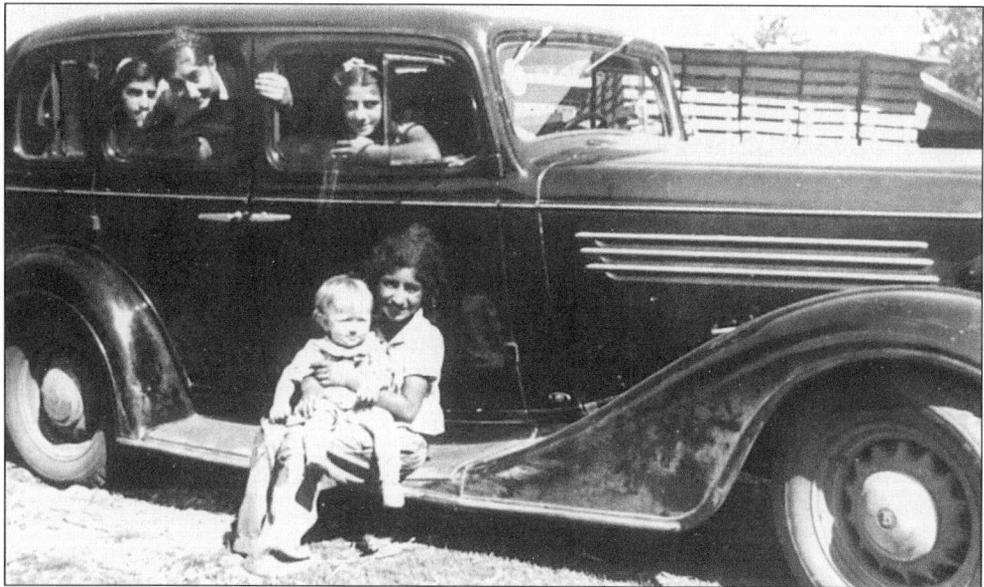

During the Depression, most onion pickers walked to the fields. But now and again an entire family arrived by automobile. Children worked as well. Those too young to pick the crop were put to work looking after even younger siblings. Not an easy life, and yet the folks in this photograph smile in the warm sunlight, taking pride in their labor.

54

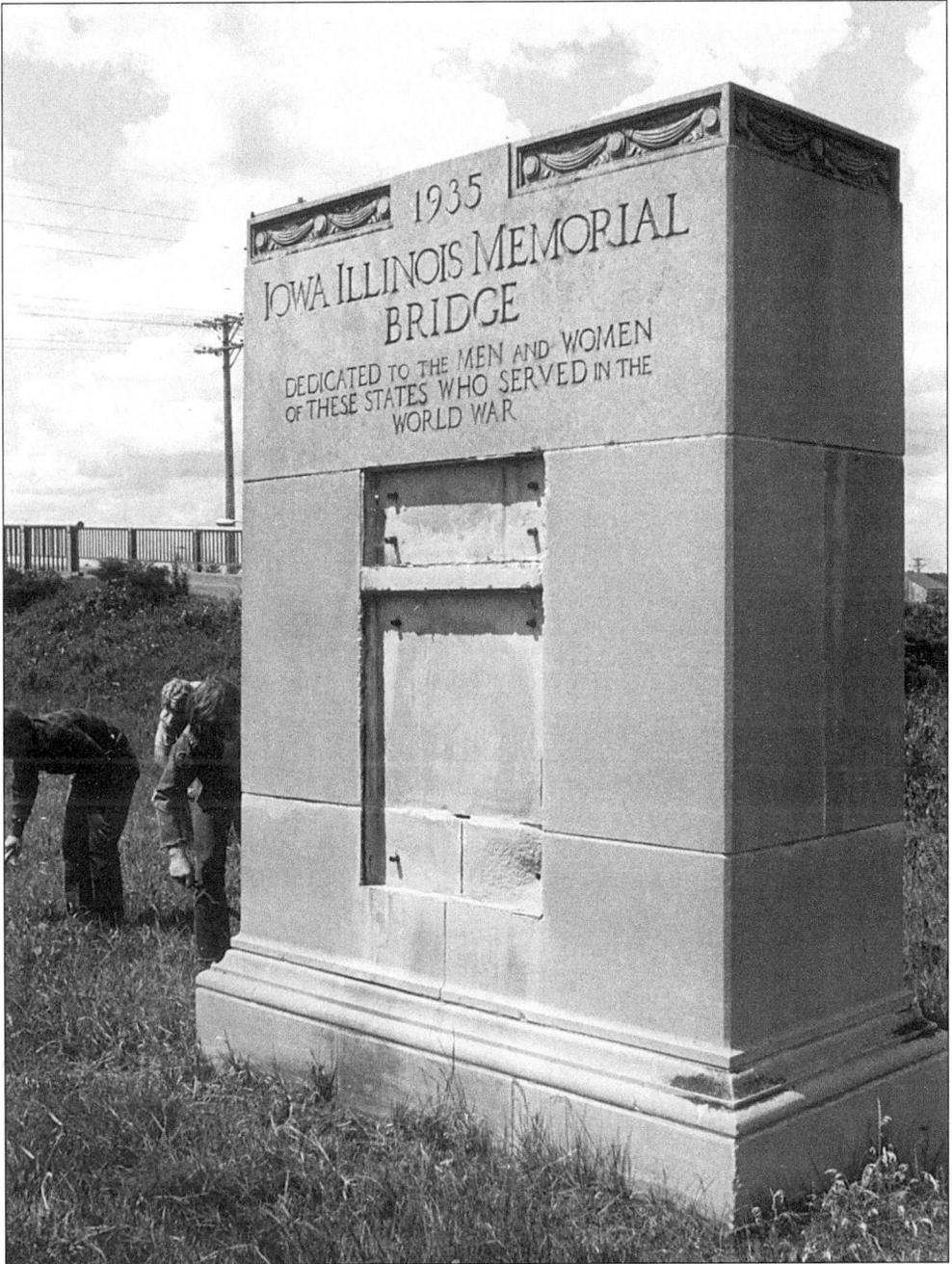

This is a case for the Hardy Boys and Nancy Drew—missing plaques taken from the stone monument at the approach to the Interstate 74 Bridge and not a clue as to the culprit. The monument was erected in 1935, coinciding with the completion of the first span of the Iowa Memorial Bridge across the Mississippi River. The site is now named in honor of former city Mayor Bill Glynn, and those missing plaques that commemorated area servicemen and women were replaced. Who took the originals? It remains a mystery.

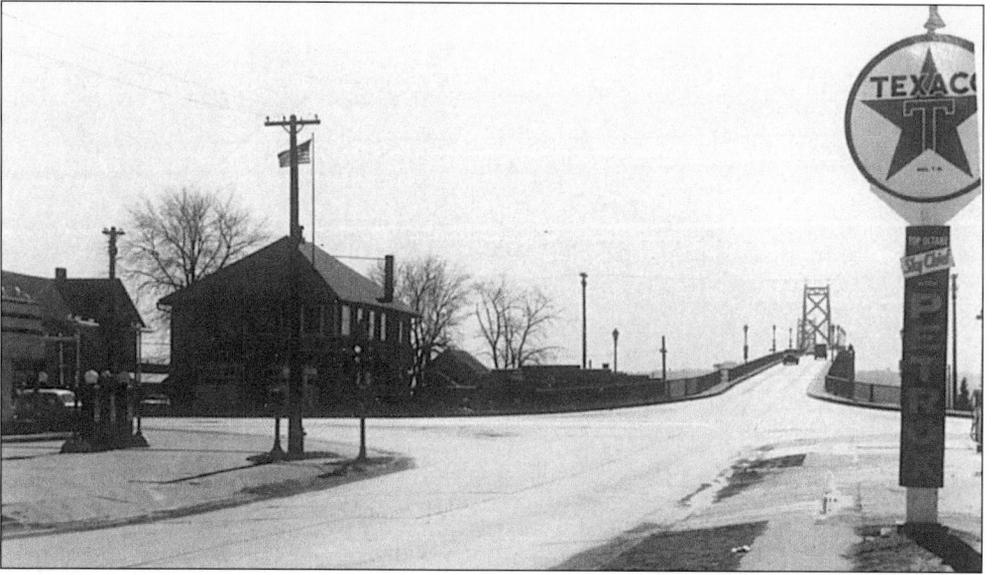

This tranquil scene at the foot of the Iowa-Illinois Memorial Bridge reflects a time when folks weren't always in such a hurry to get places. The sign of the Texaco star must surely mean there's a man on duty, and he'll fill up the tank and wash the windshields, singing a tune just like those guys on Milton Berle's Tuesday night variety show. The station and old city hall across the intersection, on the left, were torn down to make way for a second span for the bridge.

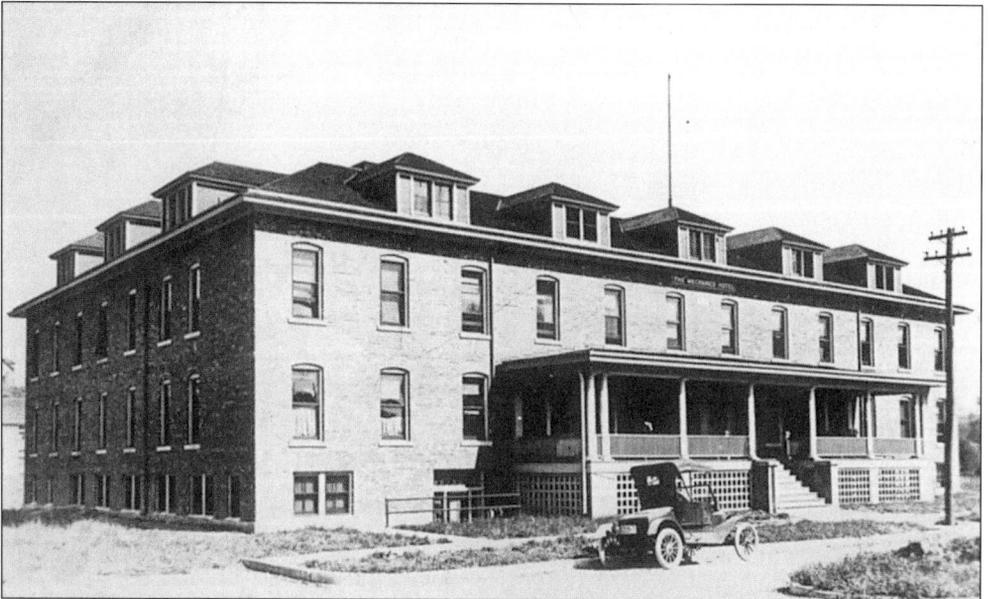

It was called the Mechanics Hotel, but it accommodated a much broader range of occupations, including executives, attorneys, and engineers. It was, however, restricted to single men only. The rooms were austere and practical, offering the bare necessities and maybe a few pictures on the walls. The lower level had a banquet room for guests to use when hosting business dinners and parties.

56

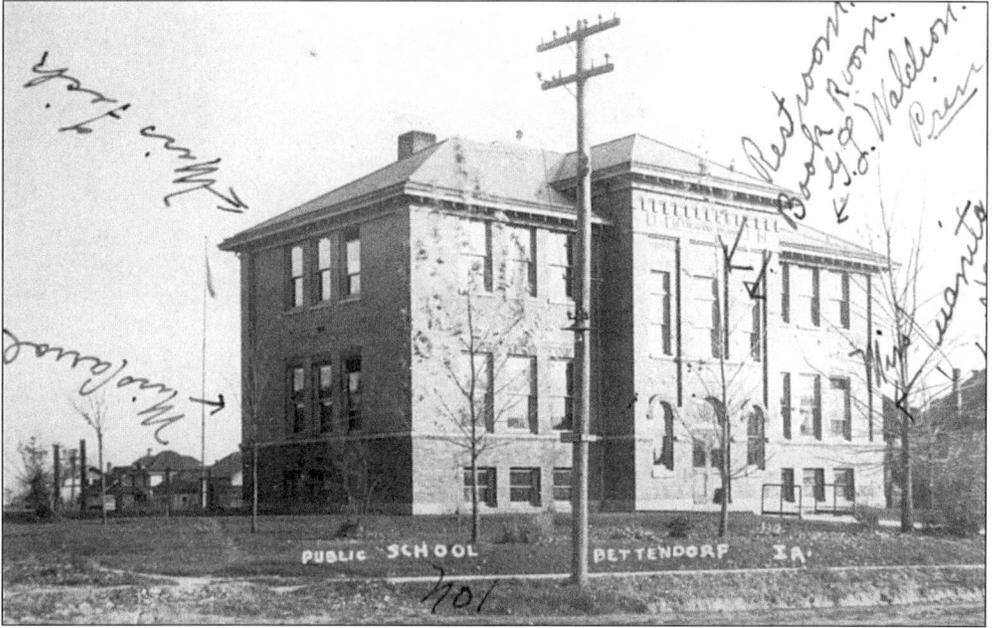

Now here is a photograph that should bring back memories for longtime residents. This is the old Bettendorf Public School, back when G.L. Waldron was principal and the staff included Miss Carroll, Miss Finch, and Miss Juanito. *Quad-City Times* columnist Bill Wundram often tells of his after-school sessions with Miss Finch.

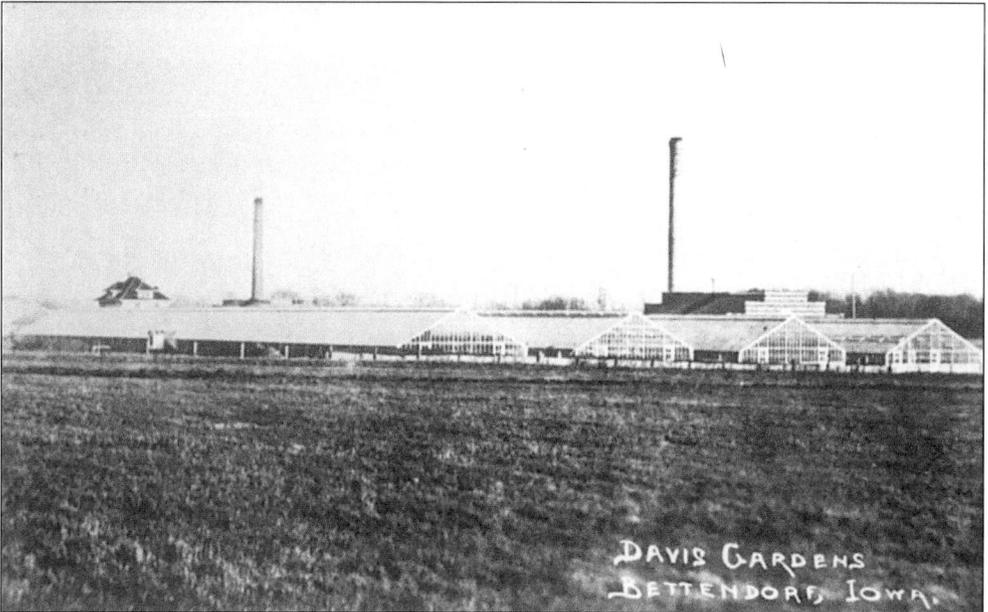

At Davis Gardens special greenhouses protected starter plants from the elements—especially important in the harsh winters here in the Upper Mississippi Valley. Fortunately, once the plantings made it into the ground, the rich Iowa soil allowed for virtually all varieties of fruits and vegetables to grow with relative ease.

Where is Tom Sawyer when you need him? That picket fence at 1101 State Street could sure use a fresh coat of paint. At least it wrapped around the yard, allowing pets (and children) to run freely within. Although automobiles had already come onto the scene when this residence was photographed, the old hitching post was still around to secure a horse and buggy.

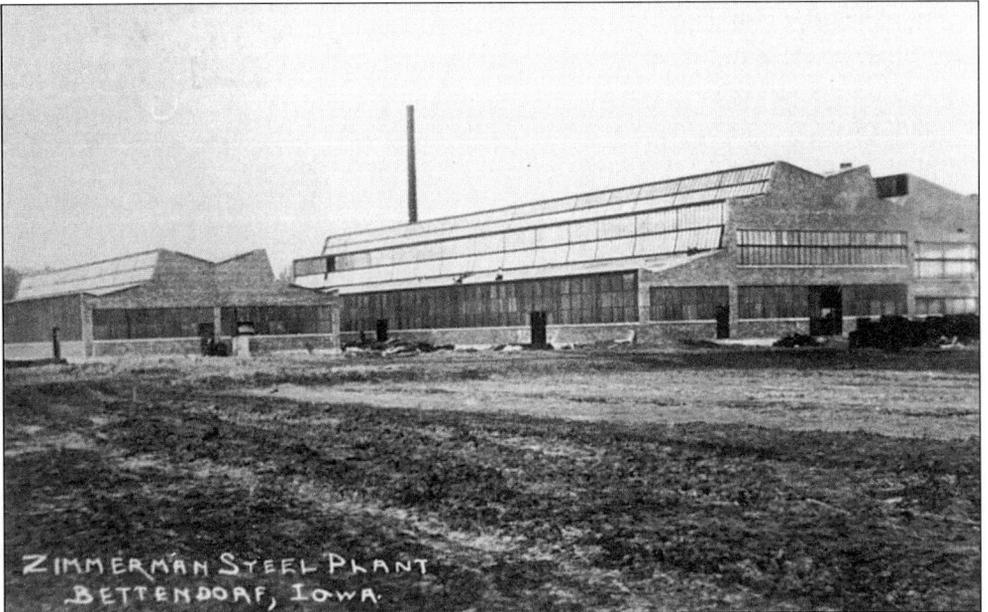

Accessibility to water and rail transportation allowed many industries to flourish in the Quad-City area. Zimmerman Steel Plant was among those to reap the benefits of being within easy access of the Mississippi River. This postcard shows the plant's sturdy chimney rising above the factory. The back of the postcard advertises a Davenport printer and its declaration that: "The name BAWDEN assures quality and durability."

58

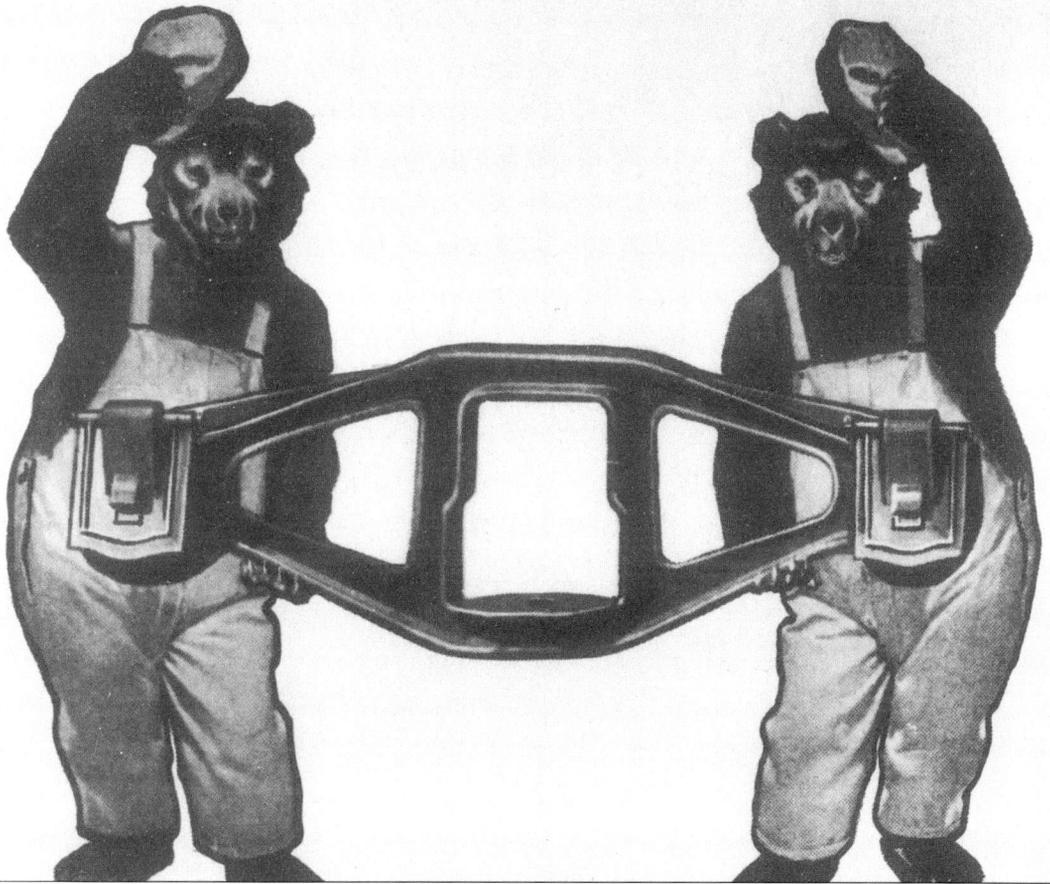

Before its patent expired, the Bettendorf truck frame was the one and only single-cast frame used on railroad boxcars. It was the invention of William Bettendorf, and was a single piece instead of the multiple steel pieces that were bolted together in previous designs. Fewer bolts meant fewer parts to come loose and cause train derailments. Railroad buffs still look for the original Bettendorf frames, recognized by a trademark "B" inside a circle that was molded into the frame.

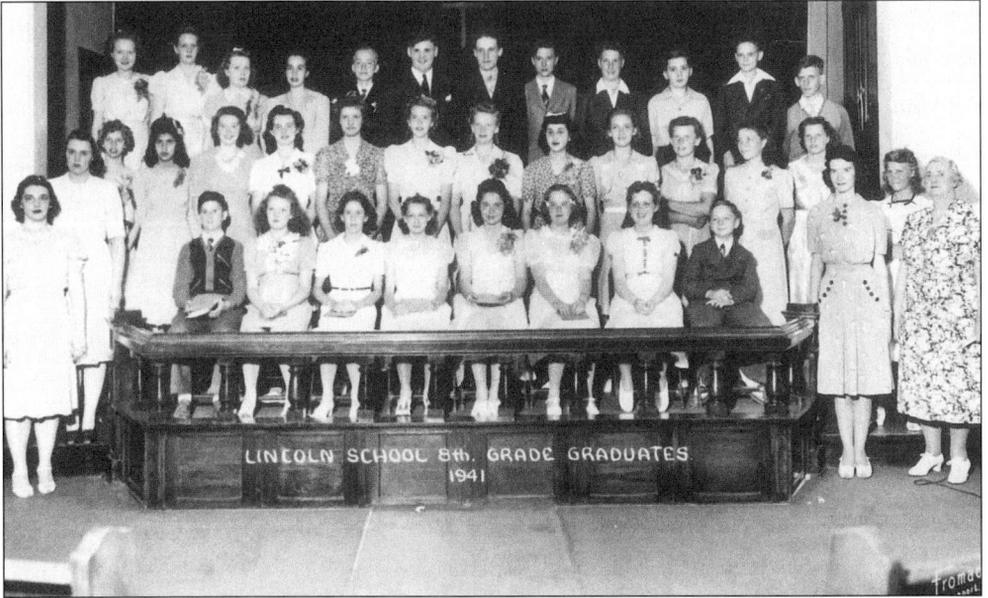

LINCOLN SCHOOL 8th. GRADE GRADUATES
1941

Across the Atlantic, European nations were in the midst of war while a new threat rose up from the Pacific. Here at home, factories were converting to military production. It was a boon to the local economy as the Bettendorf Company consigned its facilities to the production of Army tanks and Navy mine sweepers, and thousands of skilled workers who had been without work during the decade of the Depression were once again finding the means to support their families. Special moments, like this 1941 graduation of Lincoln School eighth graders, reminded us that each new generation brings hope for a better world.

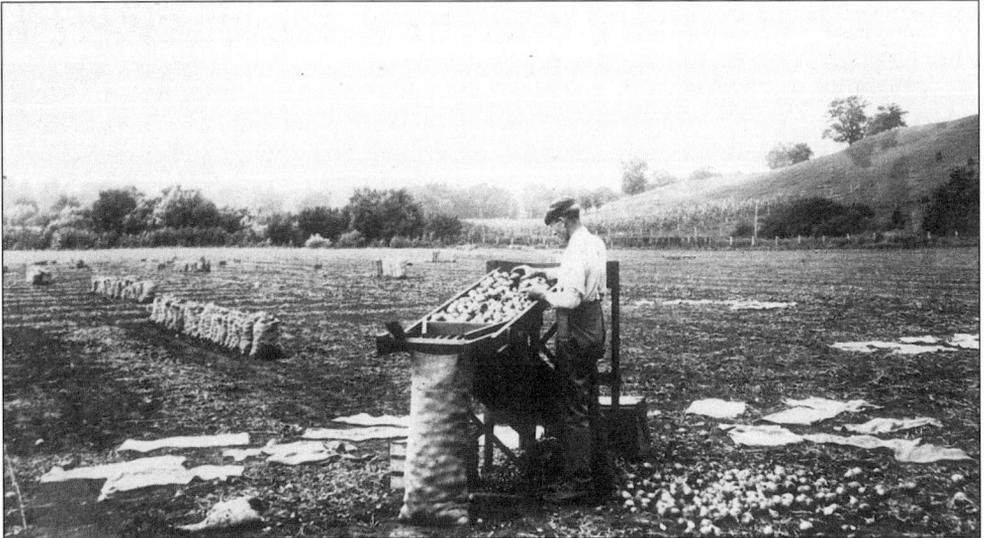

It is harvest time. A time to relish that sense of accomplishment and completion. Picking and packaging the onions from the Bettendorf fields was the final task before the fruits (some people eat onions as if they are!) of their labor went off to market. It was a tiring process—baking under the hot sun, muscles aching in testament to the long hours and grueling demands of onion farming. Yet, if the market price was good, small cash bonuses were shared among the laborers. That, and the reward of a job well done, brought personal satisfaction.

60

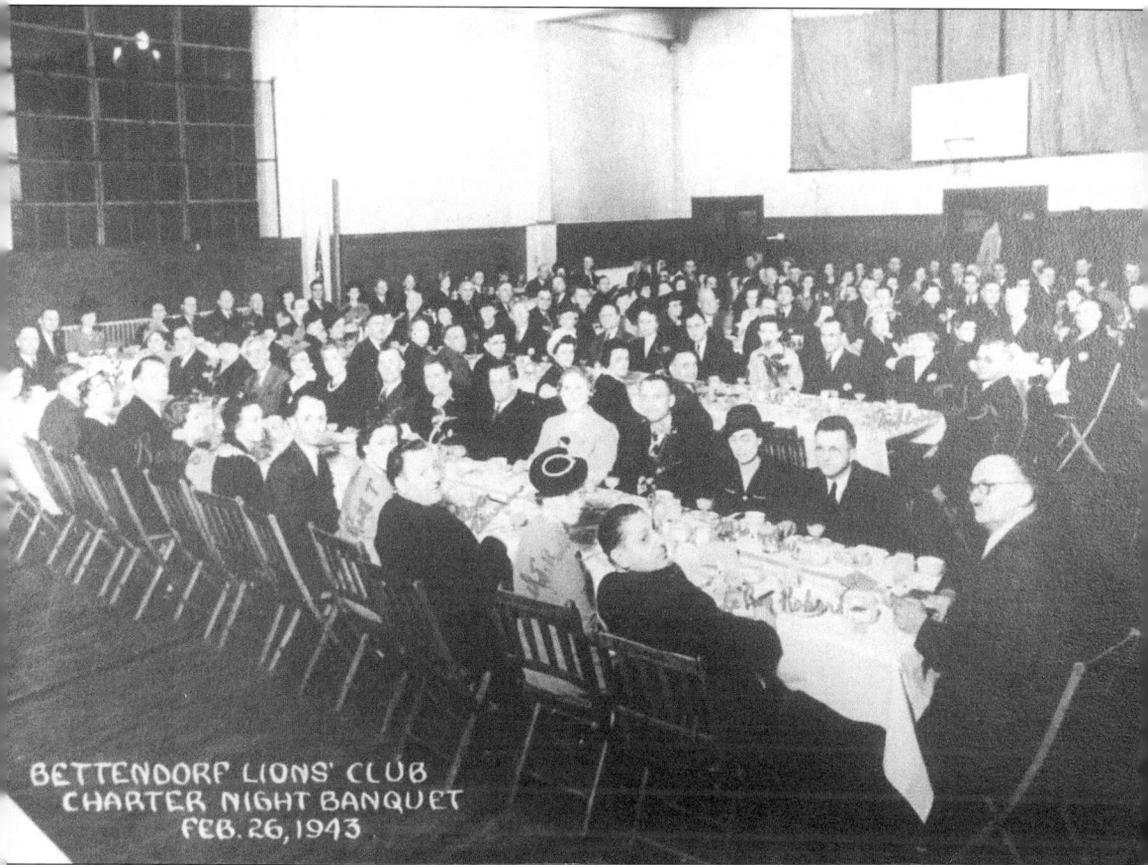

BETTENDORF LIONS' CLUB
CHARTER NIGHT BANQUET
FEB. 26, 1943

Guys had it easy, dressing appropriately for the evening in suits and ties, but the ladies had to have just the right hat to coordinate with dresses they wore to the Charter Night of the Bettendorf Lions' Club. No doubt much of the evening's conversation that February 26th in 1943 revolved around the war effort. Like towns and cities across the nation, Bettendorf sent many of its finest off to face the enemy aggressors in World War II.

This early 1950s photo shows an Iowana Dairy truck having its tank filled with gasoline. Iowana Farms was located on the hill in Riverdale. People raved about the delicious ice cream, courtesy

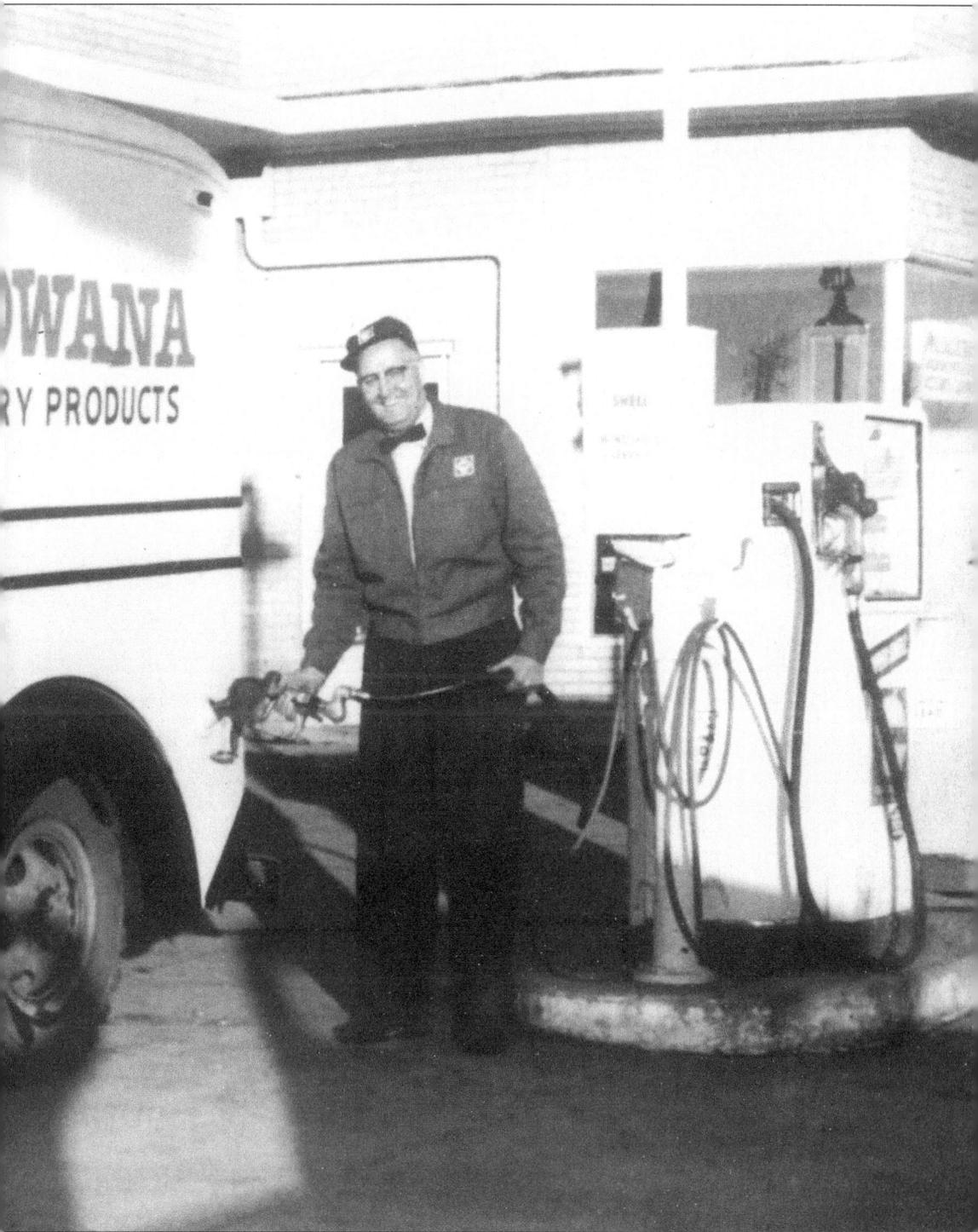

of Iowana's Holstein cows.

Harold Ross was a good businessman who knew where to place his restaurant and how to draw in customers. His original establishment opened in 1946, featuring homemade pie for 20¢ a slice. Not only did Ross's feature good food and beverage, but it also had that "Cheer's-like" atmosphere where people knew your name. In fact, many people who dine there today claim the place has never changed. Anyone for a Rossburger?

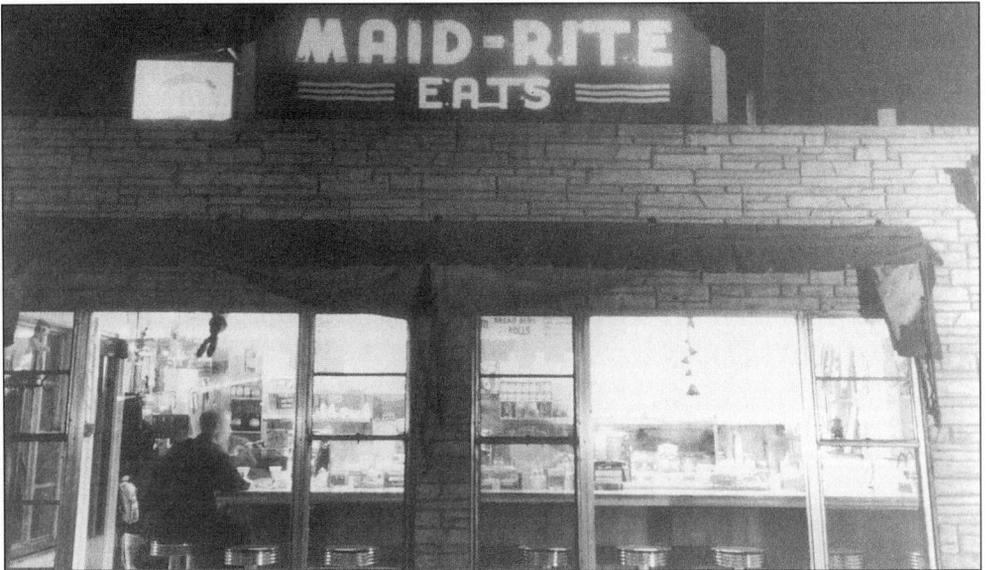

After World War II, Bettendorf returned to its peace-time patterns of life, with new businesses popping up on the landscape. Some prospered, while others slipped away quietly. But one eating spot, strategically located at the bottom of the Interstate 74 Bridge, continues to attract the traveler and loyal local customers. This is the original Ross's Maid-Rite Restaurant, snug and friendly and guaranteed to add inches to the waistline at reasonable prices.

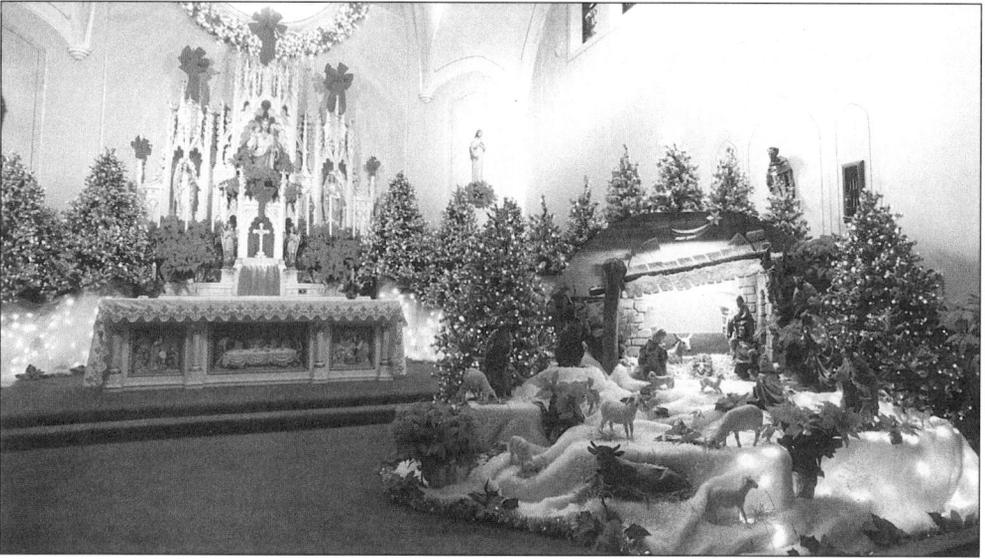

The story of that legendary night a millennium ago comes alive in a nativity scene at St. Francis Monastery, now the Abbey Hotel. In the background, the altar is banked with trees, poinsettias, and red ribbons as a familiar melody fills the air: "Away in a manger, no crib for a bed. . . ."

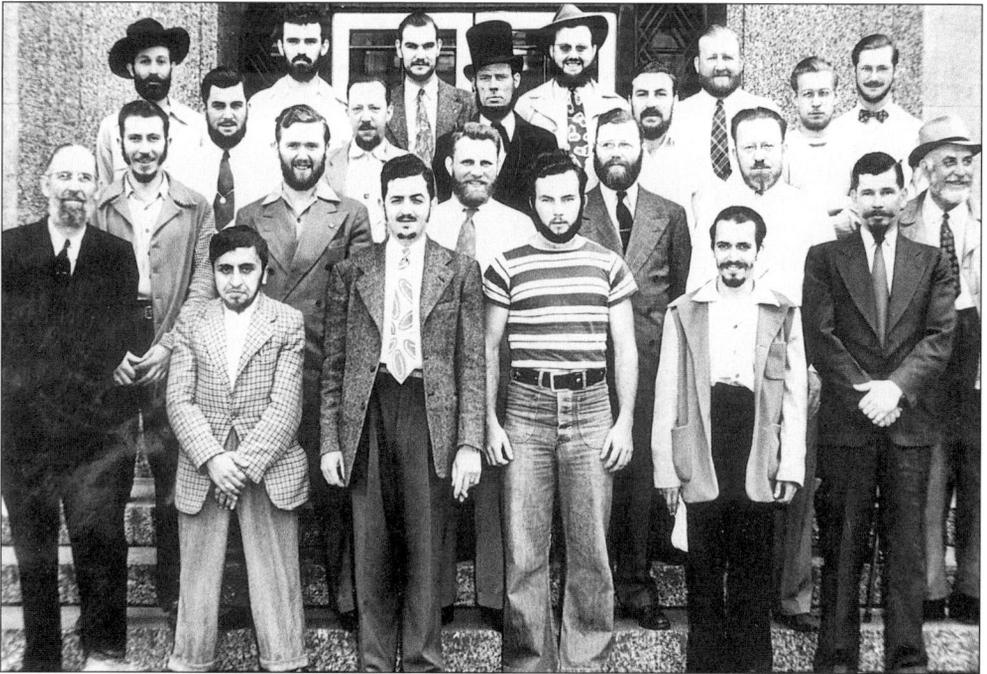

Remember the old Burma Shave signs you passed driving through the Iowa countryside? These whiskered fellows were obviously not impressed by the message. The year was 1947, and this assemblage took part in "The State of Scott County" centennial celebration with a beard growing competition. (Hmm—there's a fellow in the third row who bears a remarkable resemblance to a notable resident in Illinois history. . . .)

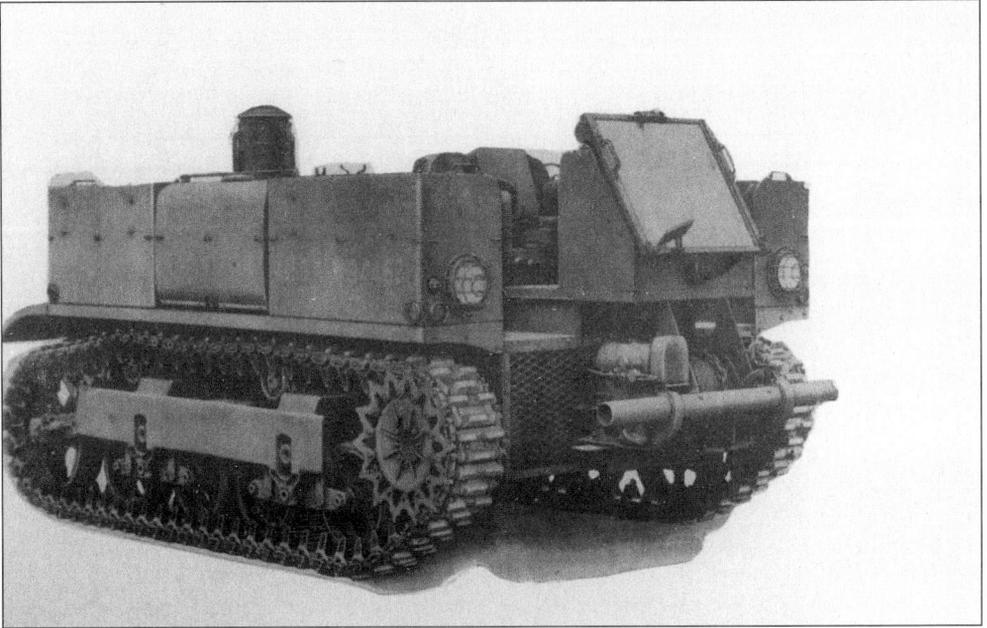

While servicemen and women battled enemies abroad during World War II, back home in the U.S.A. companies altered manufacturing schedules and assembly lines to produce top-of-the-line military implements and field equipment. The Bettendorf Company dedicated part of its plant to the production of this sturdy armored vehicle called "The Prime Mover." Factory worker Al Harris declared, "it would take a bomb to destroy that machine."

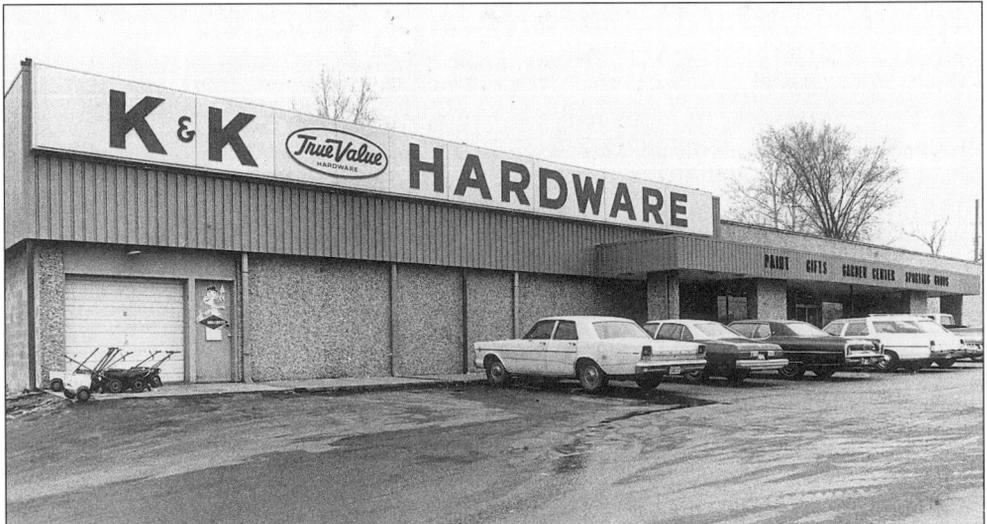

Need a hammer? How about a nail? One or a dozen—any size for any purpose. Maybe it's your lawnmower that needs repairs. Head to the epicenter of the Quad-Cities, K & K True Value Hardware. Yes, it really is, geographically speaking, the heart of the Quad-Cities; a gathering place where you're sure to catch up on all the news and views. K & K offers one-stop shopping for all those do-it-yourself types, and even manly men have been known to get into the gossip while the womenfolk dig through bins of nuts and bolts.

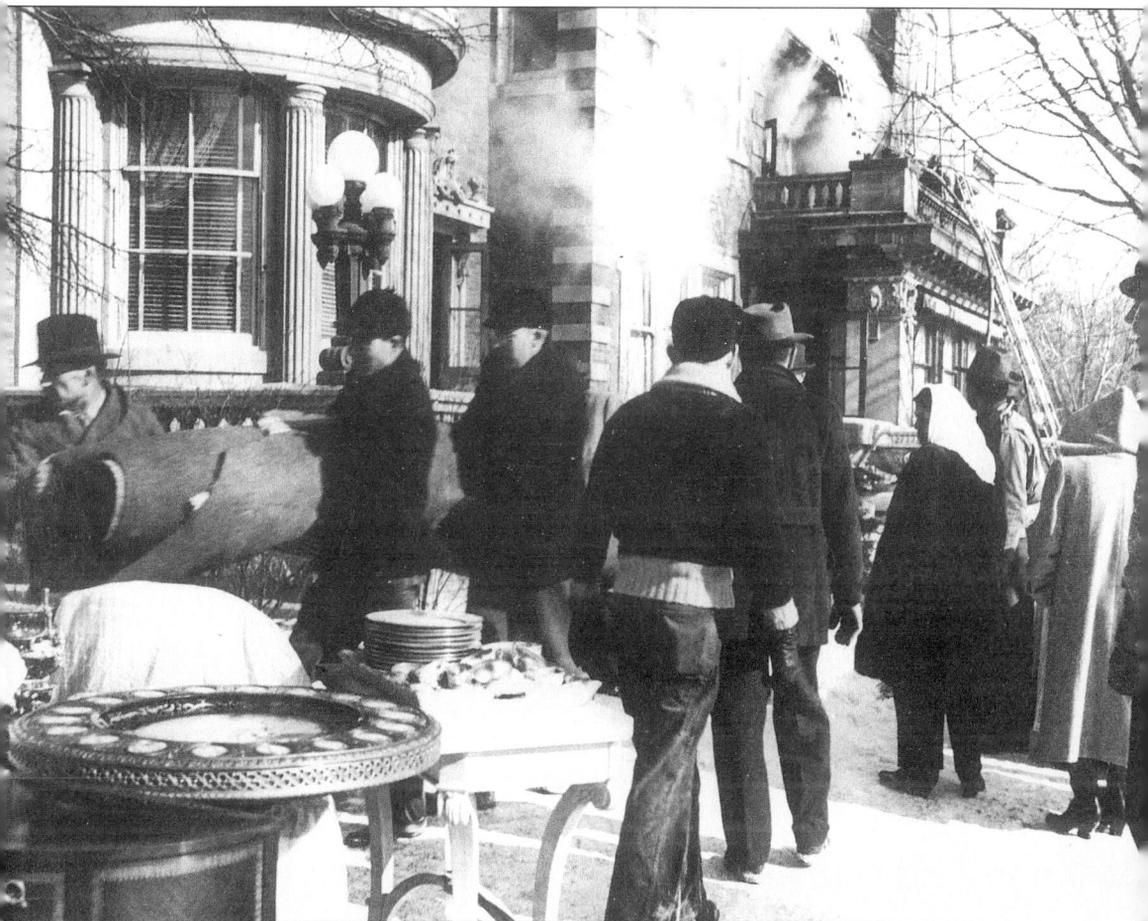

It was a biting cold day in 1947, as smoke escaped out the windows of the legendary house on the hill. Word traveled quickly around the city that William Bettendorf's mansion was on fire. The news left people shocked. Some took action, however, racing to the residence to rescue furniture, paintings, carpets, and even the fine china. "It wasn't like they were carrying out *things*," observed Franklin Jones, "They were holding history in their hands."

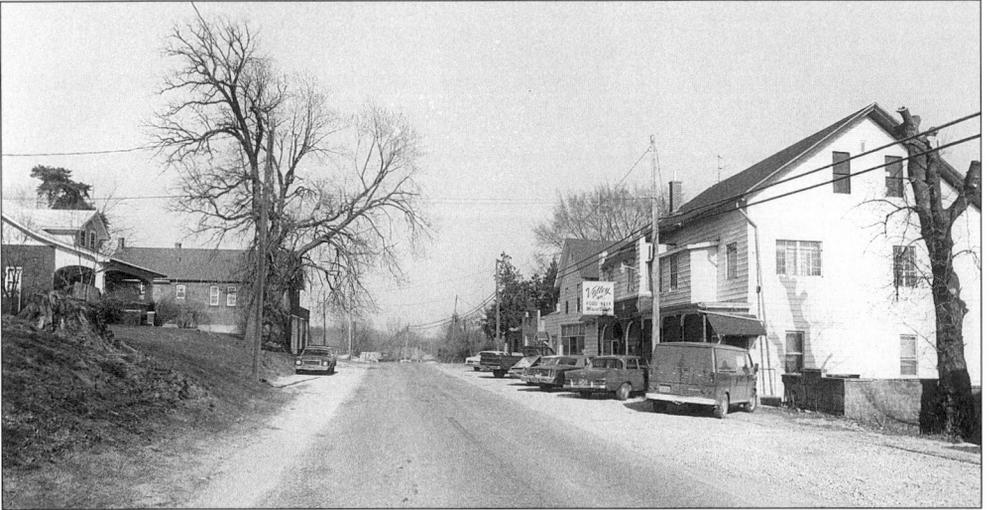

Where does Bettendorf end and Pleasant Valley begin? It's confusing for outsiders, and sometimes even for many of the locals. But both Iowa communities have existed harmoniously since the first tracts of land were homesteaded. This 1973 photo of Pleasant Valley's East Valley Drive shows what the main street in town used to look like, and it hasn't changed all that much, except that some folks still call it the "Old Highway" because it was formerly Iowa Route 417 and U.S. 67.

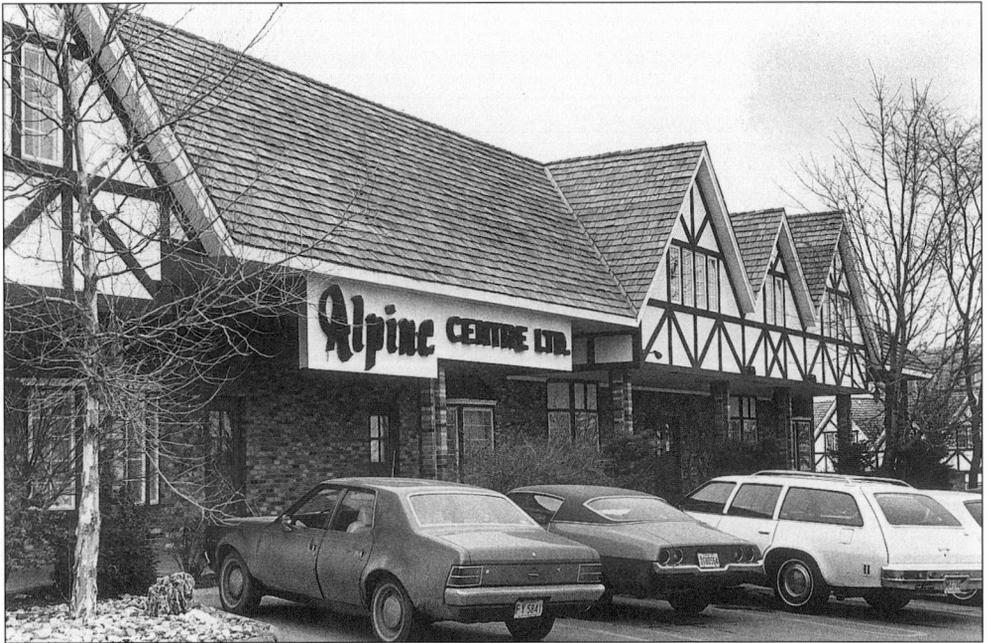

To say that Bettendorf is a mixture of peoples and cultures is true indeed, and the city's architecture is a reflection of that diversity. English Tudor is a popular style for residential and commercial architecture in Bettendorf, and the Alpine Centre Ltd. offices on Kimberly Road are an example of how the local style combines old-world charm with a new-age sensibility.

68

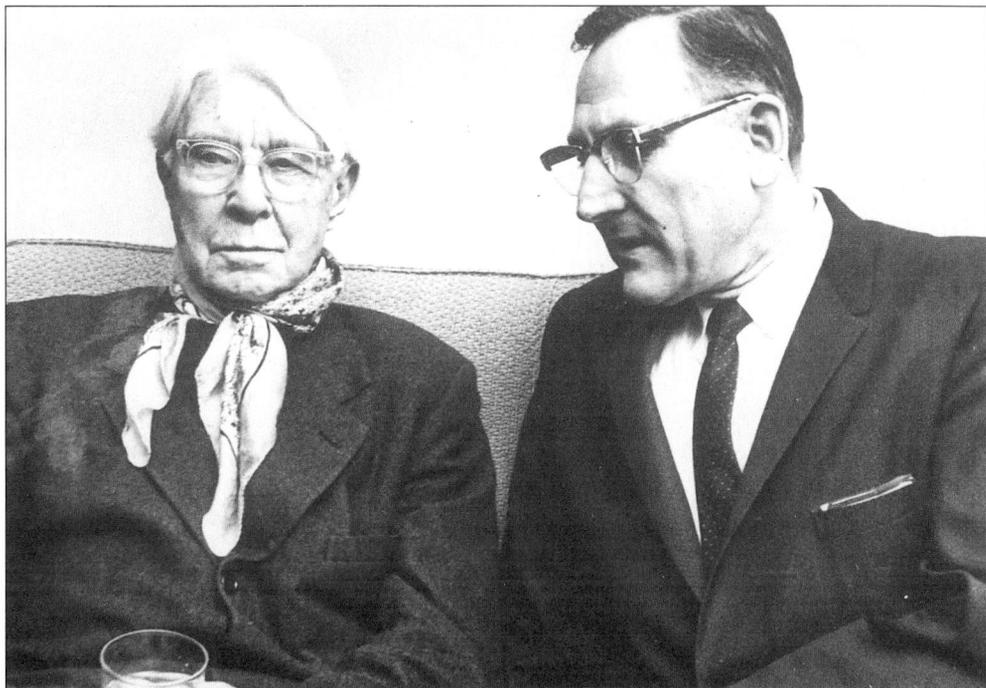

Whoever said that poetry and politics don't mix has never read the body of work by Illinois native and Lincoln biographer Carl Sandburg, seen here with U.S. Congressman Fred Schwengel of Bettendorf, who represented Iowa's First District in 1954–1964 and 1966–1972. Following his long career in national politics, Schwengel remained in Washington, D.C., to work in the arena of historic affairs and preservation. He died April 1, 1993.

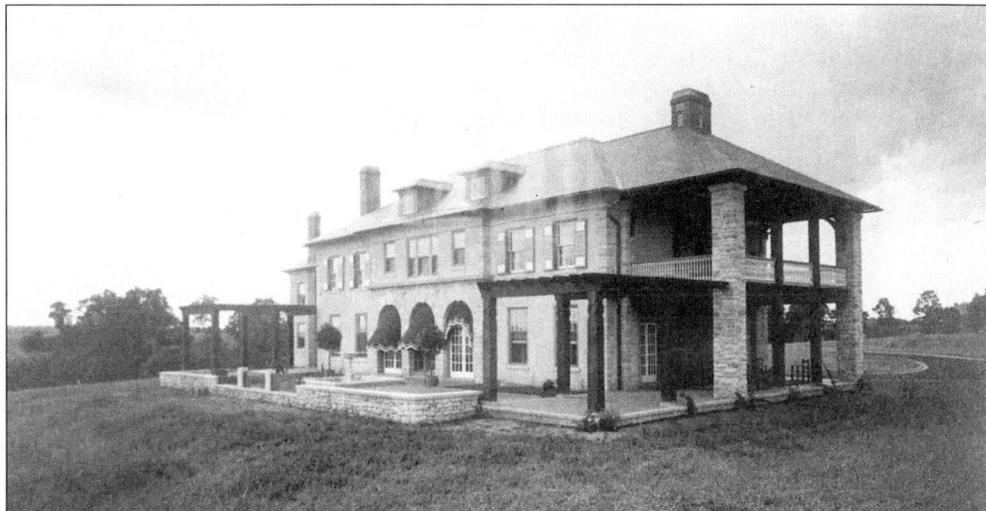

Holy Cow! That's one fine-looking place on the Riverdale landscape. And speaking of cows, that's what built this house—not just any cows, but Holsteins. They produced the very best milk. Could there be anything more delicious than a cold glass of milk? Maybe a fresh, thick shake. And Iowana Farms made them the freshest and the thickest, according to Col. G. Watson French. Although he might be just a tad partial, since he owned the Iowana Farms and this beautiful home.

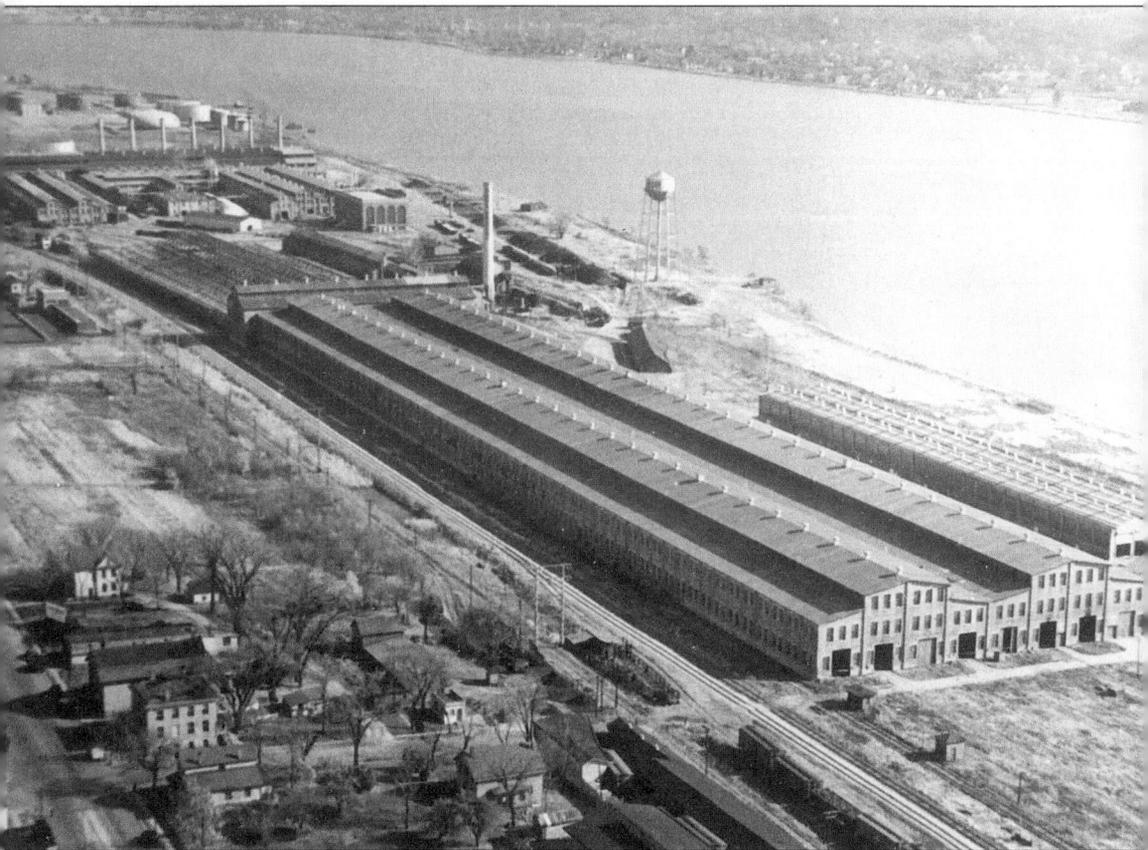

The sleek, sensible design of the J.I. Case Company (the former Bettendorf Company) offered a handsome, industrial view alongside the rolling Mississippi River. The sprawling factory spread over 250 acres and was used for the manufacturing of farm equipment after Case bought the property from the government, which had converted the former railroad car factory into a tank arsenal during World War II. A fire that started in a paint room on May 23, 1952, caused $500,000 damage. Case recovered from that disaster, but the recession of the 1980s caused the plant to be shut down.

Like so many others, this Quad-Citian served with honor in World War II, donning a sailor's uniform to answer the call of Uncle Sam. No one could have guessed that after returning safely home he would go on to be in the spotlight of national sports. The man was Jack Fleck of Bettendorf, and with some fantastic tee shots and a strong long shot he captured first place in the 1955 U.S. Master's Tournament.

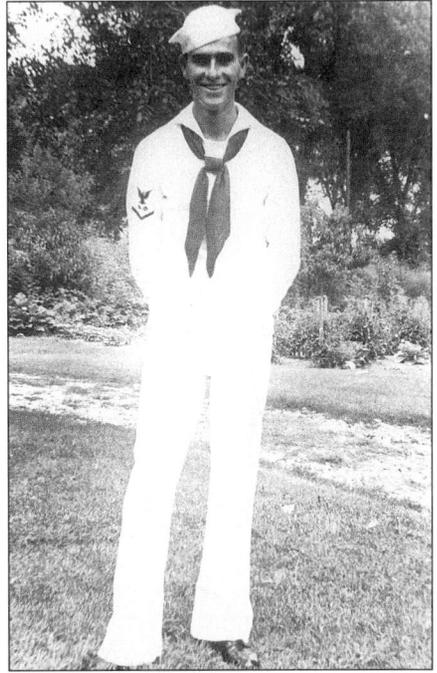

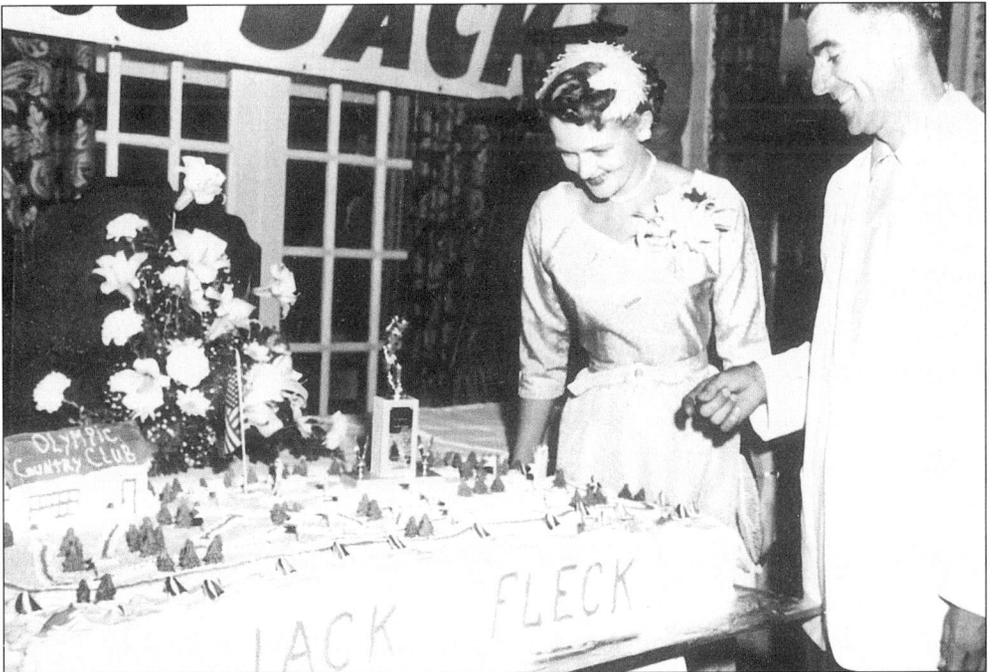

Bettendorf native Jack Fleck is 76 now, and the amiable, classy gentleman lives very much in the present. Still, memories of that 1955 U.S. Open golf tournament at the Olympic Club in San Francisco remain vivid. Fleck, a golf pro back then at a local club, won the tournament by three strokes in a play-off against legendary Ben Hogan. Fleck shot a 69 to Hogan's 72. Jack and his wife returned home to a gala parade and "calorie-free" cake celebrating the Quad-Cities' hometown sports hero.

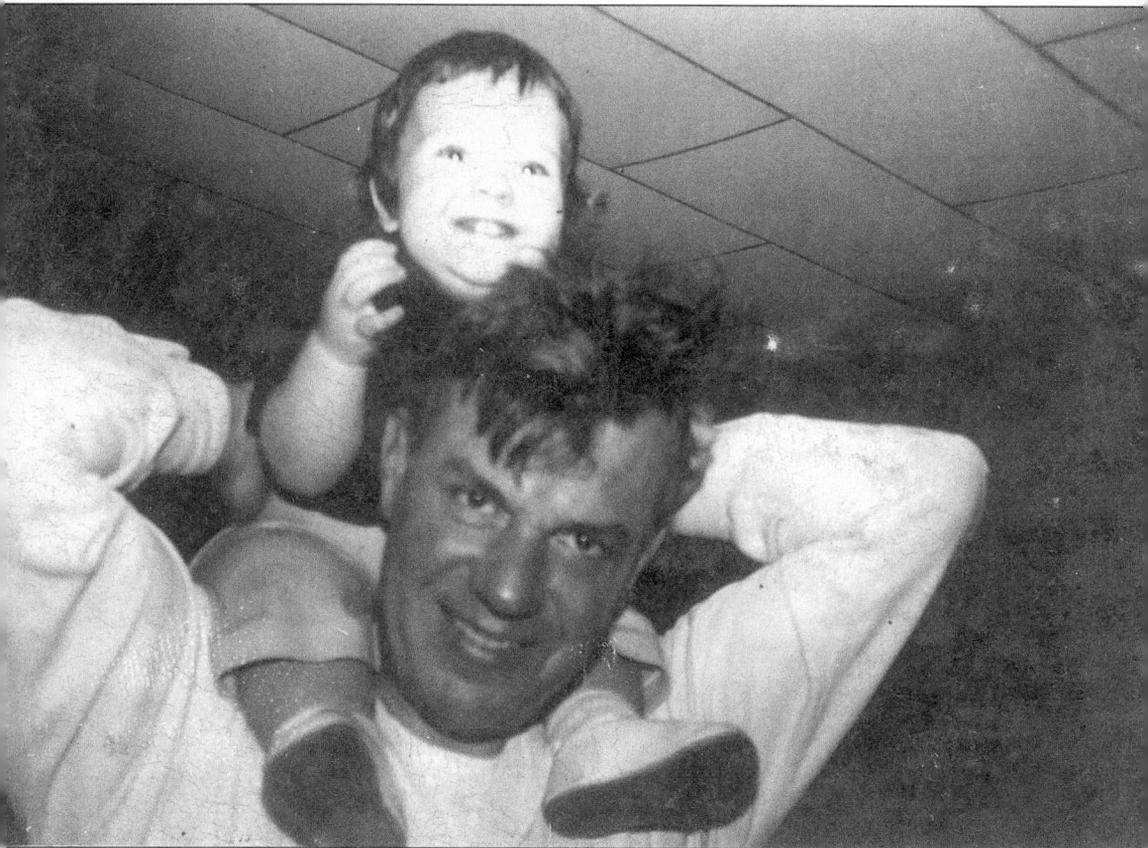

Let's play "What's My Line?" Remember that popular television game show of the 1950s? Panelists Dorothy Kilgallen, Arlene Francis, Steve Allen, and Bennett Cerf tried guessing the occupation of a guest, as moderator John Daly presided. Well, here's our guest: a smiling baby girl, celebrating her first birthday on her father's shoulders. Father and daughter "shared a passionate interest in government and politics." While Sloan generously gave his time and talents to the Bettendorf School Board and other civic organizations, his daughter grew up to become mayor. If you guessed Ann Hutchinson, pat yourself on the back.

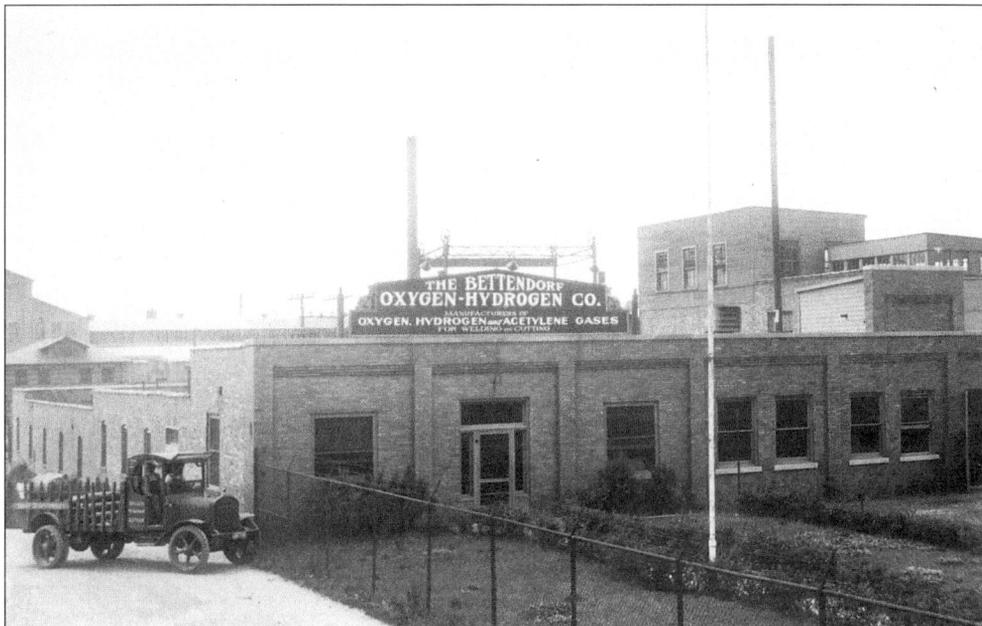

Folks working at the Bettendorf Oxygen-Hydrogen Company described their jobs succinctly: "It's a gas!" Ah, that still gets a laugh. The downtown business serviced a broad territory in the Midwest, providing oxygen, hydrogen, and acetylene gases used for welding and cutting operations. Safety precautions were closely adhered to, and few accidents were reported.

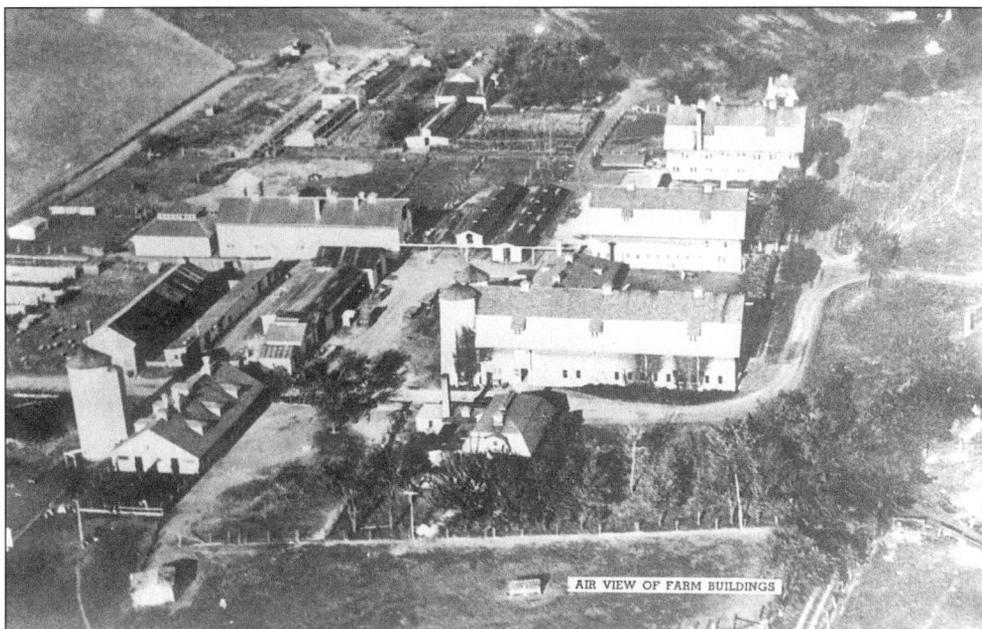

AIR VIEW OF FARM BUILDINGS

From a bird's-eye view, the Iowana Farms was a sprawling landscape of well-kept buildings, each unit an integral part of the milk and ice cream business. The farm sat majestically on a hillside overlooking Pleasant Valley. Col. G. Watson French had that look of a jolly old elf, complete with white whiskers and a twinkle in his eyes. His favorite flavor of ice cream? Vanilla, of course—*French* vanilla!

73

Look Ma, we're going to school! The year was 1958, and pre-school was a fairly new concept in the education arena. Young boys and girls seemed to take readily to the idea, getting a head start in the basics, such as learning their ABCs and counting numbers, and most important of all, learning to share and get along with others.

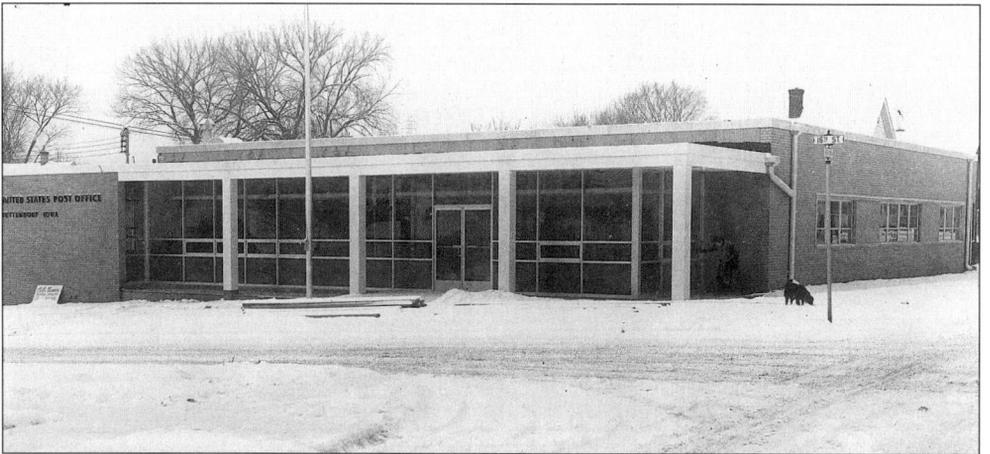

Bettendorf's Post Office relocated from Seventeenth and Grant to Sixteenth and Brown in January 1961. It cost $183,000 and tripled the work area, according to Postmaster George Helble. The move was made at a time when there was talk of increasing the cost of a postage stamp to 4¢! We may be paying 33¢ these days for first-class postage, but at least we don't have to lick the stamps. And today the old post office is a learning center for special education classes for students from Bettendorf, Pleasant Valley, and North School districts.

Most any other time, Franklin Street was a busy thoroughfare for vehicles and foot traffic. But in April 1965 it became Franklin "River," and paperboy William Farnum of Buffalo proved that the mail is not the only thing to get through rain, sleet, snow and, in this case, flood waters after the Mississippi overflowed its banks in what was then the Great Flood of record. That record would be broken nearly three decades later.

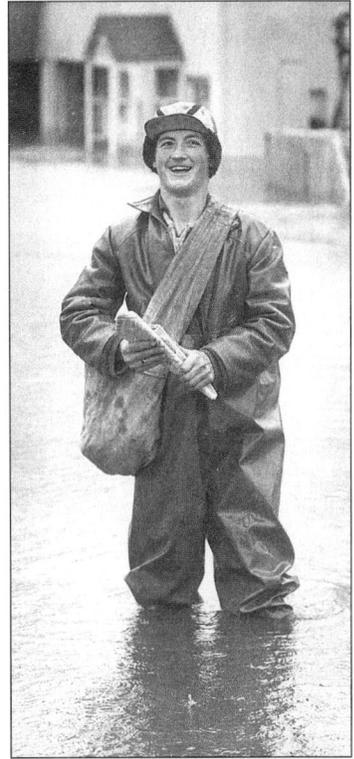

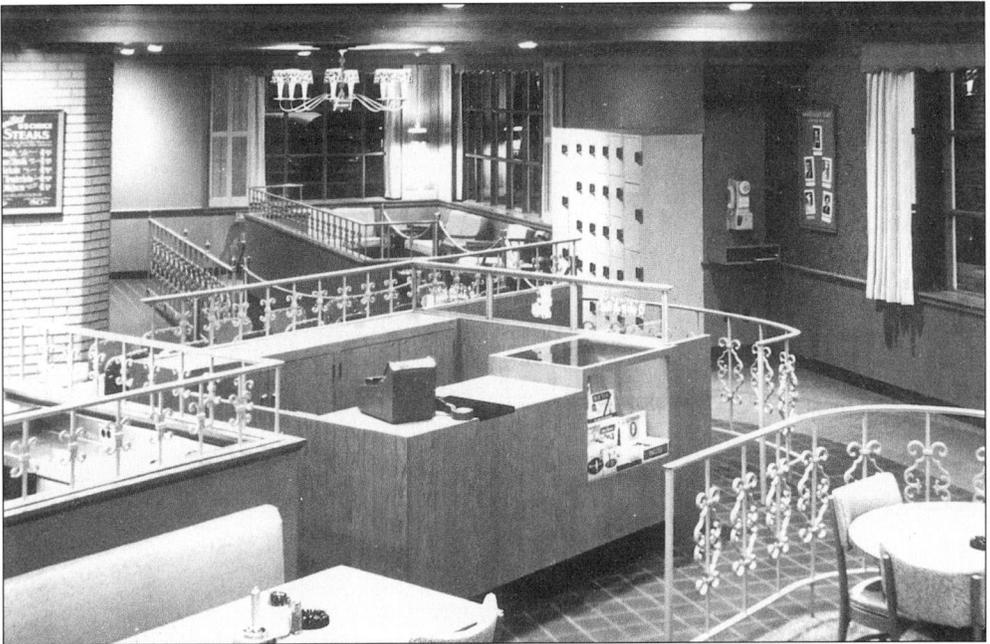

Since 1960, hungry folks have passed through the Bishop's Buffet line by the thousands, filling their trays and then their tummies. How many have resolved to skip dessert, only to give in to temptation? Bettendorf's Duck Creek Plaza is the only place left in Iowa to get that famously delicious Bishop's French Silk pie. It whispers to everyone passing through the line, "Take me."

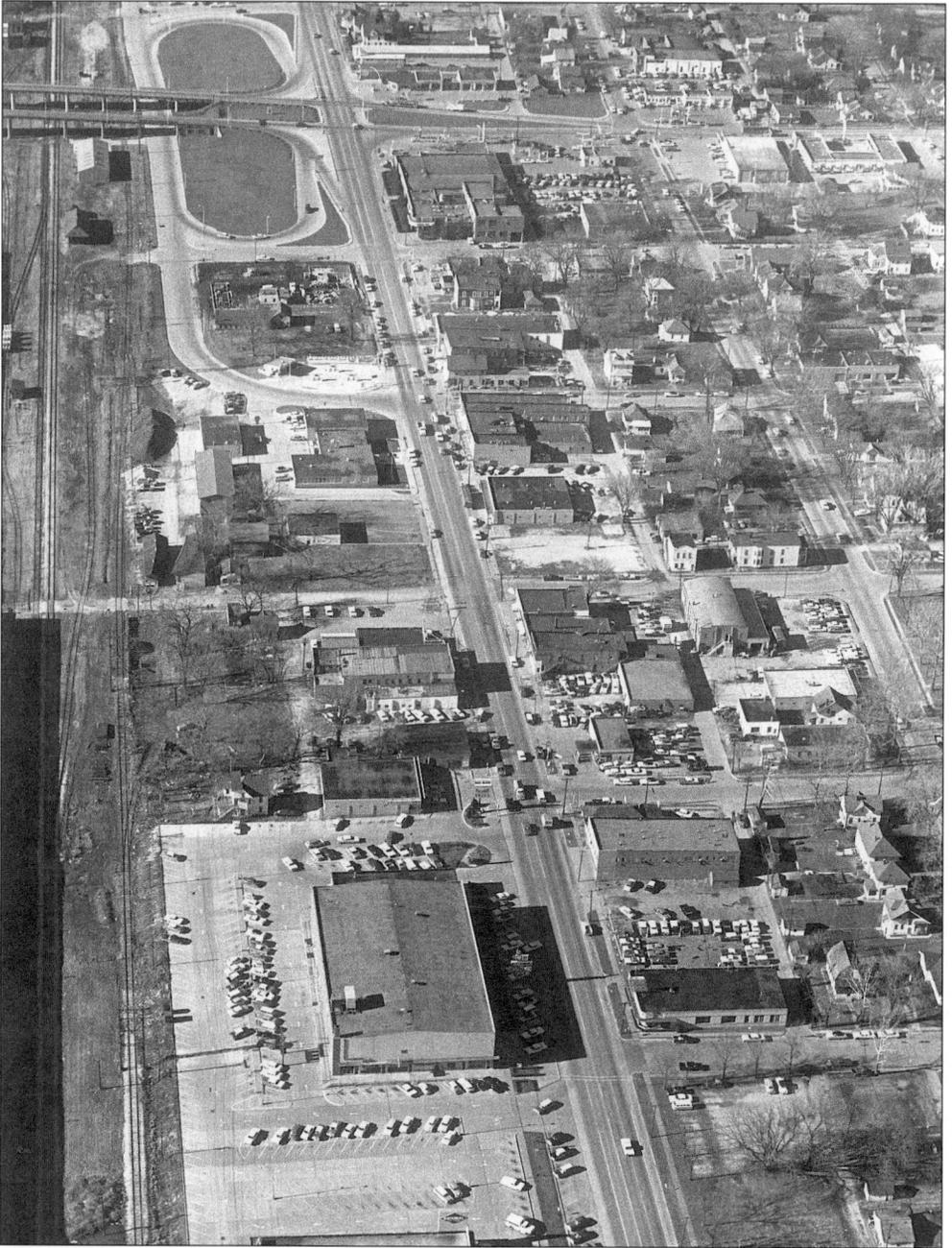

Take a close look, and if you've been around a few years this aerial view of downtown Bettendorf may spark some memories. It was shot in December of 1961, and what may be most noticeable is the relative lack of traffic and street signs along State Street. The years since have brought dramatic changes to the city and, beyond nostalgia, there's something to be said for the zest and vitality of today's Bettendorf.

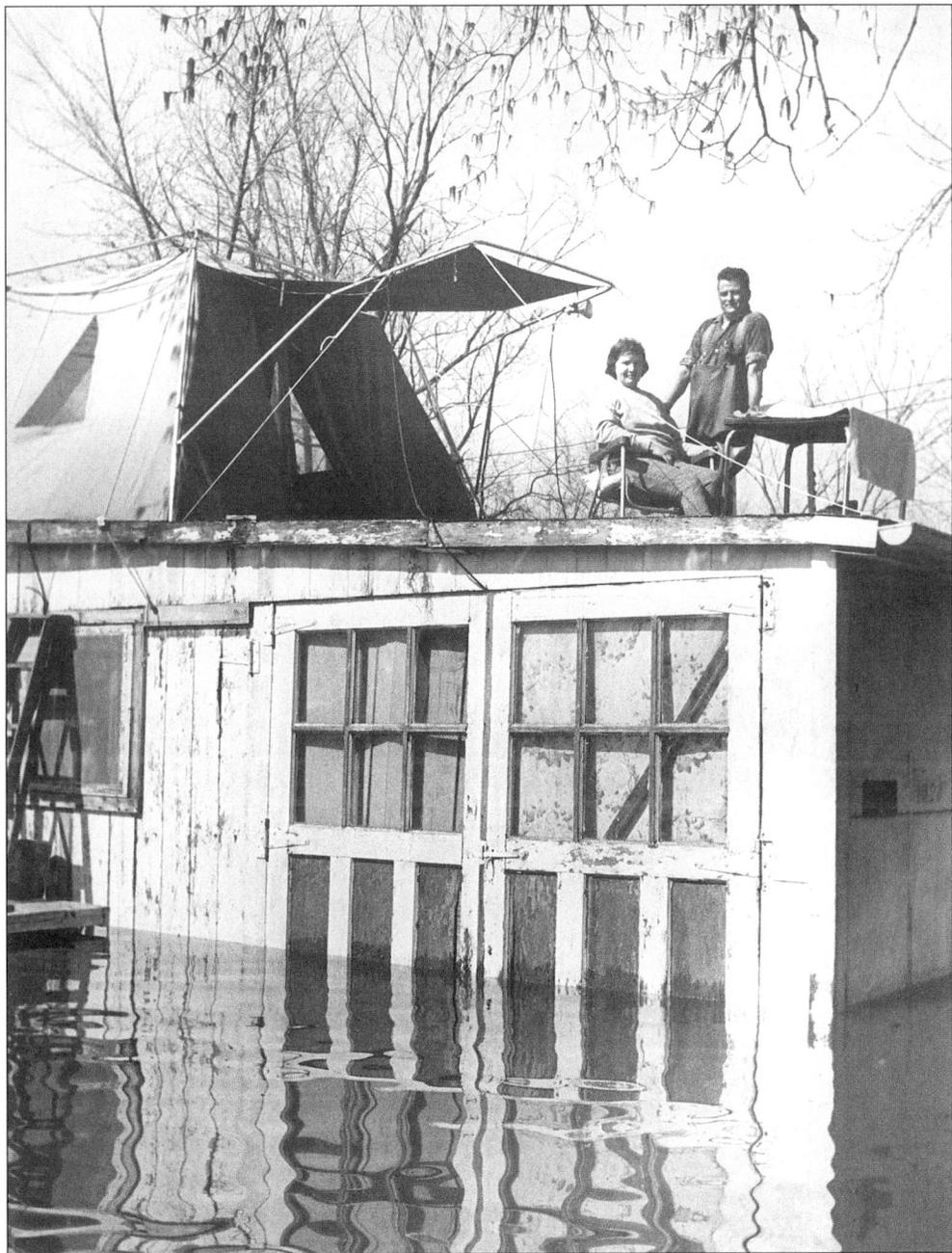

There are those who enjoy a riverfront view, but Mr. and Mrs. Isaac Fields weren't expecting Old Man River to get this close to home. Ah, but that's the way it is when living on a river plain. Another area resident, Jean Beichet, recalled wearing her boots day after day, waiting for the Mighty Mississippi to return to its banks after the Flood of '65.

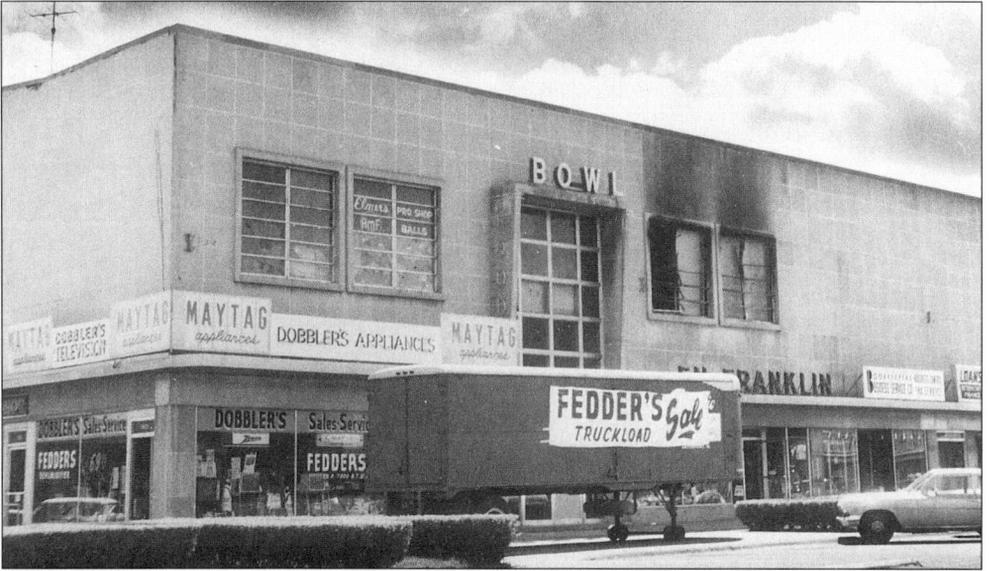

They said the grand and glorious Titanic wouldn't sink, but its maiden voyage in 1912 ended after it struck an iceberg. Folks believed it to be so when Mr. and Mrs. Joseph Bettendorf said they were building the city's first fireproof structure. But in 1962, smoke and flames engulfed the Plaza Building, destroying all but its gutted shell. Everything inside was lost, including the ground-floor bowling alley, where no longer would be heard the yells of "Strike!" and "Spare!" At least for now the Plaza stands, but the lesson here is that nothing man-made can claim immortality.

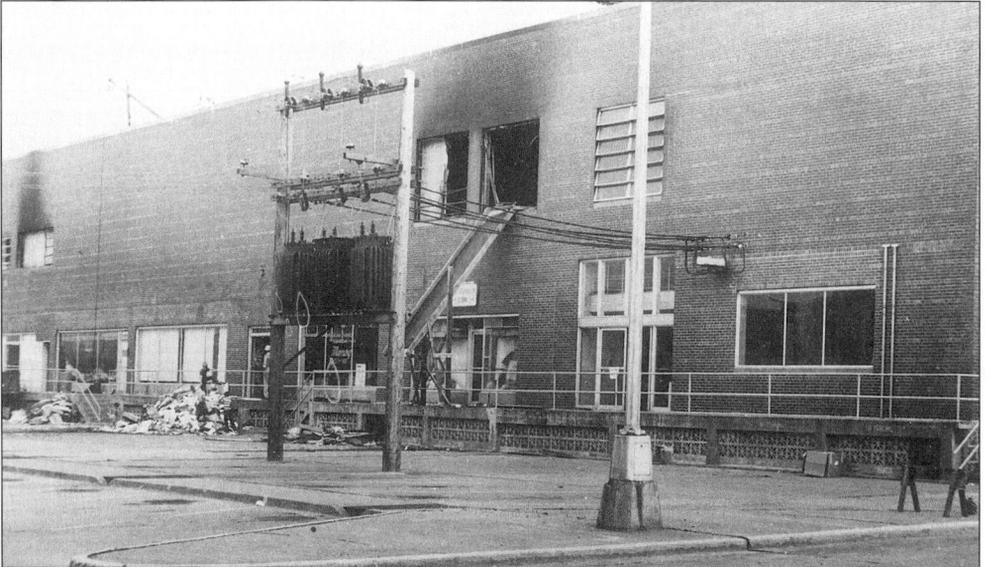

The year was 1962. President John Kennedy was dealing with the Cuban missile crisis, and astronaut John Glenn orbited the earth three times. The favorites on television were "Ben Casey" and "Dr. Kildare," while in the sports arena the "winningest" jockey, Eddie Arcaro, retired from horse racing, and the Plaza Bowling Lanes in Bettendorf was retired after a fire destroyed the alleys and everything else inside the building. "We could see the smoke from here," said Milan, Illinois, resident Alice Taylor.

78

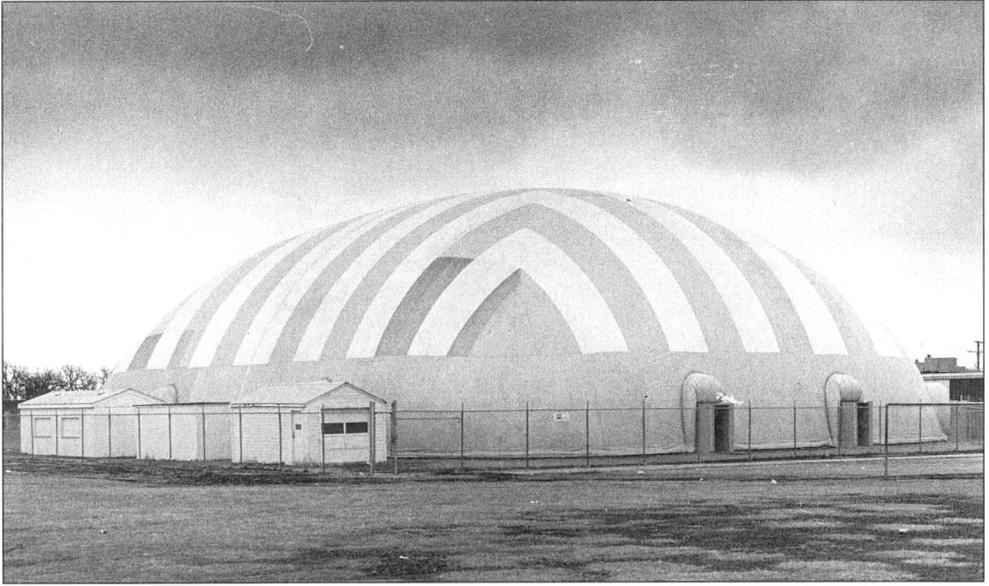

An alien spaceship in the center of the city? Maybe the circus left town without taking one of the big tents? Nope, this was a familiar landmark to Bettendorf school children in the late 1960s and early '70s. Unusual in its design but quite utilitarian, the temporary gymnasium at Bettendorf's Middle School was remembered by athletes and coaches alike as being hot in the summer and cold in the winter. But at least it kept students and equipment dry.

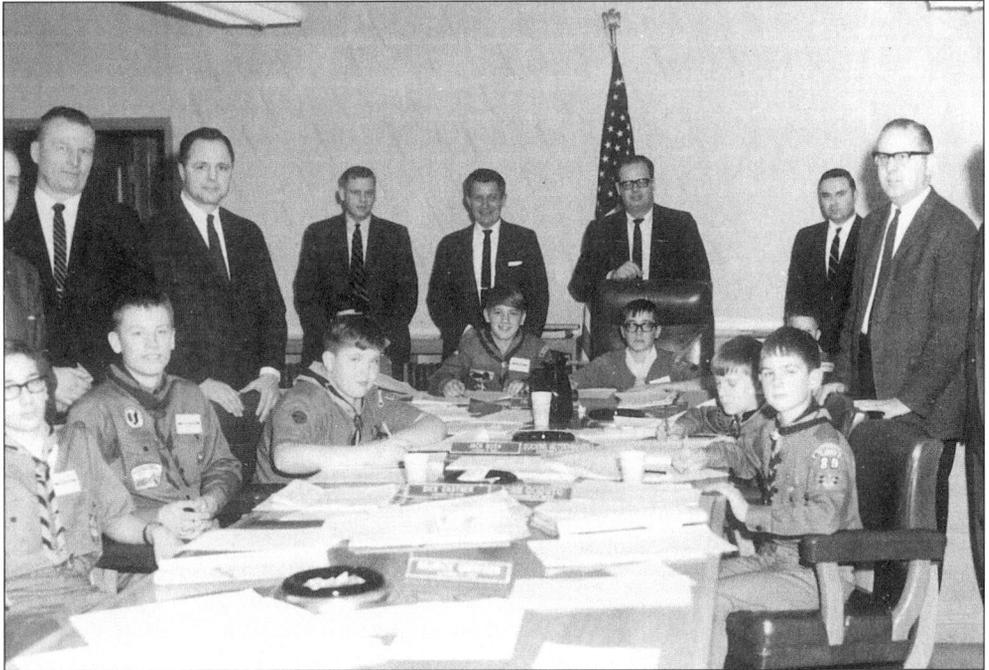

Out with the old and in with the new. Well, at least for one night, as these Boy Scouts learn about government at a Bettendorf City Council meeting in February 1969. No, the scouts did not declare the next day a special holiday for kids to get out of school, but they might have at least tried to get it on the agenda.

"Happy Birthday to you, happy birthday to you, happy birthday, dear Bettendorf, happy birthday to you." And then Bettendorf Police Chief Steve Tometich, Fire Chief Art Voelliger, and Mayor Dana Kucharo prepared to cut the cake in honor of the city's 70th birthday celebration in 1973. What, no candles? Fire Chief Art is sure a stickler for safety!

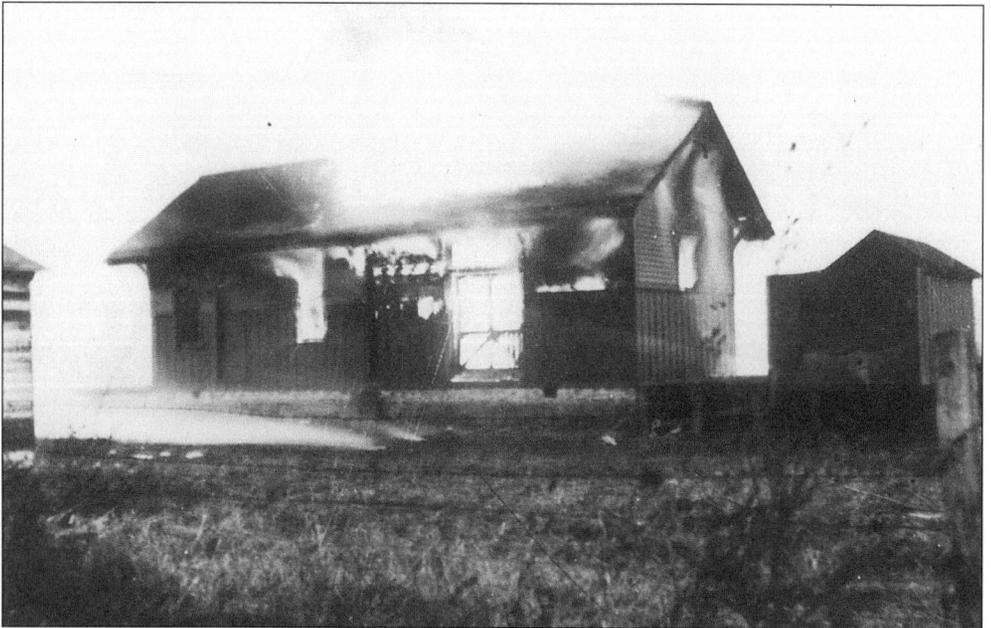

Fire is a constant threat to farmers, especially during long dry spells, which have been known to come to the Upper Mississippi Valley. Fortunately, the burning of this building—the old Pleasant Valley train depot—was a practice exercise for the P.V. firefighters. Back when the trains still arrived at this depot, it was a hectic scene at harvest time, when millions of onions were shipped off to markets throughout the country and the world.

Erected near Bettendorf Bank and Trust's suburb branch, this three-element modern sculpture by architect Art Kuehn evokes an intertwining of human endeavor and nature's resources. The arm-linked family represents the citizens of Bettendorf, the twin bridges represent the joining of communities on both sides of the Mississippi, and the eagle is America's symbol of strength and endurance. The 225-pound copper sculpture was presented to the city by Bettendorf Bank and Trust in 1972.

Bettendorf boasts a long history of eager readers and places for them to read. Old-timers may recall a time when books were rented from the Davenport Public Library and housed in the old city hall. When traffic increased, the library moved briefly to Washington School and then to the Danish Brotherhood Hall. A new library opened on Grant Street in 1960. The present facility was dedicated in 1976. Extensive remodeling took place (what better building to add another story to than a library?) and the gala dedication took place in May of 1997.

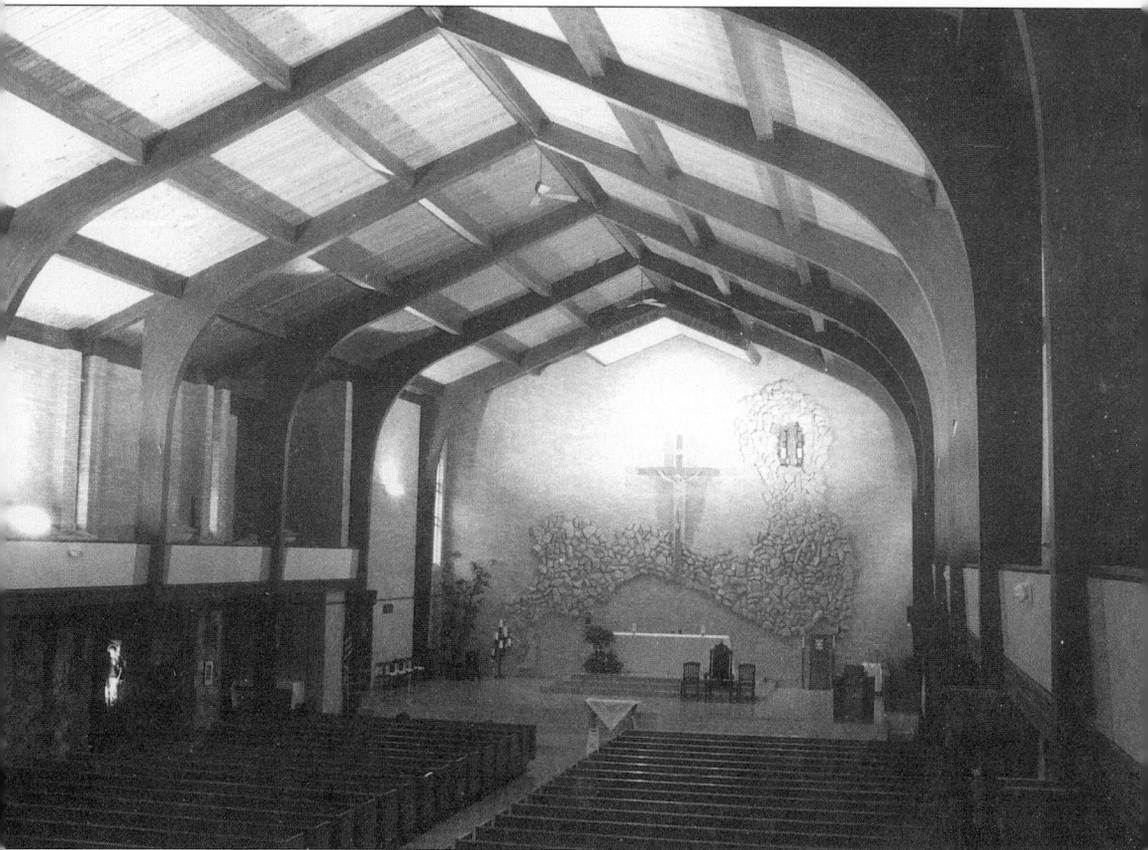

"Majestic!" "A beautiful place to worship." "The loveliest place in the city." Descriptions vary concerning Our Lady of Lourdes Catholic Church, but parishioners share a positive opinion of the nearly four-decade-old complex on Brown Street. The original church, built in 1904, lays claim to being Bettendorf's oldest church. It was located on Fifteenth Street, directly below the home of Elias Gilbert, who mapped out the town. Lourdes moved across the street in 1925, and the present complex was constructed in 1963.

The late '60s was a time of rebellion and civil unrest across the country, and Bettendorf was not isolated from it. As in cities and small towns across the nation, residents here were showered with newsletters and pamphlets protesting American involvement in the war in Vietnam. Bettendorf native Agnes Nelson said, "Someone handed me a handbill in the parking lot when I went to the drugstore and when I got home, I found the same sheet inside my front screen door."

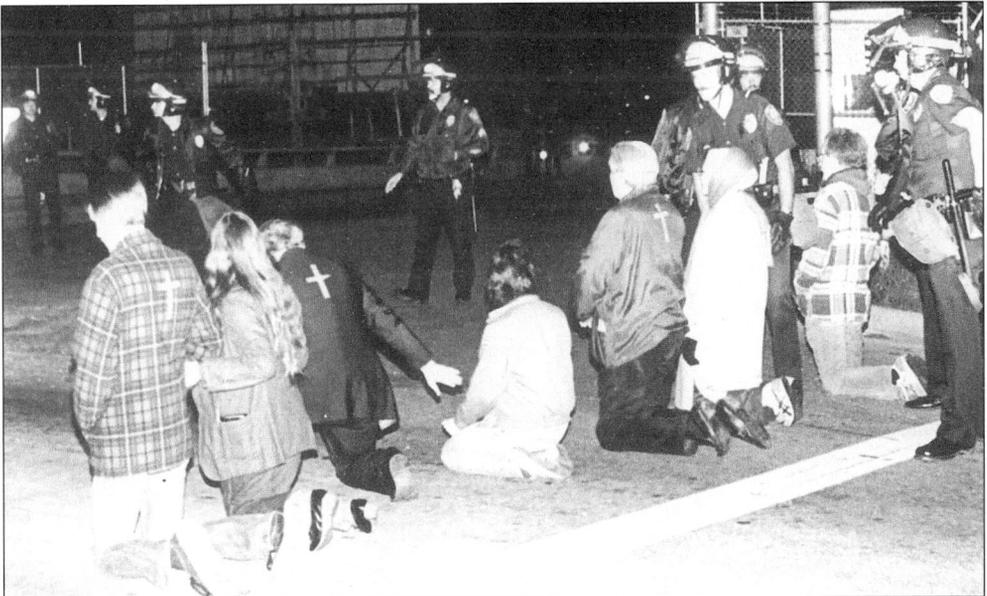

Rock Island Arsenal proved to be a magnet for anti-war demonstrations, beginning with the Vietnam War. Most were peaceful gatherings for prayer vigils. Other times protesters lined roads that led onto the island, holding up signs declaring opposition to the manufacturing of military arms and ammunition. Occasionally, protesters were arrested and police recorded names of Bettendorf residents along with Quad-Citians from both sides of the river, and from distant communities as well.

Bettendorf is enriched by its diversity, and the city's annual folk festival showcased many ethnic influences, as with these lovely Asian dancers demonstrating not only how to hold a fan, but

also how to hold the fans, as in spellbound audiences. Whether watching Belgian lacemaking or chomping into a spicy Mexican taco, the festival is a feast of delights for the senses and the soul.

Bettendorf formed its own "united nations" with an annual folk festival, attracting visitors from across the Midwest. Those attending enjoyed a little cultural exchange, getting a taste of various ethnic foods and customs. "It isn't often you get to sample a delicious German bratwurst while watching Mexican folk dancers all in one sitting," observed University of Iowa student Joey Schauenberg.

Hungry for taco pizza? It's a Happy Joe's original. Happy Joe's has been serving up pizza and fun since 1976. The corporate offices are located on Bettendorf's Happy Joe Drive, and at their restaurants throughout the region you can enjoy a sit-down meal, or you can have your pizza delivered—even to a cemetery, or so goes the story from one Happy Joe's driver. Fortunately, he was making the delivery to living, breathing customers at the Fenno Cemetery, and in the bright light of day.

The Manor offers upscale condominium living for those who'd rather have someone else take care of the yard work. Built in the early '60s by Joseph and Vesta Slaven, the complex features 104 luxury apartments. Current residents are a broad mix of young and not-so-young Bettendorfers. Resident Jean Boitscha says The Manor is not only grand, but a truly comfortable place to live.

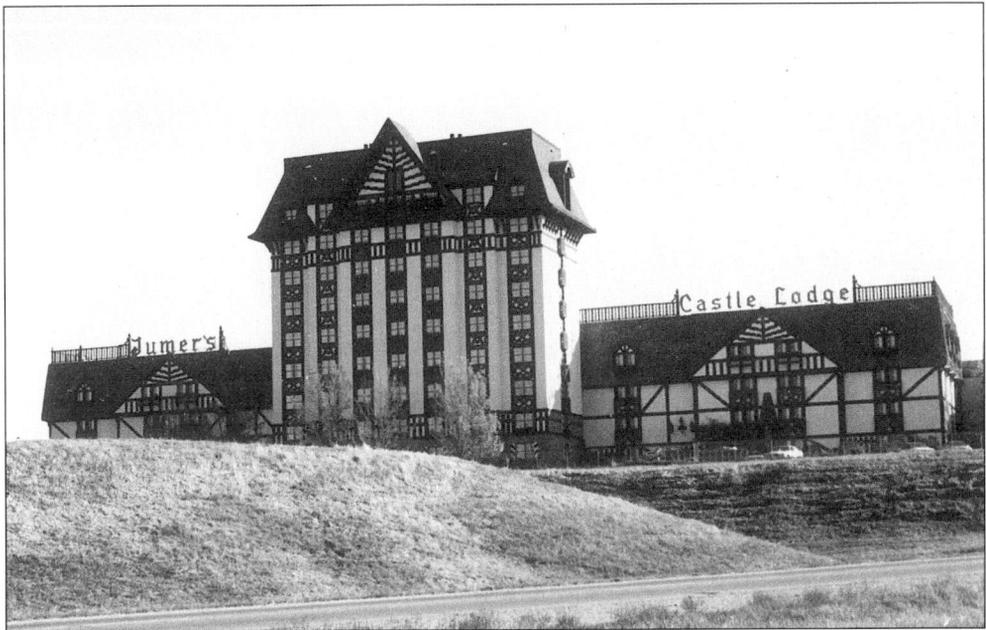

Yonder lies the castle of the king. Anyone would feel like royalty with the accommodations provided at Jumer's Castle Lodge. The hotel, just off Interstate 74 at Spruce Hills Drive and Utica Ridge Road, has been welcoming travelers since 1973. An imposing nine-story tower was added in 1978. Those first Germans who settled Lillienthal would have enjoyed the bratwurst, fresh pastries, and other German specialties served up at Jumer's restaurant.

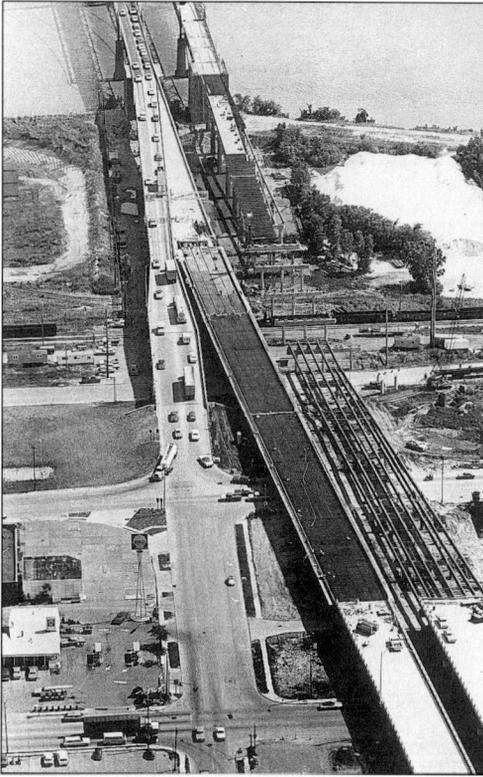

This aerial view, snapped by Superman as he inspected the Bettendorf exit of the Iowa-Illinois Memorial Bridge in June 1974, shows work progressing nicely. Note the surrounding area as it looked then. Makes you realize how much the landscape can change in a quarter of a century. Up, up, and away!

By the late 1970s, Bettendorf High School was feeling the pinch of overcrowding, such as in Tom Sullivan's drafting classroom shown here. A long tradition of civic pride in its public school system brought out the support at the polls for a bond referendum that would increase property taxes in order to secure the necessary funding for building expansion. When the taxpayers said "yes," the young "Bulldogs" barked loudly in appreciation.

Four

PROGRESS

*And where do we go from here? Do we keep the promise for this
generation and the generations to come or do we abandon the journey,
let the fields go fallow? The trains have come and gone, the factories are
turned to rubble and on the foundation of our forebears, we build again.
This time, turning back to the river and remembering that it was there
when we began. It may rise up and reclaim us all, some day. But for now
it is our strength, our nurturer. We are not alone. As long as there
is a bridge to cross, a road to follow, a new path to forge, another dawn,
another dusk, one more dream to be dreamed, we go on. We go on.*

Need to talk to the mayor? Go to 1609 State Street. Got a question about fire department
services? Go to 1609 State Street. Need police help? Yup, 1609 State Street. Many of
Bettendorf's public services are housed in this attractive (but crowded) building. Plans are in
the works for adding space onto the east and west sides and for building a second floor. The
work should be completed by 2001. In the summertime, flower gardens outside the main
entrance give folks something to enjoy as they hurry in and out with their official business.

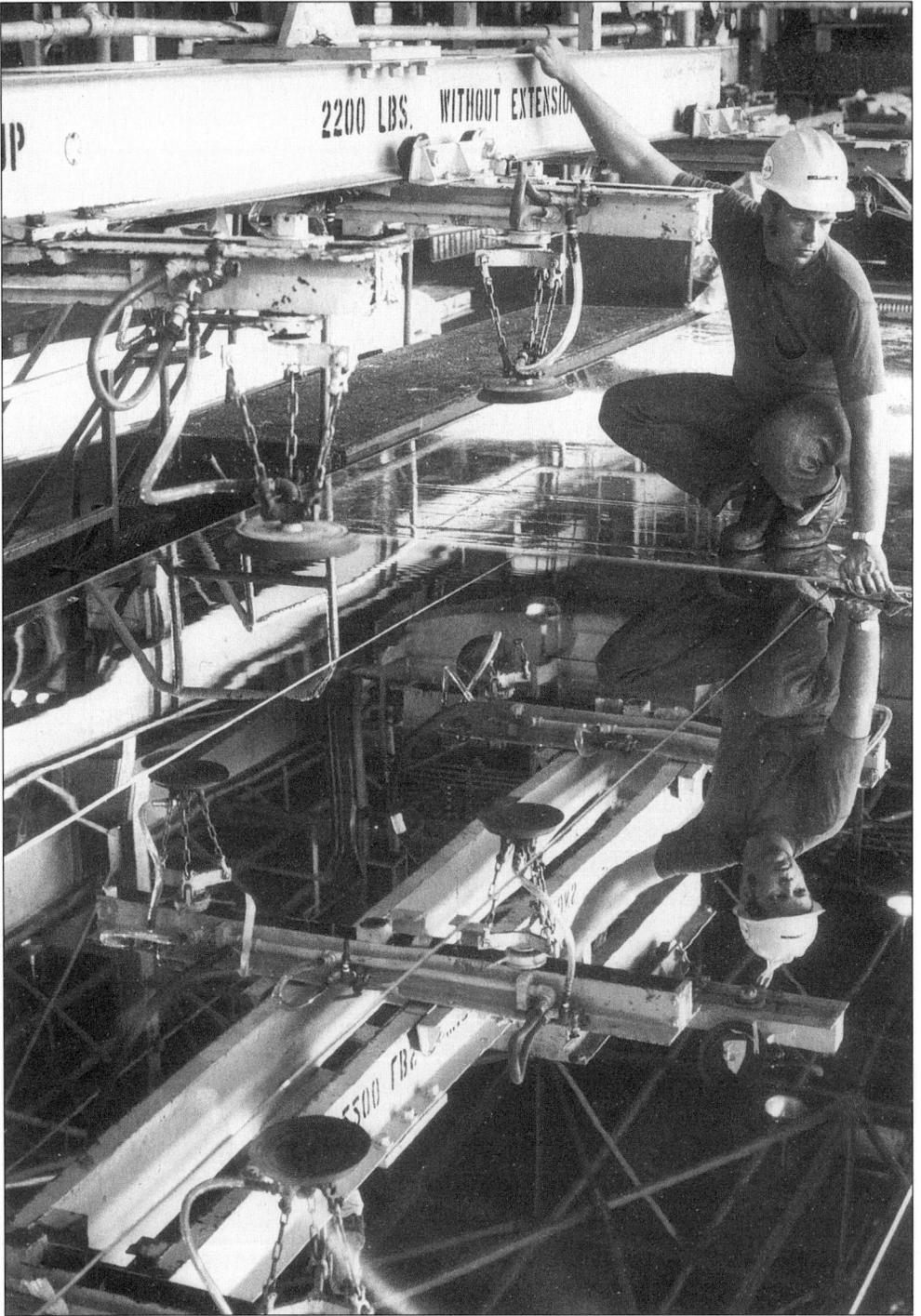

"Art through the polished aluminum skin sheet"—it doesn't have the catchiness of "Alice Through the Looking Glass." Yet, a perfect reflection is worthy of note. The site is Alcoa, 1979, and the poised fellow is Art Schaeffer, a general mechanic apprentice who helps make the aluminum sheeting used for commercial airliners.

Growing . . . growing . . . ever growing. . . . How big she'll get, there's no way of knowing. Bettendorf's population was forecasted by Mayor William Glynn to reach 50,000 by the year 1995. He made that prediction in 1976, at the time of the nation's Bicentennial Celebration. Bettendorf has yet to realize Glynn's expectation. But with subdivisions like Deerbrook, shown here, Bettendorf seems to be constantly adding new homes and businesses, and is likely to hit that mark and beyond in the new millennium.

The Bettendorf Community Center appears quiet from the outside. However, within its walls on any day there could be raging a fist-pounding euchre match, a spirited square dance, heated debates on issues of the day, gymnastics classes, or a rousing game of basketball or volleyball. The community center, built with the financial backing of the taxpayers, also houses the Park Board headquarters and the Community Food Pantry, coordinated by Wendell Hill and many dedicated volunteers.

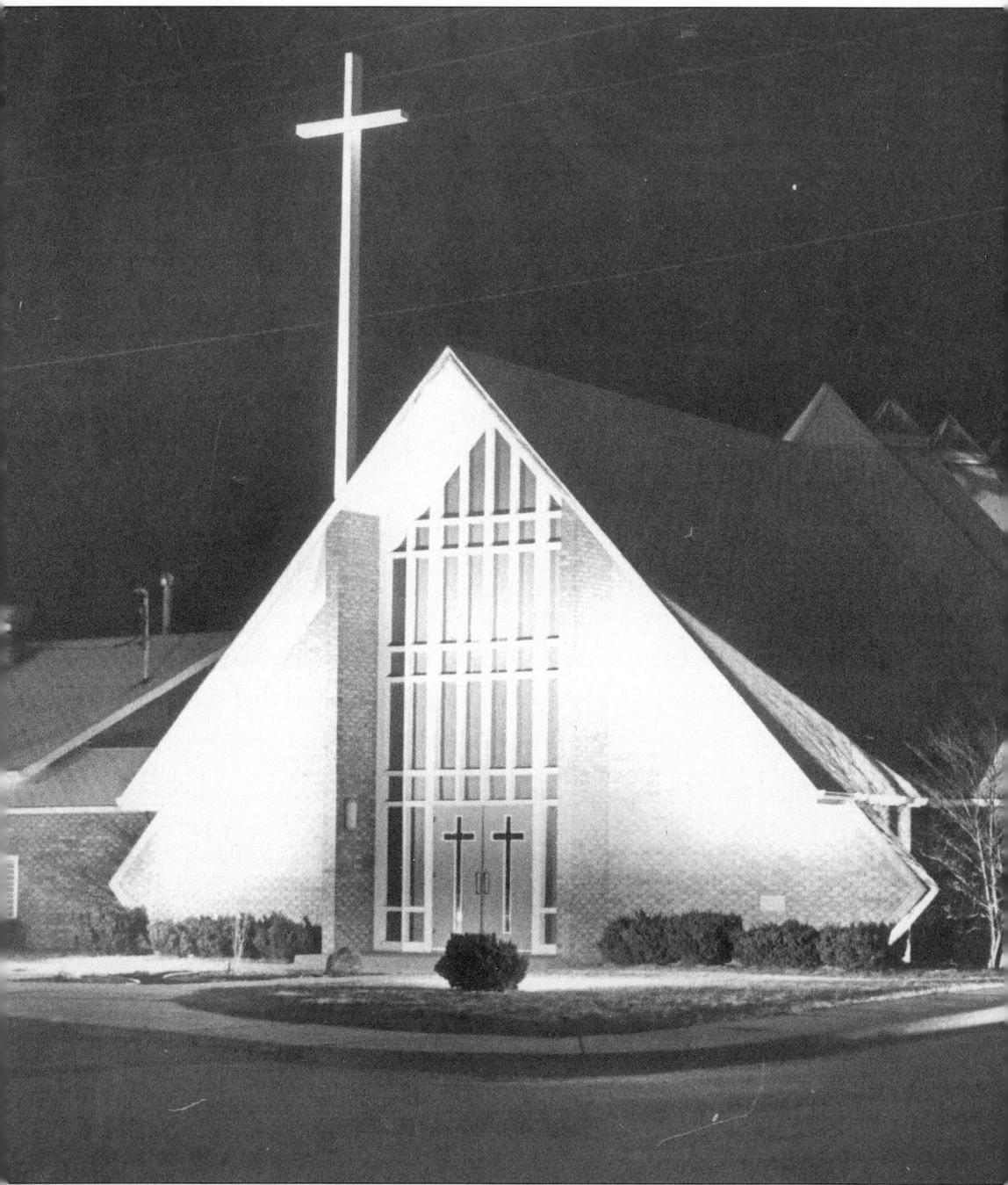

"Oh, holy night, the stars are brightly shining. . . ." It doesn't have to be Christmas for the sight of a lovely church to brighten up the night. The sleek and stylized lines of Bettendorf's Presbyterian Church are accented by dramatic lighting, which lends warmth to a cold winter

night. The original Presbyterian Church at Twelfth and Grant was the second oldest church and first Protestant congregation, organized in 1913. The first, Our Lady of Lourdes, was founded nine years earlier.

There's a bit of country in the heart of Bettendorf at this horse farm on Tanglefoot Lane near Twenty-ninth Street, holding steadfastly against the rush of civilization. Ever wonder how a place gets its name? In the case of Tanglefoot Lane, the story goes that a favorite watering hole out that way used to stay open late into the night, and this was the path customers followed home at a time when there were no streetlights, or even streets for that matter.

Outside the Lincoln Center, youngsters challenged their bodies, climbing and swinging and sliding. But once inside the building, the focus was on strengthening brain muscle. Whether it was a galaxy display to spark the imagination of future space travelers, or a poetry workshop for budding authors, the focus was hands-on learning. The new Family Museum offers greater variety and more space, but memories linger at Lincoln Park, a pocket playground built on the site of the former Lincoln Center, which was torn down in 1997.

Bettendorf, business, and Bush—three words that mesh with remarkable cohesion and success. Talk business in Bettendorf and the name Jack Bush (a.k.a. John L. Bush) is bound to come up. CEO of McCarthy Improvement Co. and president of Linwood Mining and Minerals Corp., Jack's entrepreneurial expertise in highway construction, engineering, mining, land development, etcetera brought him acclaim and earned him a place among 1999's Quad-City Junior Achievement Hall of Fame.

There was a time when librarians were "bookkeepers," but nowadays it's not just books being loaned out. Sculptures and paintings are available too. And in the age of information, demands for public libraries range from internet access, to a world-wide network of information, to space for organizations to meet, and for individuals with special interests to find fellowship among their peers. The Bettendorf Public Library fills those needs and more. Overseeing the staff and services is Library Director Faye Clow.

There's no better place to read a good book than at Bettendorf's Library, why just take a look! Bridget and Natalie Cruthirds have taken a place, a purrrty nice space, near a cat's smiling face. That's one of the Dr.'s creations for sure, *The Cat in the Hat,* you can tell by the fur. Woodcarved by Gary Patterson of Trenton, Missouri, it's just one of the library's grand treasures aplenty. So many grand tales Dr. Seuss did turn loose!

Bettendorf boasts a full schedule of cultural events throughout the year, recognizing the diverse interests of its residents. But Bettendorfers like Fred and Kathy Dodds don't merely wait around for culture to be brought to them. They put on their traveling shoes and head to neighboring Davenport's LeClaire Park to enjoy artwork displays at the Riverssance festival.

Summertime for many Bettendorf residents means the delightful sounds of music originating from the Bill Bowe Memorial Bandshell in Middle Park. Conductor Jim Crowder, the music man right here in River City, strikes up the Bettendorf Park Band for another concert under the stars.

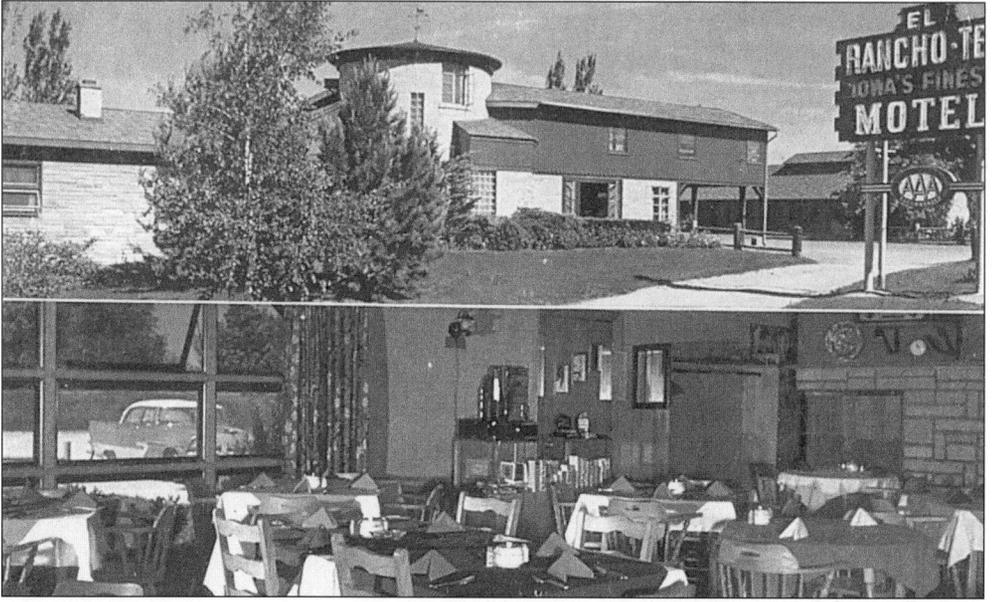

An early picture postcard of Bettendorf's El Rancho Tel and El Rancho Villa Restaurant beckons with its western motif, indeed one of the first motels catering to travelers heading west of the Mississippi on Interstate 74. Located across from Duck Creek Golf Course, the motel offered television in each of the 68 rooms, an outdoor pool, air-conditioning, and a recreation area. In 1995, El Rancho became an Econo Lodge.

Debts should be repaid. That's the firm conviction of Bettendorf resident Rick Champ, who joined the city's police department chaplain program because of the support the community has given him. Rick is a member of Bettendorf Christian Church. "If I can make a positive contribution," said Rick, "that's all the thanks I need."

Few area restaurants can top the variety (and calories!) of Jumer's Castle Lodge. Bettendorf's Rhonda Glass samples the food at Jumer's booth during a Quad-City food festival. Jumer's is always a favorite, and Rhonda barely makes a dent in the offerings. But there are always plenty more folks waiting and willing to try.

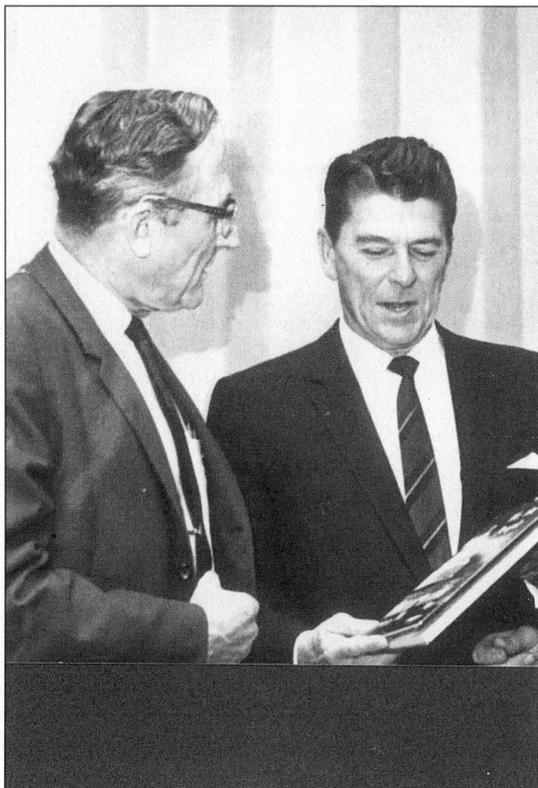

Could it be that Iowa is the subject of conversation between these notable politicians? U.S. Congressman Fred W. Schwengel of Bettendorf discusses a new book hot off the presses with fellow Republican Ronald Reagan, who grew up in Dixon, Illinois, and spent his early years as a radio announcer in Davenport and Des Moines. "I learned a lot when I was in Iowa," the president remarked later. "Of course, I had a lot to learn."

The Iowa Masonic Nursing Home and Retirement Village occupies land and a turn-of-the-century mansion that was originally built for William Bettendorf, who tragically died shortly before the home was finished in 1910. It was sold to the Grand Masonic Lodge of Iowa in 1927 and operated as a sanitarium until being expanded to a residential care facility for the elderly.

Call him an entrepreneur, a professional musician, a golf fanatic, or just one heck of a nice guy—Al Steinbrecher is all that and more. Al and his wife Betty opened their Bettendorf Office Products business in 1977, and since then it has grown to employ 15 people and added Evergreen Art Works, a supply store for the creative-minded. When he isn't running the store, Al plays baritone sax with the Bettendorf Park Board, the Kix Orchestra, as well as several smaller jazz groups. He also serves on the Catfish Jazz Society's board of directors. On the golf course, Al's under par . . . at least for a hole or two. But he's definitely above par when it comes to community spirit.

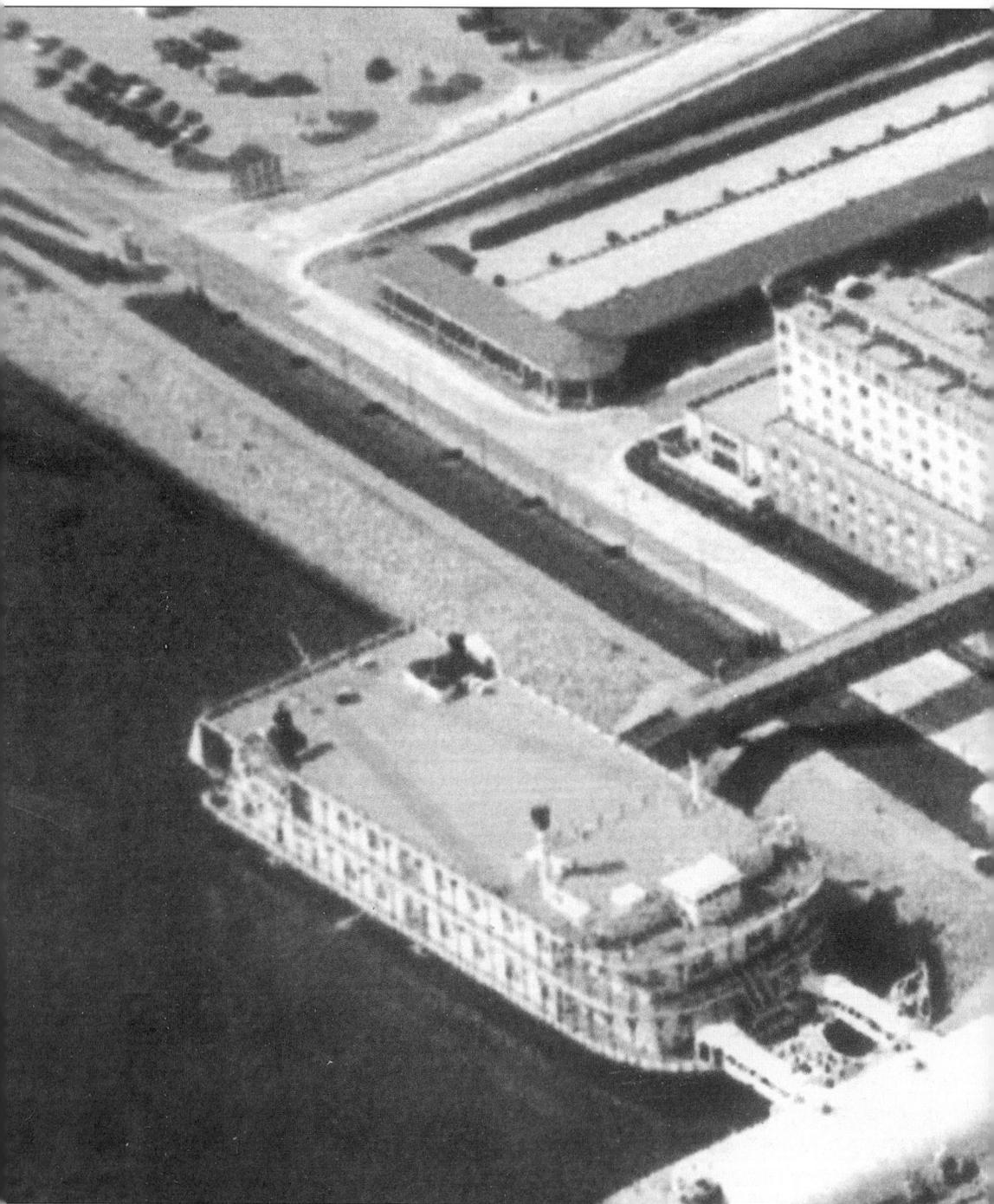

"Luck, be a lady tonight . . . Luck, be a lady tonight. . . ." More than lyrics from a "Guys and Dolls" song, *Lady Luck* represents fun and games on the Bettendorf shoreline of the Mississippi. The present casino holds up to 2,300 passengers and crew; it's 300 feet long and 100 feet wide, with two decks of gaming rooms. Roger Craig's Sports Bar, located on the second deck, is named in honor of the hometown hero and San Francisco 49ers champion running back.

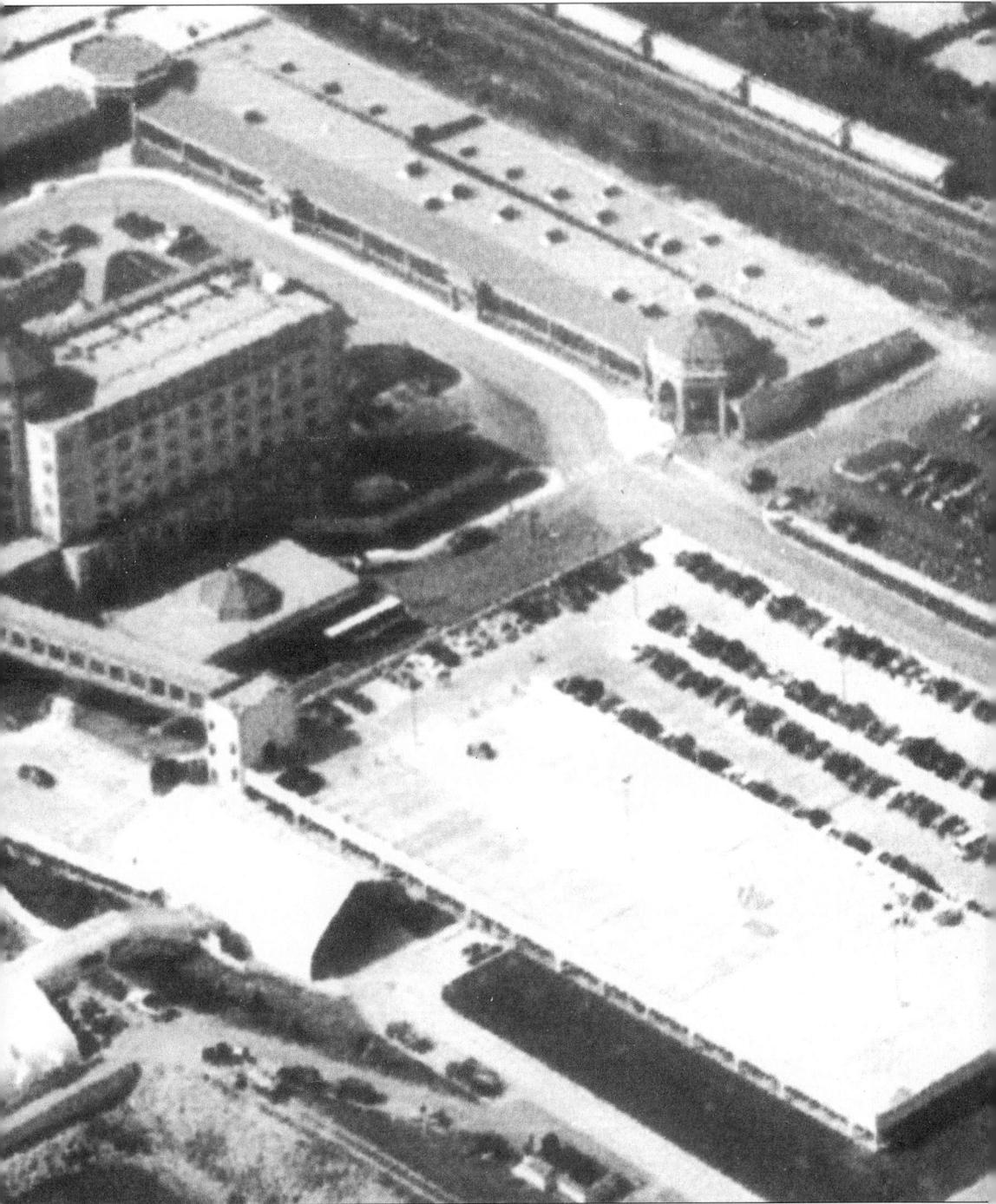

Sporting events can be viewed from more than 30 television screens throughout the bar. The *Lady Luck* is open seven days a week, 24 hours a day. The eight-story Lady Luck Hotel sits on shore, across the walkway to the casino. The hotel banquet room features an expanded buffet, while the 300-seat Showroom offers live entertainment on weekends.

Chowing down on sandwiches at the Waterfront Deli, the Miller family—Deborah, Martin, and their son Chris—enjoy living in Bettendorf because it has some of the finest eating establishments in the Quad-Cities. This is one of their favorites. Lots of folks agree, and the owners of Waterfront Deli show their appreciation with an annual Thanksgiving dinner for those who have no families with whom to share the holiday.

Mary Ruffcorn of Bettendorf's St. John Vianney Roman Catholic Church studies a Crop Walk poster, advertising the September 1993 event to raise awareness and funds to help the hungry. Sheila Fitts of Quad-Cities Churches United, pictured here in the center, was handing out kits to representatives from participating Quad-City congregations, including Ruth Longnecker of First Christian Church in East Moline.

Since first opening in Davenport in 1884, St. Katharine's School has offered the highest standards in educational curriculum. It began as an Episcopal parochial school for girls, with a separate boys' school, St. Mark's, being added later. The school moved to Bettendorf, occupying the former Joseph Bettendorf mansion on Sunset Drive, and is now a non-denominational private school, with an impressive college preparatory curriculum and classes for pre-school through twelfth grade.

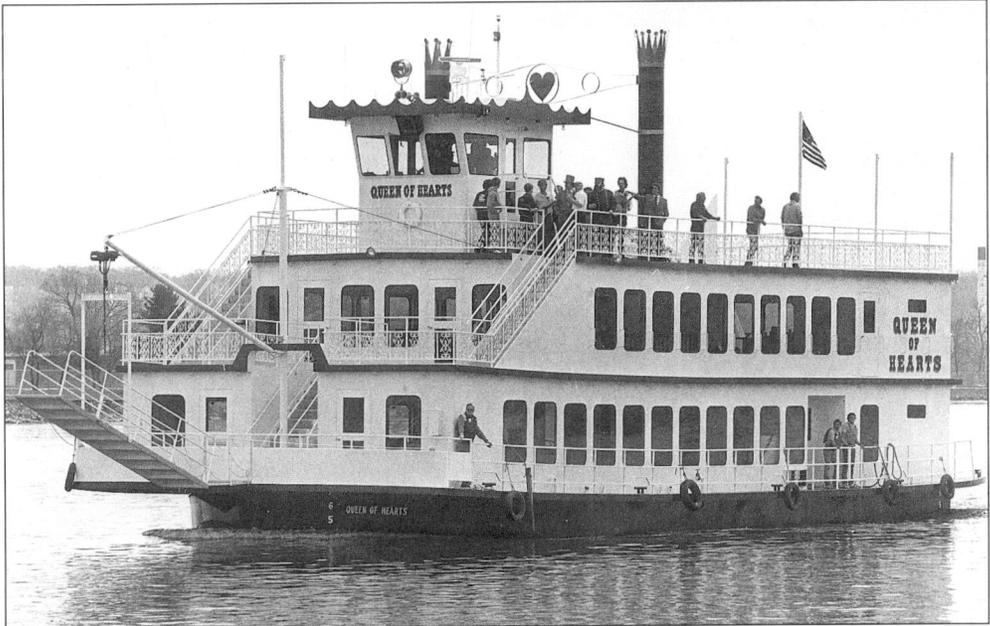

Few boats grace the Mississippi with such dignified elegance as the *Queen of Hearts*. It's one of the great things to see in the Quad-Cities, whether standing on the deck, enjoying an afternoon cruise, or watching from land as it churns the waters of the Mississippi. Alan and Donna Barnes took a honeymoon excursion on the boat. "It's where we met and where I proposed," said Alan. "The *Queen* had to be part of our wedding plans."

Bettendorf has long been known for its hospitality. Visitors to the city are often heard saying how genuine the warmth of the welcome is. This amiable spirit came alive when visitors from Russia shared in a picnic as part of the festivities during the Quad-Cities Peace March. People love to eat, whatever their nationality, and eat they did at this gala picnic in Bettendorf.

It was 1983, and what brought these visitors from the Soviet Union to Bettendorf's levee was the Quad-Cities Peace March. Clearly, smiles have no need for translation, and friendship is contagious. Major changes were in store for the Russian travelers when they returned home. We all cheered when President Ronald Reagan declared, "Mr. Gorbachev, tear down this wall," and the Cold War Era was finally coming to a close.

106

Bettendorf students and their teachers get plenty done in the classrooms, but there's also special opportunities for learning in the world beyond, as in the case of these Bettendorf school children, who took a jaunt across the Mississippi River to attend the Children's Literature Festival, an annual day-long event held at Wharton Field House in Moline, Illinois.

Bettendorf's population grows steadily each year. It grows like a family with each new member, as in the Childs household, when Mr. and Mrs. Gary Childs welcomed newly-adopted Erika in 1980. "It's simply a good place to live," observed current mayor Ann Hutchinson. "A clean and safe city which serves the needs of the families who live here."

"Go for it, Roger! Show 'em how the game is played!" The year was 1986, and Quad-Citians, as with football fans across the nation, thrilled to the gridiron exploits of Bettendorfer Roger Craig, running back for the San Francisco 49ers. Ernestine, Roger's mom, hosted a game party with Roger's sister Christine, her daughter Carsha, sister Brenda Lytle with her son Franklin, and brother Artez. Now that the three-time Superbowl champ has retired, he can often be seen hosting at the sports bar named in his honor on the Bettendorf levee.

Vern Berry's collection of family recipes was made into a book, *Roots and Recipes: Six Generations of Heartland Cookery*, and Vern became a best-selling author for Pelican Books at the age of 85. She moved to Bettendorf from Tipton after her husband's death in 1973 and found a new focus for her life among the Quad-City writing community, becoming a member of the Quad-City League of American Pen Women, where she met fellow Bettendorfer Connie Heckert, who collaborated with her on the publication of her book.

Not all of Bettendorf's interesting sights/sites are located in the downtown and commercial areas. Some special scenes are tucked away in residential neighborhoods, like this colorful mural located on Lincoln Road just off Eighteenth Street. The painting has undergone a few changes since it was first created in 1989, from all athletes to a wider representation of professions, cultures, genders, etc. "It brightens up the corner," notes one neighbor. "I can't stand it!" says another, proving once again that art is in the eye of the beholder.

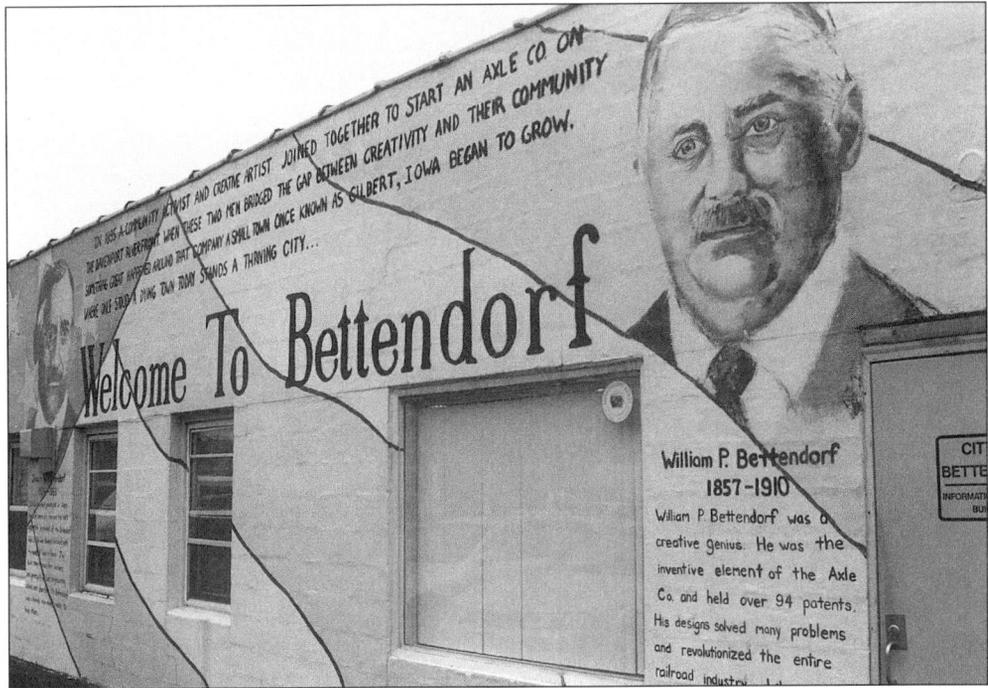

Bettendorf has many distinctive and personal features that set the city apart in a class of its own. The city, named in honor of brothers William (1857–1910) and Joseph (1864–1933) Bettendorf, is a daily bustle of activity at City Hall Annex, where the founders' portraits welcome city residents and visitors alike.

The *Quad City Queen*, shown here docked at Leach park in 1986, was one of Bettendorf's favorite attractions, until it pulled anchor to join the brigade of gambling boats. "She was a proud boat," observed a Bettendorf native who remembered her first incarnation as the *Mississippi Belle*, "and she seemed to have a personality all her own."

Helicopters dotted the Bettendorf skyline during the Duck Creek Flood in 1990. From high above, they tracked the progress of the rampaging waters and broadcast special update reports, keeping city officials, emergency-rescue crews, and the general public informed. "It was cool to see the helicopters close up," said seven-year-old Rick Carlson. "But the mess in our basement was not cool at all."

No, it can't be! Bettendorf folks along Duck Creek got the shock of their lives when the usually peaceful waterway spilled its banks and turned backyards, front yards, and whole neighborhoods into swimming pools. That long, anxious summer of 1990 seemed to never end, but those who survived the ordeal agreed that the flood and its aftermath bonded neighbors together as they'd never been before.

Condominium and apartment complexes have sprouted up where the corn used to grow, blossoming in abundance in the last few decades, with more folks preferring to have someone else shovel the walks, mow the lawn, and handle all those annoying home repairs. The Chateau Knoll complex at Bettendorf's Twenty-ninth and Middle Road features the English Tudor influence and a trio of handsome flags flapping in the autumn breeze.

Ah, those lazy, hazy, crazy days of summer. And what better place to spend a hot sunny day than at Bettendorf Middle Pool? Lifeguard Tammy Driever keeps an eagle eye on the swimmers, looking out for anyone who might need her help, or for the somewhat too-exuberant water sprites. Not to worry, Tammy, these swimmers appear to be on their best behavior, just having fun in the sun.

112

"Once upon a time, in a faraway castle, there lived two lovely princesses. . . ." Actually, the castle is only as "faraway" as Learning Center Drive in Bettendorf. These "lovely princesses," enjoying some giggles in the castle, are Taylor and Hannah Watt. The exciting Family Museum features countless displays and exhibits, attracting the young and the young at heart. The facility was financed by a $10.5 million bond referendum in 1994, with the dedication of the museum taking place on May 17, 1997.

Educating the next generations is a top priority in Bettendorf. Residents turn out to support the schools, be it as a cheering section at a Bettendorf High School Bulldogs game, or in offering standing ovations for young thespians in a school performance. Parents and teachers are a team, and that makes for eager learners, as shown in the smiles of these Mark Twain elementary students.

Like so many Bettendorf families, the Peterson quartet is very active in the community, sharing their skills and talents. Mark Peterson is a partner with Moorhead and Peterson, CPA, in Moline. He's a member of Moline Noon Kiwanis and also serves as treasurer of the Midwest Writing Center. His wife Karen teaches at Augustana College in Rock Island and serves on the Bettendorf School Board. Besides being top students in the classroom, daughter Katie and son Matt are active in sports, and dad even helped coach Katie's baseball team.

Right here in River City—the Bettendorf Park Band is a musical favorite for folks throughout the Quad-Cities. It was founded in 1967 by Ernie Beerends, then band director for Bettendorf Schools, with an original roster of 35 musicians, which has since grown to 105. The band's current director is James Crowder, who assumed the baton in 1988. Past directors have included Ed Waligora, Roger Naylor, Richard Stodd, and Jim O'Briant.

114

The name Connie Heckert on a book cover is a signature of writing artistry blended with professional craftsmanship. This Bettendorf native juggles the demands of loving wife and mother with the deadlines of author, the latter winning her accolades from a wide audience of readers, and the former keeping her grounded. Her children's picture book, *Dribbles*, became a national award winner, while her numerous volumes on family life, enterprise, and local history grace the shelves of many public and personal libraries.

Bettendorf, along the Mississippi, enjoys a grand view of many events throughout the year. Most take place during the daytime, but now and then there's something to be seen after dark. One of the more spectacular sights is the annual Venetian Lighted Boat Parade. Boat owners garnish their vessels with bright, colorful lights. "Just Say No" admonishes this public service-oriented messenger. As for the boat being eye-catching, we "Just Say Yes."

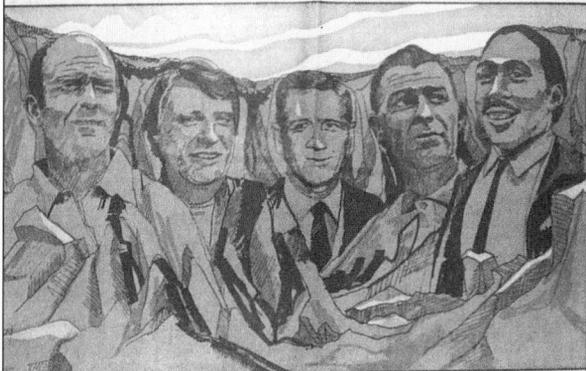

cards slam Mets................ Page 2C
Sox Page 2C

The fabulous five

ayden, Craig, Fleck, Reade and Nelson are first inductees

THE
QUAD-CITY SPORTS
HALL OF FAME

Presented by the QUAD-CITY TIM

The Hall of Famers' stories ...

Roger Craig: Remembering his roots Page 4
Jack Fleck: A memorable victoryPage 4
Don Nelson: A hardcourt successPage 5

In April 1987, the *Quad-City Times* announced the first inductees into the Quad-City Sports Hall of Fame. Among those chosen by a panel of 26 local sports media personnel and officials were Bettendorf natives Roger Craig and Jack Fleck, and Elmer Layden of the famed "Four Horseman of Notre Dame," who was married to Bettendorfer Edith Davis. At a "Salute To Sports" evening at the Davenport Adler Theatre, these three were present, along with Augustana's Bob Reade and basketball coach and player Don Nelson. All but Layden, who died in 1973, were on hand to receive their honor.

There's nothing like a tasty peanut butter and jelly sandwich, says young Bettendorfer Aaron Speer—or at least he *would* say it if he didn't have his mouth full. Thanks to that Micro Slicer at Aaron's right, he is able to chomp down on two fresh and evenly sliced pieces of bread, crust and all. Bettendorf is the home of sliced bread, another of many patented "firsts" of the Bettendorf Company.

116

The old Fenno Cemetery in Bettendorf provides a final resting place for about 45 early Pleasant Valley settlers. After a handful of teens desecrated gravestones in 1996, members of the Bettendorf Key Club restored and repaired damage done by their classmates. When finished, one weary worker said, "It looks like a cemetery, again." Bravo Bulldogs!

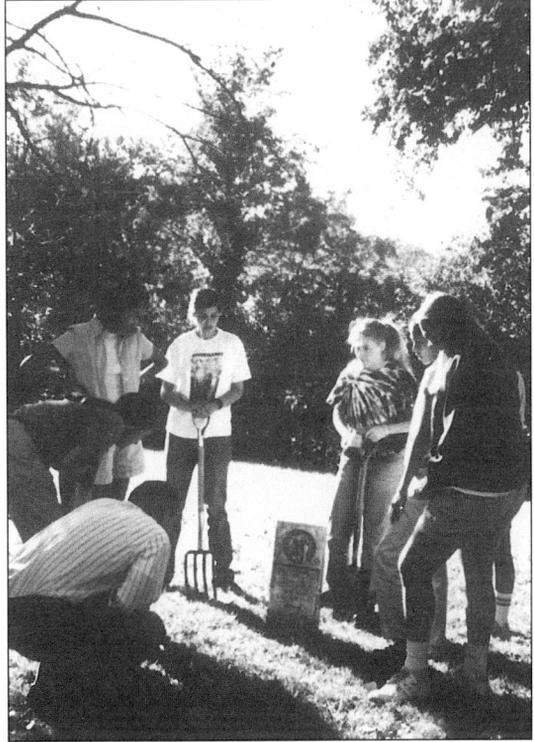

A longtime resident of Oakbrook Drive in Bettendorf, Dr. Lenny E. Stone resides with his wife Anne and son Daniel. This distinguished fellow has served as president of Scott Community College since 1986. He received his B.A. and M.S. degrees at Western Illinois University, and his Ph.D. in educational administration from the University of Iowa. He has been involved with the Bettendorf Chamber of Commerce, United Way of the Quad-Cities, and the Quad-Cities Rotary Club.

117

It's Friday night in Bettendorf. There are those who are spending the evening in front of their television sets. But for those who prefer live action over "Nash Bridges," there's nothing like watching the Bettendorf Bulldogs take on a gridiron adversary under the stadium lights. A

longtime powerhouse in Quad-City sports, young men and women athletes from Bettendorf High School have achieved a distinguished reputation for quality play, as well as sportsmanship.

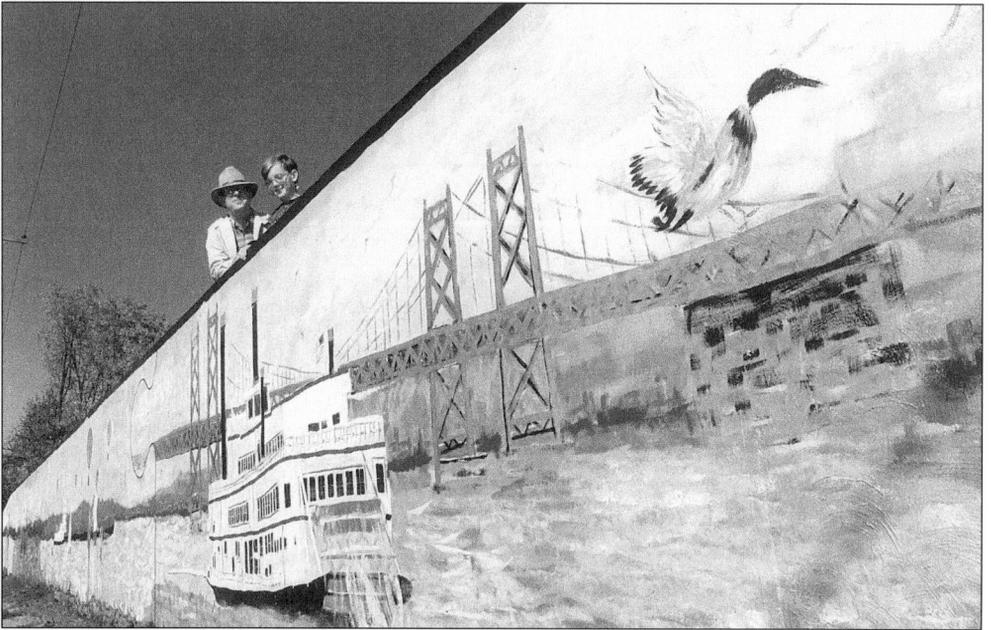

A city's history can be captured in various ways, such as through the words and pictures collected in this volume. Artist Jim Richardson chooses to *paint* history, creating this mural at Eighteenth Street and Central Avenue. His ten-year-old son Joey seems pleased with the completed image—a river saga painted on stone.

For the sixth year in a row, R.J. Boar's captured the Reader's Choice Award for best barbecued ribs in the Quad-Cities. The contest, sponsored by the *Quad-City Times*, asked area residents to submit the names of their favorites in a variety of categories. "Better make it R.J. Boar's!" cheered the masses once again in '99. Part of the Bettendorf restaurant's success comes from linking up with downtown events. Employee Henry Rottman posts the latest news regarding an upcoming "ribfest."

Carmen Miranda she's not. She'd have those bananas on top of her head if Quad-City Arts volunteer Laurie Smazal was doing an imitation of the '40s musical star. All Laurie intended was to display some of the fruit, which was provided courtesy of Eagle Foods, a sponsor of the QC Arts fund-raiser held July of 1992 at the Steamboat Landing in Bettendorf. Can you say Boonoonoonoos? Never mind, just have a banana and split.

Trick or Treating in Bettendorf? Nope, not even close. Mary Shenk is wearing this colorful creation for the third annual Culturefest, held in April 1990. The local event was organized by members, like Mary, of Cultural Awareness Council Worldwide. The collection of masks at the event proved a big hit with kids, many of whom were heard begging parents, "Can I have one."

Jackie Crouch was known as Bettendorf's "orchid queen," and this photo shows why. Jackie's legendary green thumbs (and all the other fingers, too) nurtured flowers of classic beauty, which she gathered up for display at the annual Illowa Orchid Society shows, as in this 1990 display at Duck Creek Plaza.

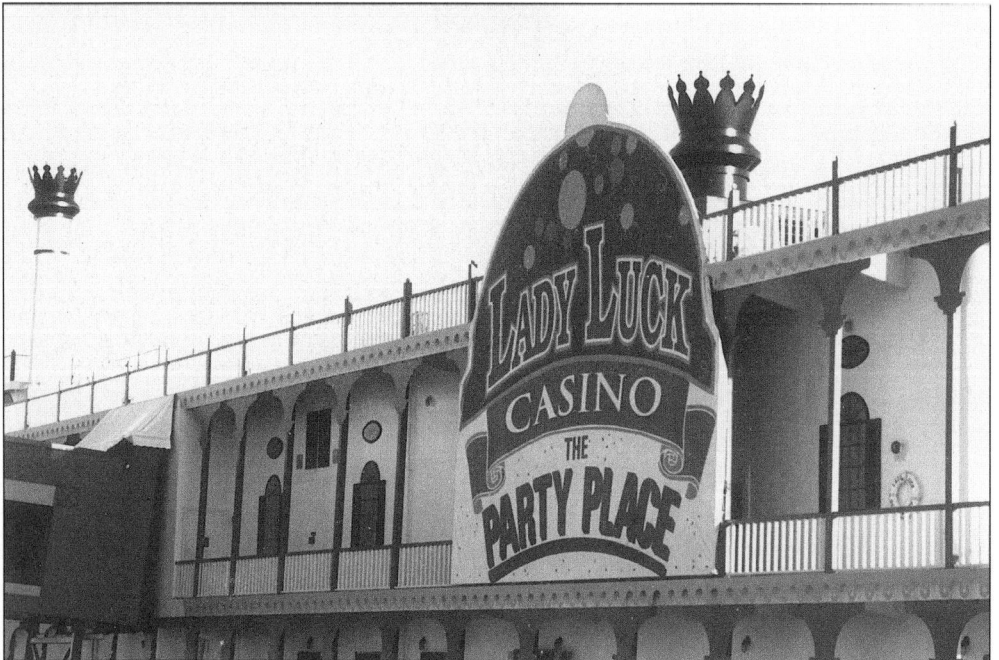

Throughout the main and upper decks of the *Lady Luck* casino boat there are slot machines, card games, roulette wheels, and many other games of chance for the gambling enthusiast. The boat features a 4,000-square-foot gaming area on the Bettendorf riverfront, and it's powered by a diesel engine that propels "Z-drives," which are like outboard motors at the stem.

Is there anything more fleeting than youth? Carl Schillig was born May 6, 1979, and by age 15 had already distinguished himself as a scholar, athlete, friend, and loving son. Here he is crossing the finish line at the Tipton Invitational in September 1994. Days later, Carl was struck and killed by a car in East Davenport. In his memory, the annual "Run For Carl" raises funds for scholarships and area charities. Whenever a Bettendorf youth performs an act of courage, it could be labeled "Carl's Way of Living."

"I've almost got a bite!" Anthony Speer used his imagination and a tree branch to go fishing in Crow Creek Quarry Pond Park. Formerly mined for granite, quarry operations drowned in the 1960s, when equipment struck water and the owner was unable to dam up the leak. The city developed walking trails and scenic overlooks around the old quarry and opened it to the public in the fall of 1999.

Even when an educator is not in the classroom, his/her thoughts are on how to reach the young minds of the students and bring out the very best in every young child. Here, Principal David Fairweather welcomes students to the new Riverdale Heights Building, which opened its doors in January 1996. The state-of-the-art building has expanded since then, adding eight additional classrooms and more opportunities for children to learn and grow.

Few city matters raised as much controversy as the heated battle over construction of a women's health care clinic on Spruce Hills Drive. The Planned Parenthood facility was completed in September 1999, after years of courtroom debate and confrontations between pro-life and pro-choice advocates. "Never saw people get so riled up," observed one long-time resident. "Guess it shows that our people care about the city."

Whenever he could, Bettendorf's "chief teach" John Finnessy got out into the classrooms to lead the "charge of the mite brigade." The Bettendorf school superintendent is seen here reading a favorite story to an eager group of listeners. After learning he had cancer, Finnessy

gallantly turned the reigns of leadership over to interim superintendent Wayne Drexler in September 1999, but not before he successfully led the effort for a bond referendum to bring much needed building improvements.

"And the luck of the Irish to you, too." Perhaps that emerald isle far across the sea boasts many a handsome young leprechaun, but in Bettendorf they don't come much cuter than two-year-old Jordan Juehring. With his snappy green hat firmly in place, this young lad straightens his tie just in case a cheerful colleen comes strolling by. Who could resist those bright eyes and that innocent grin?